Praise for i sold Andy Warhol (too soon)

"The story of a business culture that has grown more venal and volatile in recent years . . . Art dealers have played a pivotal role in this pricey shuffle, and Mr. Polsky paints them as an entertainingly infantile, manipulative bunch . . . That Mr. Polsky operates at the periphery of the art world, and knows it, is an appealing aspect of *I Sold Andy Warhol (Too Soon)*."
— *Wall Street Journal*

"Polsky [is] the Rodney Dangerfield of the art dealers . . . someone not afraid to take a stand on the real value of an artist. He knows that auction results and artistic achievement are not at all the same." — *San Francisco Chronicle*

"Entertaining . . . [Polsky's] memoir takes the reader on a wild ride about the business of buying and selling this real estate, where one must learn how to play it cool, even when millions of dollars are at stake." — *Huffington Post*

"Richard Polsky has captured a carnival of greed, arrogance, fear, and power. Sometimes art shows up almost by accident. Welcome to Wall Street's twin, the marketplace of people who make the product, people who hustle the product, and people who invest in the product. This is not a pretty picture. A buyers-be-warned guide to the insider schemes of art. Roll over, Rembrandt."
— CHARLES BOWD̶E̶N̶

Some of the ̶

i sold Andy Warhol.
(too soon)

also by Richard Polsky

Boneheads: My Search for T. Rex
I Bought Andy Warhol
The Art Market Guide (1995–1998)

Richard Polsky

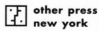

other press
new york

Copyright © 2009 Richard Polsky

First softcover printing 2011

ISBN 978-1-59051-456-6

Production Editor: Yvonne E. Cárdenas

Book design: Simon M. Sullivan

This book was set in 10.75 pt. Electra by Alpha Design & Composition of Pittsfield, NH.

10 9 8 7 6 5 4 3 2 1

LIBRARY OF CONGRESS CATALOGING-IN-PUBLICATION DATA

Polsky, Richard.
 I sold Andy Warhol (too soon) / by Richard Polsky.
 p. cm.
 ISBN 978-1-59051-337-8 (hardcover) — ISBN 978-1-59051-374-3 (e-book)
 1. Art—Economic aspects—History—21st century. 2. Art—Marketing—History—21st century. 3. Art—Collectors and collecting—Psychology. I. Title.
 N8600.P65 2009
 381'.45709—dc22

 2009017791

This is a work of nonfiction. However, the author has reconstructed conversations to the best of his recollection. The author has also, in some instances, compressed or expanded time, or otherwise altered events for literary reasons, while remaining faithful to the essential truth of the stories.

FOR PARKE GEORGE

Any time you sell, it's a blunder.

RICHARD L. FEIGEN, New York gallery owner

contents

i sold Andy Warhol.
(too soon)

The 106-page Christie's auction catalog arrived with a thud. What was unusual was the volume featured only a *single* painting for sale. Normally, a catalog this thick contained an *entire auction's* worth of material. But this was May 2007 and the art market was poised to take the next leap into eight-figure territory. Christie's had gone overboard to promote its latest treasure, Andy Warhol's *Green Car Crash*. Aside from the superior quality of the painting, the magnitude of its pre-sale estimate was equally breathtaking: $25 million to $35 million. The auction record for an Andy Warhol painting was $17.3 million — a benchmark set only a season earlier when a large "Mao" sold to a Hong Kong investor.

As a thirty-year veteran of the art world, I had never seen anything like the marketing effort behind *Green Car Crash*. Everything felt so over the top. As I thumbed the catalog's pages, I marveled at all the superlatives used to describe the painting: *masterpiece, extraordinary, powerful, challenging,* and *provocative*. There were scholarly essays, which spoke of the painting in solemn tones, as if it were the Holy Grail. Then there were

the illustrations of the canvas, with close-ups shot from every conceivable angle, allowing the reader to pore over each Ben-day dot. There was even a section that reproduced a pastiche of 1960s magazine ads used to seduce potential car buyers, though none of these vehicles resembled those in the painting. Perhaps more compelling were the photographs of Andy Warhol. He was captured in his youth, during the early 1960s, when there was no high-end art market to speak of. Back then a million dollars for a painting was inconceivable—a plateau not reached until 1980 when Jasper Johns's *Three Flags* was sold to the Whitney for that exact amount.

Green Car Crash depicted a grisly automobile accident. It must have been a hell of a collision, as the victim had been thrown from the car and impaled on a telephone pole. Just below him, the overturned vehicle was covered in flames. In 1963, Warhol had a photo silk screen made from a newspaper photo of the accident, and transferred the image onto a phthalo-green canvas that measured ninety by eighty inches. Warhol's genius was his sense of placement. He intentionally overlapped multiple photo silk screens of the crash, creating rich black tonalities. He also left parts of the canvas blank, giving the viewer's eyes a rest from the numbing repetition of the disturbing scene.

The night before *Green Car Crash* came up for sale, Sotheby's had already set the benchmark. In the midst of a record-filled night, it sold a Mark Rothko painting from the collection of David Rockefeller for $72 million. Sotheby's had gambled big and won. It guaranteed Rockefeller $46 million for his picture, plus part of the upside. What was so surprising was that the record for an equally good Rothko was $23 million—set only six months earlier in November 2006.

Sotheby's had also scored with Francis Bacon's painting of Pope Innocent X. This work brought $52 million, helping Sotheby's set the new standard for an entire sale of contemporary art. Sotheby's grossed $254 million, leading to a post-sale love fest among auction house personnel, obviously anticipating some healthy bonuses. The *New York Times* gushed the next morning about Sotheby's impressive triumph. The reporter wondered, what was next?

It took only twenty-four hours to find out. The following night, Christie's topped Sotheby's record by about $130 million, tallying $384 million. The sales room crackled with energy, occasionally breaking into applause as painting after painting soared above estimate: a de Kooning from 1982 was knocked down for $19 million, Warhol's *Lemon Marilyn* brought $28 million, and yet another Rothko sold for $26 million.

As for *Green Car Crash*, it did not disappoint. The rumor was Los Angeles collector Eli Broad coveted the Warhol and planned to donate it to the Los Angeles County Museum of Art. The night of the sale, auctioneer Christopher Burge introduced the painting and immediately began extracting bids from the audience. A paddle shot up each time Burge raised the ante by $500,000. The room's currency conversion board hummed along with each offer. Experienced auction-goers noticed it listed an additional form of legal tender: the ruble. It was a sign of the times—the art market was now truly international.

As the bidding reached $50 million, there were only two bidders left vying for the prize. At $60 million, there was bidding "from a new place." Larry Gagosian, arguably the world's most successful dealer, had entered the competition. But he was quickly shoved aside as the painting ultimately sold to an unidentified telephone bidder. *Green Car Crash* brought $71 million

(including buyer's premium). Its sale was the period at the end of the sentence for an unprecedented outpouring of money for contemporary art—for the moment.

The next day, I received a number of calls from clients and colleagues who stumbled over their words, desperate to get a handle on what happened. The art market had lost all reason. While it was certainly fun to analyze the week's events, it wasn't very productive. The sobering message was the emergence of the auction houses as the new alchemists, converting oil and canvas into gold. As other dealers continued to phone, anxiously speculating on what was next, I grew weary of listening to their theories. All I knew for certain was the profession of art dealer was in trouble.

breaking up is hard to do

I think it's worth at least $300,000," I said over the phone, to fellow art dealer Jonathan Novak.

"It doesn't matter what *you* think. I can get you $200,000 for your 'Fright Wig' painting right now!" yelled back Novak. "You should take the sure thing. The market's peaking for Warhol. Come on, you only paid around $50,000 for it. I'll even tell you who my client is—Andy Rose—and he pays fast."

It was early 2005—only two years before *Green Car Crash* came up for sale. By all appearances, the market for contemporary art was robust. Yet, there was something disquieting in the air. The recent Michel Cohen scandal festered like a piece of rotting fruit.

Cohen was a well-known private dealer who managed to abscond with approximately $50 million worth of blue-chip paintings and was now a fugitive from the law. The result was an unsettling wave of mistrust among colleagues. What was so scary was that he was *one of us*. He was a dealer in good standing, well liked by everyone, having earned the industry's respect after over

a decade in business. When Cohen took a multimillion-dollar Picasso painting on consignment from the Richard Gray Gallery, all he did was sign for it. Likewise, when he borrowed millions from Sotheby's to recycle into one of its sales, his signature was all that secured the loan. No one asked for bank references. If someone had, he would have found out Cohen was rapidly going broke. He had become addicted to playing the stock market, specifically high-risk options, and kept making the wrong bets.

Cohen became so desperate that he met with an investor in front of a Monet painting at the Metropolitan Museum of Art, and insisted he had the right to sell it. He concocted some outlandish story about how it was once part of the Holocaust plunder. Cohen explained how the original owner had been determined, and the courts had declared his heirs to be the current rightful owners. According to Cohen, the heirs were planning to sell. He explained to his investor that the painting was worth $6.8 million, but if they moved quickly, he could secure it for $5 million. Supposedly, the next day the collector wrote Cohen a check for the requested sum. As you might guess, the investor never saw the money or the painting.

The media jumped all over the Michel Cohen story and amplified its implications. There were no safeguards in place to prevent what happened. The art world operated on verbal agreements and trust. After the news broke, I heard a dealer end a conversation by saying, "Don't pull a Michel Cohen on me." Both parties laughed, nervously. Now that we were in a boom market, the stakes had grown higher, along with the need for greater caution, maybe even contracts.

As someone who knew Cohen fairly well, I was interviewed by several publications. I even gave one reporter an ill-thought-out quote, "Yeah, I'm out a million dollars to Cohen." Later, I con-

fessed it wasn't true—I just wanted my fellow dealers to believe I had a million to lose!

I was reluctant to part with my Andy Warhol self-portrait, especially when evaluating it against a questionable offer. I began to reflect on the significance of my Fright Wig—so called because Warhol's silver wig was standing straight up, as if he had stuck his finger in a light socket. It was a hard-won trophy—the end result of a lengthy search to buy the right Warhol. Sure, I was pleased it had appreciated. Everyone likes to be right. But this was more than just an investment; it was part of my soul. Every time I gazed at it, I felt connected to the art world. Others might have more money, but I had a cool painting.

Still, my sense that the art market was cresting weighed strongly on me. An even heavier weight was brought to bear by Rachael, my new bride. Without getting into too much of the drama, this was a woman who never met a shop she didn't like. While the concept of a high-maintenance wife has become a cliché, in this case the term was apt. I was hemorrhaging money, trying to keep my monthly Visa statement below $15,000. A couple hundred grand for the painting would buy at least a year of time, until, I hoped, my marriage stabilized.

One thing I knew—I wouldn't take Novak's offer. If he was dangling $200,000, that meant he was selling it for at least $220,000. A ten-percent profit was the absolute minimum a dealer made on a transaction of this size. I could try selling it privately to one of my own collectors. However, that strategy brought with it a different set of issues. Most of my clients who were interested in Warhol already owned paintings by him. Besides, I knew I would come off as greedy if I asked for $300,000, since there was no precedent for a twelve- by twelve-inch Fright Wig bringing anywhere near that at auction.

The obvious answer was to explore the possibility of putting it up to Sotheby's or Christie's. To the uninitiated, dealing with the auction houses is like crossing an unmarked minefield. On the surface, everything seems calm and orderly—the dangers are hidden from view. When you place that initial exploratory call to a department specialist, everything sounds so positive.

An experienced seller will typically play both major auction houses off each other. Sotheby's and Christie's are fully aware of this. Often, they try to discourage you from dealing with the competition by making a preemptive offer. In my case, I had no preference whom I dealt with. Since Christie's had the higher profile at the time, I decided to call it first.

I spoke with Robert Manley, director of the evening sales, who said, "I think your painting will do very well. As I'm sure you know, the market for Warhol is particularly strong. But just to encourage bidding, why don't we go with a modest estimate—say, $150,000 to $200,000."

Manley's thinking was sound. When a potential bidder views his auction catalogs, each lot comes with a pre-sale estimate of what it's expected to sell for. Estimating paintings requires the skill of a Zen master, as it's all about finding the right balance. Too high of an estimate and you scare away buyers. Too low and you undermine the value of the painting.

Pressing Manley further, I asked, "Would you consider putting the painting in the evening sale?"

I was playing hardball. The evening sales are where the auction houses place their most important property. Generally, the crowd you get at night is wealthier and more eager to spend. People dress up, especially the wives of rich collectors. There's a macho mentality to an evening sale. People overbid on a regular basis. They're often trying to make a statement by saying, "I've

made a shitload of money so I don't care what it costs—I want to be a hero to my spouse and go home a winner."

Manley responded, "I wish I could do it. But you know what's happened—the evening sale is all about super-expensive pictures. Right now, a painting worth several hundred thousand dollars is only a mid-range day-sale work."

He was right. Realizing I didn't have much leverage, I decided to take a different tack: "If I agree to consign it to you, I want optimum placement in the day sale."

Positioning my Warhol at the right spot in the sale would maximize its price. An auction is like a concert, with the auctioneer functioning as the conductor. If orchestrated properly, the house can increase its take just by creating the right rhythm to the sale. The auctioneer starts with a quiet prelude of pictures, then uses some of the more expensive paintings to build the sale to a crescendo.

Manley was amenable to my suggestion, "I'll go even one better. We'll hang your Warhol with the evening sale paintings during the preview."

Now he was talking. About five days before the actual sale, each house puts on an elaborate exhibition of the works to be auctioned. This allows collectors to inspect the paintings in person. Condition reports are issued. Questions can be asked. If you're a good client, the department head will treat you like an insider. He'll disclose the level of interest in the work you covet. He will also discreetly tell you what you should be prepared to bid if you hope to be successful.

From my perspective, the advantage of having my Fright Wig hang with the high-ticket items was obvious. Seeing my picture sandwiched between a de Kooning and, say, a Rauschenberg sends a signal to the collector. If it's well lit and given generous

breathing room, even better. All of these indicators play on the subconscious of the buyer.

I told Robert Manley I'd think about it and get back to him. Meanwhile, I placed a call to Sotheby's. Going straight to the top, I requested an audience with Tobias Meyer, the worldwide head of contemporary art and the company's star auctioneer. Meyer wasn't in, but returned my call in short order.

"Hello, Richard," he said, with a subtle German accent.

I was pleased to be speaking with him, knowing Meyer was a legitimate Warhol expert. After I explained what I had to offer, Meyer responded, "We would love to have your *pink* Fright Wig. It's a wonderful picture."

The only problem was my painting was green. On the other hand, I knew I should cut him some slack—Meyer seemed overwhelmed by his responsibilities. The pressure on him to bring in major properties and sell them was intense.

"So what do you suggest for an estimate?" I asked.

"How about $100,000 to $150,000?"

"That seems a little low to me."

With a slight chuckle, he said, "Come on, you know how the game is played. It should do much better than that."

I agreed, thanked him for his time, and told him I'd let him know either way. After a few days of mulling things over, I made a second call to Christie's. It was obvious to me that Christie's wanted my property more than their competitor did, or at least that was the vibe I got. I believed in doing business with whoever displayed the most enthusiasm.

Deciding to press my perceived advantage, I said to Manley, "Look, I'm interested in working with you, but I think it's a mistake to go with too low an estimate. I think we need to go with $200,000 to $300,000."

Establishing the low end of an estimate is crucial. It is directly tied in to the reserve the seller puts on his property—the minimum he will accept. However, the reserve cannot exceed the bottom of the estimate. Right then and there, I decided if I couldn't get at least $200,000 for my painting (the amount Novak offered me), I'd simply take it home. Eager to close the deal, Manley acquiesced. I told him I needed to discuss it with my wife, but in principle, everything sounded good.

The next day, just to play devil's advocate, I called Phillips de Pury, the number-three auctioneer in America. Around five years ago, this once sleepy auction house received a large infusion of cash, which it used to acquire market share by aggressively luring sellers with offers of a guarantee. However, this tactic once backfired—big time. In 1998, Phillips promised the esteemed collector Heinz Berggruen $120 million for a raft of Impressionist and Post-Impressionist pictures. The ensuing sale was a disaster, as the paintings sold for far less than the guarantee.

I wound up talking with Michael McGinnis, Phillips's head of contemporary art. McGinnis had a nice way about him and a strong sense of reality. He was smart enough to know he couldn't compete financially with the big boys. Instead, he emphasized personal service—he'd work hard for you.

I told him about my painting. McGinnis was very forthcoming, "We'll give you an estimate of $250,000 to $350,000, and I'll give you a choice of including it in the evening sale or putting it on the cover of the day-sale catalog."

I was impressed. Deciding to see how far I could push him, I asked, "How about a guarantee?"

McGinnis paused for a moment. Then he said, "We could do that."

"How would it work?"

"I would be willing to guarantee you eighty percent of the low end of the estimate, which would net you $200,000. But anything it brings above that we split 50/50."

I already knew auction houses often "sold off" their guaranteed lots to investors. Typically, they would "guarantee the guarantee" for half of the profit. In that case, the auction house wound up with only twenty-five percent of the amount that exceeded the guarantee.

Before I could respond, McGinnis added, "If you look at your upside, I would advise against taking a guarantee, but I'll do it if you want."

He was right. If the painting sold for $300,000, I would be entitled to all of it. If I took the guarantee, I would only end up with $250,000.

I told McGinnis I appreciated his candor and would consider his offer. That night, I sat around debating the best course of action. I still hadn't completely resolved whether to auction the painting. On a pure business level, the reason to sell was compelling. But this picture meant more to me than just money. I secretly wished I could get advice from a higher authority.

By sheer coincidence, my mother called. Needing to unburden myself, I told her I was considering selling my Warhol. Her prophetic words were, "Don't sell it. Think of all you went through to get it. Are you that desperate?"

The answer was yes—both financially and emotionally. I was feeling stressed by my pressure-filled relationship. Rachael was insistent that I sell. She coldly asked, "What would you rather look at, your painting or *me*?" Putting my wife before a work of art seemed prudent. With that in mind, I reached a decision to call Christie's in the morning and make the deal.

My discussion with Robert Manley went smoothly. We worked out the terms and agreed to a strategy. A few days later, the contract arrived. I made sure everything was in order, signed the papers, and made plans to ship the Fright Wig. Once it was physically out of my hands, it was psychologically easier to let go.

Soon, May rolled around. I anxiously awaited the arrival of the auction catalogs. When they came, I could barely contain my excitement as I rapidly flipped the pages, searching for my painting. And then I came to lot number 285. There it was—sort of.

To my utter astonishment, the painting had been poorly reproduced. Its electric green color had been muted to a pale green. As I tried to control my anger, I got Robert Manley on the phone.

"Robert, hi, it's Richard Polsky. I just got my catalog. What happened to the color of my painting? It looks washed-out!"

This was not the sort of call auction-house personnel look forward to getting. There is nothing worse than a disgruntled consignor.

"Uh, hold on a second. Let me grab my catalog and take a look," said a frantic Robert Manley. "Yeah, here it is. Hmm, I see what you mean but it's not that bad. Anyone serious about bidding will want to see it in person."

"Sure they will—if they get that far after seeing the catalog," I said, growing increasingly upset.

Manley tried to console me by saying, "Don't worry, we're still going to hang it with the evening-sale works. It will do fine."

But fine wasn't good enough. I was looking to knock the ball out of the park. The reality was there wasn't a darn thing I could do about it. Sure, in theory, I could withdraw my painting from

the sale — probably without penalty. But the catalogs had already gone out. The damage was done.

A few weeks later, I found myself in Rockefeller Center, greeted warmly by Gil Perez, Christie's doorman extraordinaire. How he remembered the name of every single visitor was beyond me. I was there to preview the sale. True to his word, Manley did a beautiful job installing my painting. It looked like a million bucks, or at least two hundred thousand.

It unnerved me to see my Warhol momentarily orphaned. I felt like I had let it down. Worse, I felt like I had let myself down. I kept trying to rationalize the situation, insisting I had done the right thing. I stood back from the Fright Wig, observing the parade of collectors and dealers who walked by it, hoping to catch an encouraging snippet of conversation.

A few days later it was auction time. As Rachael and I made our way to our seats, I caught a glimpse of Andy Rose, the collector who had previously made an offer on my Fright Wig, standing at the back of the room. Before we sat down, I ran into several of my colleagues. Even though the catalog description failed to disclose I was the seller, everyone apparently knew. There are few secrets in the art world.

The funniest thing was how many people wished me luck. It was funny because it was all so insincere. The German word *schadenfreude* came to mind. Loosely translated, it means finding pleasure in someone else's pain — preferably someone you know. I could tell that my fellow dealers secretly hoped the painting tanked.

The nature of the art business is that it's filled with pettiness and jealousy. There's little mutual respect. That's because anyone can become an art dealer. No one needs a license. You don't have to pass a test certifying you know art history, have taste and ethics, and so on. Most dealers are staked by their wealthy fami-

lies. Yet, they believe they're self-made. The expression, "Born on third base, thought I hit a triple," comes to mind. Everyone is insecure about their accomplishments, which often leads to a great deal of bad behavior to disguise the truth.

Since my painting wouldn't appear until an hour into the sale, I sat there in agony. Each lot took about a minute to sell (or not sell). As my lot inched closer, I started to fantasize. What if my canvas brought $400,000 or $500,000? What if two crazies started fighting over it, got caught up in the heat of the moment, and it brought $1 million? Stranger things have happened.

A few minutes later, a Warhol "Marilyn Reversal" painting came on the auction block. This image was based on Warhol's great "Marilyn" series from the early 1960s. Only in this case, he created a negative image of Marilyn Monroe's face and screened it onto a green canvas—the same color green as my Fright Wig. Although the painting was only a little bigger than mine, measuring eighteen by fourteen inches, it carried an estimate of $250,000 to $350,000. Since the Marilyn Reversals were completed in 1986 (the same year the Fright Wig was painted), I saw it as an indication of how my painting would do.

The bidding on the Marilyn Reversal opened at $160,000 and quickly jumped in $10,000 increments. When it passed $400,000, I was pleased. When it passed $500,000, I was ecstatic. Final selling price? $688,000. I turned to Rachael and smiled. She smiled back. For that brief moment, we were united. All thoughts of our deteriorating marriage were put aside. I took her hand and grasped it firmly.

Then the moment of truth. I was overcome by a wave of nausea as the solicitous female auctioneer spoke, "Lot number 285, the Andy Warhol self-portrait. Do I have $140,000 to start?"

All eyes were on the center of the stage. The painting itself was on a circular rotating pedestal, flanked by a white-gloved

porter. Warhol's likeness glowed with a spooky penumbra under the glare of a lone spot light. The painting was expertly framed in black; it never looked better.

Then a strange thing happened. There wasn't a single bid. Nothing. Nada. I nervously scanned the room, desperately looking for a waving paddle. An eternity seemed to pass. The auctioneer implored the crowd, "Do I have $140,000? Any bids at $140,000?"

I looked at Rachael. Our eyes locked, as if to communicate, *"It's not going to sell!"*

"I have $140,000!" yelled the auctioneer. "Who'll give me $150,000?"

Whew.

"$150,000, $160,000, $170,000," she chanted. The bidding started to gain traction.

"180,190 . . ."

The painting was now only one bid away from reaching its reserve.

"I have $200,000," she cried.

It no longer belonged to me.

At that point, the bidding began climbing in $20,000 spurts. Rachael squeezed my hand as the price soared to $320,000. Visions of the Marilyn Reversal flashed through my mind.

"Three hundred and twenty thousand once, twice. . . . Any more bids? I'm going to sell it now for $320,000."

I said to myself, *Don't bring the gavel down! Not yet!*

But down it went. "Sold, for $320,000."

With the buyer's premium, it brought $374,400. After deducting my seller's premium, from the $320,000 hammer price, I would receive a check in thirty-five days for $304,000.

I looked at Rachael. She seemed relatively pleased. I myself was relieved. Sure, I had greedily hoped for more. But what the

heck, it could have just as easily brought only $200,000 and I would have been forced to take it.

A few lots later, we got up from our seats and slowly edged our way out of the room. Andy Rose caught my eye and shrugged his shoulders. Jonathan Novak looked over and mouthed the words, "Not bad." As I passed Los Angeles dealer Manny Silverman, he whispered, "Think of all the taxes you're going to have to pay!"

Once outside the salesroom, a stranger approached me. He was tall, well groomed, perhaps fifty, and carried himself with a European elegance.

"Hi. I'm John Lindell. You don't know me, but I just bought your painting," he said beaming.

He continued, "You probably don't remember this, but I once sent you an e-mail telling you how much I enjoyed your book, *I Bought Andy Warhol*. That's when I fell in love with your painting on the cover. I actually came all the way from Finland on my company's plane to buy it."

As sad as I was to see my painting go, I knew it had found the right home.

the way we were

The moment the check from Christie's hit my money market account, I was overcome with profound regret. Seller's remorse was an understatement. I had violated the cardinal rule of art dealing: never get emotionally attached to your inventory. Acquiring the Warhol Fright Wig had been a twelve-year odyssey—a hard-won victory. Given how expensive Warhol's work had become, I seriously doubted whether I would own another again.

Now it was gone.

Compounding my grief was an unhappy episode at Chanel. Since the Warhol sold, I kept my promise to Rachael to buy her a long-coveted designer jacket. It was a metaphor for the times and brought back memories of my last big score in the late 1980s—when buying my first wife a mere black derby from Morgan LeFey sufficed. She had been my partner in a gallery that promoted artists who we thought mattered. Now, I was married to someone who reflected the current state of the art market—we were the ones who mattered.

Within an hour of the successful Fright Wig sale, Rachael and I arrived at Chanel's flagship store on Fifth Avenue. As Rachael browsed, an elegant saleswoman struck up a conversation with me.

"How are *you* today?" she asked.

With a grin, I responded, "It's been a good day. We just sold a painting at auction for a lot of money, so I thought I'd treat my wife to a jacket. She's wanted one for some time."

The saleswoman nodded appreciatively. As I glanced over at Rachael, she shot me a dirty look. I couldn't figure out why. Meanwhile, she continued to try on different styles until she selected one—a classic pink rendition of a short Chanel blazer. Some $4,550 later (plus tax), we parted the doors of the boutique and spilled into the swirling foot traffic of Manhattan.

I spoke first, "So, you must be thrilled."

Rachael said nothing. She still had a sour look on her face.

I said, "What's wrong?"

"I'll tell you what's wrong—that wasn't the experience I was looking for."

Perplexed, I asked, "What do you mean?"

"You made it seem like it was a big deal buying the coat, bragging about selling a painting so you could afford it."

Starting to catch on, I said, "So you wanted the saleswoman to think this was just an everyday event—like we do this all the time? That's ridiculous! Who gives a shit what she thinks!"

Rachael just glared at me, "Like I said, it wasn't the experience I was looking for . . ."

Shopping faux pas aside, the bigger issue was how to reinvest the Warhol money. In the past, I simply took my profits and bought another painting. If you knew the art, and could tell the difference between a good Ed Ruscha and a great one, you

couldn't lose. Now you were thinking like an MBA and invest-
ing like a Wall Street trader. You spent your days poring over a
myriad of auction statistics determining which paintings might
appreciate. You also factored in everything, from which high-
profile collectors were buying which artists, to how many given
examples by a blue-chip painter were likely to come onto the
market. Only then did connoisseurship kick in.

But the art market wasn't always this complicated or money
hungry.

In 1984, when I opened my own gallery in the Bay Area, the
art world was still old school. Prosperity was important, but it
wasn't valued above the art itself. My role model was Ivan Karp—
the tastemaker who discovered Warhol, Lichtenstein, and a slew
of others. I too wanted to identify new artists and become their
advocate. But I soon learned that was pretty tough to do in San
Francisco, or any city other than New York. With the media,
museums, auction houses, and the most important galleries
located in Manhattan, New York controlled the scene. Four
years later, I grew weary of being a gallerist—dealing with the
artists' insecurities, dealing with my own inability to develop
their careers, and dealing with the outrageous expense of run-
ning a space. Without financial backing, I knew it was time to
be practical. There was little profit in dealing emerging talent.

Fortunately, in 1988, the market for blue-chip art entered its
first boom cycle. I closed Acme Art and moved to Los Angeles,
a city with the second-largest American art scene. It was a heady
time. If you had a decent credit line, you could afford to specu-
late like the big boys. Armed with $500,000 in credit from Santa
Monica Bank, I spent every penny buying inventory, sold every-
thing, reloaded, and did it all over again. During the late 1980s,
my income was probably the equivalent of a good orthopedic
surgeon's. The embarrassing thing was that almost anyone with

a bankroll could do what I did. You would simply point at a Sam Francis painting (regardless of quality), say "I'll take it," and "jack" it up to auction.

Alas, in May 1990, the art market cratered. By most estimates, art depreciated by approximately sixty-six percent. Put another way, paintings were worth about a third of their peak value. There were many horror stories about gallery closings and private dealers being wiped out. I still remember colleagues calling me with desperate offers: "I paid $135,000 for this Motherwell painting, but you can have it for $65,000." Unfortunately, I was in no better straits than they were.

The art market slowly clawed its way back during the mid-1990s. The lengthy process gave me plenty of time to think about my next move. Having watched the whole thing crumble made me risk averse about buying inventory. Since the resale market no longer felt viable, I thought more and more about selling a service rather than a product. Solid information on investing in art was hard to come by. There weren't any market-oriented guidebooks, just the occasional art dealer memoir, long on anecdotes and short on useful suggestions.

With that in mind, I tried to transition from art dealer to "art market expert." As a precursor of things to come, I wrote a series of books called the *Art Market Guides* that rated artists like stocks, based on their performance at auction. The feedback from my colleagues was certainly entertaining. If I evaluated one of their artists as a "Buy," the dealer sung my praises. Conversely, if an artist a dealer handled was designated a "Sell," he dismissed me as "someone undisturbed by knowledge."

Once the Internet went mainstream, the *Art Market Guide* became a weekly column on *Artnet*'s online magazine. Readers often commented on my features. Some of the letters were outrageous. One memorable e-mail was from an art-loving

dominatrix in Las Vegas. Obviously trolling for clients, she insisted I needed to be disciplined, before my art world opinions got me into hot water.

Another scary response came from a woman who was upset I compared Jean-Michel Basquiat's career to that of Jimi Hendrix, prompting her to send me a nasty e-mail calling me a "racest." Actually, that was the kindest thing she said about me. Her ugly diatribe was the rantings of a deeply disturbed human being. I decided to respond by pointing out her shortcomings as a writer, commenting on her poor grammar and spelling—a big mistake on my part. Within minutes, I received another note, this one threatening to kill me if we ever met in person. Rather than provoke further animosity, and risk having her make good on her threat, I let this lunatic have the last word. The only good thing to come of the episode was an appreciation of dealer Ivan Karp's insistence on carrying a sidearm. Sometimes art brought out uncontrollable passions in people.

After my adventures with *Artnet*, which lasted approximately three years, I continued to write occasional freelance magazine pieces, but with less conviction about the work I evaluated. I was finding it increasingly impossible to visit an art museum and enjoy what I saw. When I looked at an Ellsworth Kelly, rather than marvel at the deceiving simplicity of his compositions, all I could think about was what it was worth. It wasn't that I no longer understood the art or lost my sense of connoisseurship; it was more the expression "money changes everything" had come true.

Like it or not, I was well on my way to joining the new breed of art dealers. There was no cynicism in my heart—just a realization that the scene had moved on. It used to be all about the art world: visiting artists in their studios, socializing with collectors, and hanging out at art fairs with your fellow dealers. Now, it was all about the *art market*.

The biggest shift in marketplace fundamentals was that *there were no fundamentals*. While it's true the art market has never been regulated, there was always a hierarchy of participants. Based on whether you were a collector, dealer, or artist, you always knew where you stood—and how you were supposed to conduct yourself.

During the early 1950s, the collectors held the reins of power. That's because there were too few buyers to go around. People who bought modern art were considered true eccentrics. Investment was the furthest thing from their minds. There was little chance their purchases would ever be worth more than they paid for them. Dealers such as Betty Parsons and Peggy Guggenheim had to beg and cajole their few clients to buy a Jackson Pollock. Anyone who saw the movie *Pollock* is familiar with the near-hopelessness of that situation.

Later in the 1950s, Sydney Janis, a successful shirt manufacturer, applied simple business principles to promoting the top Abstract Expressionists. After luring away key talent from rival galleries, he immediately lowered each artist's prices (since they weren't selling), gradually raising them once they caught on. This marketing tactic allowed Willem de Kooning, Franz Kline, and Mark Rothko to finally eke out a living. Despite Janis's success, there were still plenty of quality paintings around and not enough people to acquire them.

In the 1960s, with the coming of Leo Castelli and the Pop movement, the power shifted to the artists. Once Jasper Johns, Roy Lichtenstein, and Frank Stella became big sellers, artists began to drive harder bargains. To retain their loyalty, Castelli shrewdly put them on monthly retainers. He also made other accommodations. When directly challenged by Robert Rauschenberg—who began funneling work to the rival Knoedler Gallery—Castelli looked the other way. Even the great Andy

Warhol, who was nominally represented by him, was allowed to sell out of his studio. Castelli understood his top artists were now successful enough to write their own ticket.

The 1970s were mostly a fallow period for the art market. The one exception was the infamous "Scull Auction" at Sotheby's. In 1973, Robert and Ethel Scull—also known as "Bob" and "Spike"—put up a large chunk of their contemporary art collection at auction. Until then, auction was considered the province of Impressionism, American painting, and modern art. Contemporary art was untested. But that all changed the night the Sculls' hoard of predominantly Pop Art sold for profits of more than one thousand percent, prompting Robert Rauschenberg to shove Robert Scull after the auction, incensed by all the money he made from his work.

By the early 1980s, the pendulum swung yet again—this time to the art dealers. In 1984, the year I opened Acme Art, I remember seeing a catalog from Japan titled, *Mary Boone and Her Artists.* The not-so-subtle message was that the dealer was the one who really mattered. The collector was no longer buying art; he was buying the *art dealer.*

Everyone remembers how Boone created the concept of the "waiting list." She'd insist that wealthy individuals purchase her lesser-known artists in order to be offered her best ones. If you wanted an Eric Fischl, you had to work your way into her good graces by buying the inferior Michael McClard. The funny thing is Boone's strategy worked. Some of the nation's biggest collectors reveled in the gamesmanship. Her artists appreciated in value. And other dealers began to adopt her approach. Buyers had to prove themselves worthy not only to Boone but also to Arne Glimcher of PaceWildenstein, and eventually Larry Gagosian.

At least the boundaries were defined during the 1980s. There were clear-cut rules for collectors, as well as a specific dealer

code of conduct. Art dealers were ranked according to the importance of the art they handled. If you weren't a dealer in the top five percent, you paid homage to your superiors in order to get what you wanted. You had to find ways to ingratiate yourself. The expression "paying your dues" was trite but true.

It reminds me of an analogy I heard about the rock music world. During the 1980s, there was a nightclub in North Hollywood called On the Rox. One night, Alice Cooper was holding court with some budding rock stars. Then Paul McCartney walked in. One of the guys jumped up to approach the ex-Beatle. Cooper grabbed him and said, "You aren't cool enough to talk to Paul McCartney—you haven't earned the right." Cooper may have been a questionable musician but he "got it."

Besides meeting fellow dealers who represented the most sought after artists, I also learned the value of getting to know those with the right social connections. The New York dealer Charles Cowles was a good example. I wanted to participate in a new art fair in Los Angeles. My gallery applied for admission and was promptly turned down. Although Acme Art was fresh to the scene, I already had done a number of impressive (or so I thought) exhibitions, including one-person shows of Joseph Cornell, Andy Warhol, and Ed Ruscha. Still, I was rejected.

Only a month before the art fair was due to open, I visited Charles Cowles at his SoHo gallery. When he mentioned he was participating in the Los Angeles fair, I recounted how the organizing committee hadn't seen fit to let me in.

Cowles smiled and asked, "Do you really want to do it?"

I replied, "Yes, of course I do. It would be great to get that sort of exposure."

Without hesitating, Cowles picked up the phone and called the show organizer in London. With his deep baritone, he bellowed, "Hello, Felicity, it's Charlie. Listen, I'm sitting here with

Richard Polsky. He's a serious up-and-coming dealer, and a friend of Jim's [Corcoran] and mine, and you must let him in the fair."

Cowles listened and nodded. Then he got off the phone and smiled, "Okay, you're in. But I told them you'd promise not to complain about your booth's location."

I was stunned. One thirty-second phone call from Charles Cowles was all it took.

To do business with the right dealers, it was important to get to know them as individuals. Even if you weren't wealthy, these dealers would take you seriously if you showed the proper respect. It wasn't so much about kissing up to them as it was an awareness of who they were and what they had achieved in the art world. Before you requested an audience with Karp, you were fully briefed on his days as Castelli's gallery director, when he championed so many significant artists. You wouldn't dream of inviting Cowles to lunch without being prepared to acknowledge his pioneering ownership of *Artforum* magazine. As for Corcoran, before ever meeting him, you were aware he controlled part of the Joseph Cornell estate.

It was assumed before you opened a gallery that you had a working knowledge of the art dealers who came before you — your "ancestors." Every young dealer owed a measure of gratitude to Alfred Stieglitz, Charles Egan, Betty Parsons, Peggy Guggenheim, Sidney Janis, Martha Jackson, and Leo Castelli. They were the pathfinders, the ones who paved the way. Their operations were about an openness of spirit and a sense of adventure. Though many of these individuals came from money, they were on their own when it came to laying the foundation for the art world as we know it.

While the roles of collectors, artists, and dealers have changed over the years, it's the auction business that's undergone the big-

gest upheaval. Specifically, the line of division between the auctions and the galleries has become blurred. In the early 1980s, it was understood that galleries discovered artists and promoted them. Over time, if the consensus of the art world deemed them worthy, they became auctionable. There was no auctioning of works by young artists, when the paint on their canvases was barely dry.

Now, it's commonplace to see a work dated 2007 come up for sale in 2009. Galleries blame the auction houses for acting irresponsibly. Auction houses protest it isn't their fault: "We're not responsible for the markets of individual artists, we just reflect them." From their point of view, if a Jeff Koons four-foot stainless steel red heart suspended from a gold ribbon, which sold for $2 million during its initial offering from Gagosian in 2007, could one year later bring $15 million at auction, why wouldn't they sell it and pocket a seven-figure buyer's premium? Even if they knew that collectors already holding works from the same series were attempting to boost prices by bidding up the Koons heart, what were they to do? It may not have been ethical, but it was legal. The auction houses were going with the times. And the times dictated that it was hip to be greedy.

It wasn't so much that the auction houses used to act with discretion. It was more that everyone understood his or her role in the art market food chain and realized there had to be at least minimal cooperation for each facet to succeed. The bottom line was that the auction houses and the galleries needed each other. The galleries developed talent, and the auction houses validated it.

Back in the early 1980s, the auction scene was moribund. Sotheby's and Christie's were places where members of the trade went to buy inventory. There were few collectors who attended the sales. While the stories about scratching your ear and going home with a Renoir are a bunch of nonsense, the auctions were

relatively unfriendly to nonprofessionals. That all changed when the shopping mall developer Alfred Taubman bought Sotheby's in 1984. With a background in retail, he refashioned Sotheby's into a user-friendly experience. He encouraged the public to consign and bid by removing the mystery from the process. Attending an evening sale became fun, sexy, and, with Taubman's "up-front" policies, transparent.

Once collectors began to catch on, dealers immediately began treating auction houses like the enemy. They saw lucrative consignments migrate from their back rooms to the auction block. Veteran gallerists wrung their hands and saw it as the end of the "dealer advantage." All a collector had to do was consult past auction results and he instantly knew the relative value of the Sam Francis "Blue Balls" painting you offered him. Worse, he might bypass you altogether and just buy a similar one at auction.

But a funny thing happened on the way to anticipated disaster. During the late 1980s, helped by an improving world economy, prices for contemporary art began to rise — thanks mainly to the auctions. The auction houses brought credibility to the prices dealers charged in their galleries. They also brought liquidity. Despite their perceived status among dealers as "vermin fit only for extermination" (to use a Woody Allen expression), there would no longer be an art market without auctions. Regardless, there was plenty of money to be made as a dealer — as long as I didn't blow it on Chanel.

of stucco homes and ketchup bottles

It was now April 2006. A lot had happened over the last eleven months. Most significantly, my marriage finally collapsed. The divorce proceeding went relatively smoothly. That's not to say it didn't exact a price. When the smoke cleared, most of my money from the Fright Wig sale was wiped out. It was a deadly combination of splitting the proceeds and paying plenty of taxes. The irony was that in the end, I lost both my painting *and* my wife.

After a few weeks of shock, I realized it was time to move on. With the art market gathering momentum and poised to step to the next level, I was ready to reinvest what was left of my Warhol money. As I began to search for the right deal, a cold reality hit me — quality works of art had become too expensive. The art market had passed me by. The $100,000 that remained from the Fright Wig was nothing. Or as my colleague Edward Nahem said to me, only semi-sarcastically, "Earning $2 million a year as a dealer is the new middle class."

The truth of the matter was there was no longer a middle class in the art world. In that sense, the art market accurately mirrored

the rest of America. You either had money or you didn't. You either represented auctionable artists or you handled painters with no market outside of your gallery. Your application to Art Basel Miami was either accepted, or you settled for exhibiting at the "other" satellite fairs. You either got a reserved seat at the evening auctions or you stood with the riffraff behind the red rope.

As I took a hard look at the new art dealing landscape, I concluded I had to return to my roots when I brokered deals rather than "took a position." Even brokering had become thorny. You no longer needed buyers—there were plenty to go around. You needed sellers. People who owned a significant picture knew what they had and could take their pick of which dealer to work with. Art dealing had always been about relationships. But now, not only did you have to convince the property owners that you could get them a fair price, they had to believe you could get them more money than anyone else. You did so by offering them a menu of choices: a private sale, setting up a "guaranteed" deal at auction, or in the event of an entire collection perhaps a show at a gallery—with a catalog to serve as a lasting monument to their good taste.

Though the window of opportunity to broker undervalued work was rapidly closing, there were still tiny niches of the market that had yet to be fully exploited. One was Photorealism. Back in 1984, my gallery did an exhibition of watercolors by three of the movement's finest practitioners: Ralph Goings, Robert Bechtle, and Richard McClean. I got the show through Ivan Karp, who represented all three. The exhibition sold out. Oddly enough, it all went to one customer—the Southland Corporation, parent company of the 7-Eleven convenience store chain. The success of the show triggered a long-term friendship with Karp.

Though Karp was always linked to his advocacy of Pop Art, he went on to have a second epiphany during the 1970s. His gallery, O.K. Harris Works of Art, helped launch the Photorealist movement. These artists were known for their technically proficient works, heavily influenced by photography. The biggest name in the group was Chuck Close (airbrushed giant portraits that revealed every blemish and pore), followed closely by Richard Estes (New York urban landscapes) and Charles Bell (marbles, toys, pinball machines).

Among Karp's discoveries was the uncanny sculpture of Duane Hanson. Each life-size figure was cast in polyurethane, from an actual person, and ultimately dressed in clothing appropriate to that individual's trade. A typical Hanson sculpture was a bank guard, wearing his uniform, with a holstered pistol at his side, positioned leaning up against a wall. Coming upon this figure, whether in a gallery or a collector's home, was always a memorable experience. Hanson's sculptures were so realistic that you expected them to walk away. Sadly, Hanson died of cancer, thought to have been brought on by the highly carcinogenic resins used to cast his figures.

However, it may have been Robert Bechtle who was Karp's most compelling artist. Many art historians credit Bechtle with being the first Photorealist. Now in his seventies, Bechtle made his mark painting scenes from San Francisco's Potrero Hill district. His deadpan realism transformed a street's bland stucco homes, with their pedestrian cars parked in the driveway, into images of poetic resonance.

Karp had been Bechtle's dealer for almost thirty years. Then, in 2005, Bechtle abruptly left for the Barbara Gladstone Gallery. Unfortunately for Karp, Bechtle switched allegiances just before his first retrospective at the San Francisco Museum of Modern Art.

The logic behind his move was understandable, if a bit cold-hearted. While Karp did his part to nurture Bechtle's career, he had done little to promote him to a higher level of recognition. The problem was Karp's gallery had been pigeonholed as a realist gallery. Since an artist's reputation is based in large part on the context in which the work is displayed, Gladstone offered a stronger showcase. Her gallery's reputation was far more cutting edge than O.K. Harris. She represented Matthew Barney, known for his elaborate videos, and one of the most respected artists around. Naturally, Bechtle knew this. With his retrospective looming, he decided to make his move.

For Gladstone, this was akin to winning the lottery. The wall labels at the museum exhibition credited each available painting to her gallery, giving the implied endorsement of the institution. Not only that, but a handsome catalog accompanied the show, providing a valuable promotional vehicle. Gladstone immediately raised Bechtle's prices. The going rate for a new Bechtle canvas leaped from around $80,000 to approximately $125,000. The rising auction market also did its part. Paintings at auction exceeded $250,000.

It all came down to context.

With Bechtle in mind, I decided to visit Karp in New York and look for other candidates ripe for defection. While I walked down West Broadway, I felt a twinge of nostalgia. As an aspiring art dealer, I "made my bones" in SoHo. Back in the 1980s, the area was populated with galleries run by individuals with personalities as distinct as their artists. The ambiance of the area's cast iron architecture put you in just the right mood to look at art. So did a snack from Dean & Deluca.

SoHo was now colonized by designer-label clothing shops and expensive furniture stores. It was still a wonderful destination — just not for viewing art. Only a handful of galleries remained.

Generally, those few gallery owners who hadn't migrated to Chelsea owned their spaces and the lofts they lived in, such as Louis Meisel and Ivan Karp. Ironically, they were the two biggest Photorealist dealers. These elder statesmen had no plans of moving. They were content to enjoy their lives as they were. If collectors wanted to see them, they knew where to seek them out.

I entered O.K. Harris, which had a round bronze plaque affixed to the door with the gallery name and the designation: "Founded in 1493." Karp could usually be found front and center, often wearing a New York Mets baseball cap. Occasionally, he sported a necklace made of watermelon seeds. Karp was of medium build, bald, and more often than not had a smoldering cigar resting between his fingers.

Unlike most gallery owners, who hid in their offices to avoid artists and the unwashed masses, Karp was highly approachable. But he was becoming less visible. Karp had begun to slowly transition the gallery to his son Ethan's care. It must not have been easy. He was such a vital personality, and so deeply involved in his gallery's discourse, that he was finding it hard to surrender control. That point was driven home as I found myself in the midst of a minor father-and-son fracas.

Karp was standing there, gesturing with his hands, "Ethan, would you pull out a Dan Douke painting for me—you know, the one that's a revelation of a fresh sort."

Ivan Karp talked this way. His colorful command of the English language and his rapid delivery were a marvel. Ethan, who was in his forties, obeyed his father. Or at least he tried to. For some reason, the Douke canvas was stuck, wedged vertically between a piece of cardboard and a metal dividing dowel. Ethan struggled to extract the painting. The more he tugged on it, the deeper the canvas became mired in the rack.

Karp grew impatient. He strolled over to the troublesome painting and with a quick flick of the wrist managed to shake it loose. Turning to his eldest son, he quipped, "That's a mighty piece of cardboard, Ethan!"

Then Karp turned to me, "Polsky, what do you want?"

Despite having done numerous deals, as well as having socialized together, all I was to him was "Polsky."

I responded, "Why is it whenever I walk in to your gallery, you treat me like the UPS man?"

"What do you mean? I'm very fond of the UPS man!" laughed Karp. "Anyway, what brings you in today?"

"Not to bring up a sore subject, but do you have any Robert Bechtles for sale? I know he was disloyal . . ." I said cautiously, letting my words trail off to give Karp the opportunity to jump in.

Rather than sound bitter, he responded philosophically, "What are you going to do? It happens."

"You mean you're not upset that on the verge of his big moment—when you probably would have sold some paintings out of his museum show—he chose to leave?" I asked, feeling more indignant than Karp.

He just shrugged. Clearly, Karp had mellowed with age. This was a man who always had a witty insult for any individual who displeased him. I remember when he called an annoying radiologist/collector from Berkeley a "cockroach," referred to a pair of female art dealing partners from San Francisco as "evil," and exposed one of my hometown's biggest dealers as a "deadbeat."

After he told me there were no more Bechtles in the gallery's stock, I inquired about their most expensive artist, Ralph Goings. There was a lone canvas for sale. It measured three by four feet and depicted a still life of restaurant condiments: a Heinz ketchup bottle, a shiny metal napkin holder, a glass sugar dispenser, and

a pair of salt and pepper shakers. It was classic Goings—a diner interior with a nod toward a slice of vanishing America.

Karp pointed and spoke, "Does this meet your requirements, Polsky?"

"What's the lucky number?" I asked.

"Luck has nothing to do with the price," chortled Karp. "Though its availability *is* your good fortune."

Then he yelled, "Ethan! How much is the Goings?"

"It's $425,000!"

"That's all?" said Karp, with mock surprise.

I don't know why but I started laughing. Karp ignored my outburst and said, "This painting's an absolute masterpiece, full of verve and conviction, and the last one you're likely to see in this gallery."

My ears perked up. It sounded like Goings was about to follow Bechtle's lead and jump ship. This was the sort of insider information dealers live for. Unlike the stock market, insider trading was highly legal, and something you bragged about when you pulled it off. My thinking was if Karp was prepared to give me a sizable discount—twenty percent was not out of the question—I should try to tie up the Goings. I knew just who I could sell it to.

Then I wondered which gallery was Goings about to defect to? What if it was Gagosian? Maybe he decided Goings and Photorealism were undervalued. A single show at one of his international spaces and you'd be looking at $600,000 for the painting—maybe more. Or perhaps it was PaceWildenstein? I knew that a number of estates it handled were depleted—such as Mark Rothko's. Maybe Goings was part of their master plan to refresh their roster of talent. There was also the possibility that Paul Kasmin, son of the British dealer who discovered David Hockney, was adding to his conservative but impressive blue-chip stable, which now included Frank Stella.

As I was about to grill Karp to get a sense of where Goings might be headed, he beat me to the punch, "You know, it's really tragic . . ."

I interrupted, "Yeah, I can imagine how bad you must feel. First Bechtle, now Ralph Goings."

"What are you talking about, Polsky? He's not well — Goings is so ill he can barely hold a brush," said Karp, looking deeply concerned.

I was stunned. Just like that, my plan fell apart. The public's assumption that once an artist dies his work increases in value is false. More often than not, the market becomes flooded with paintings, which was what happened to Sam Francis. For a period, his work actually declined in value. In theory, I could still broker Karp's painting and pitch the potential buyer about how well it would do at auction. Recently, a Goings canvas brought a record $450,000. Still, it had been my experience that Photorealism (with the exception of early Chuck Close) never triggers inspired bidding. Without Goings switching galleries, my strategy of convincing a collector that it was a good investment had no chance of succeeding.

Once again, context is everything.

Later that day, I received a phone call from Andy Rose, the collector who made Jonathan Novak a lowball offer to buy my Fright Wig. I could envision him standing there. Chances are he would be wearing black slacks, complemented by a navy blue T-shirt, and a black blazer — only one layer short of a look. Andy's tall, slender physique allowed him to wear those Italian designer clothes that so many out-of-shape men in their fifties wish they could wear.

Andy was recently offered an orange Fright Wig from the New York gallery C&M Arts.



I responded, "Is it a good one?"

"It's okay. The screening of the image doesn't thrill me. I don't like it as much as yours—I mean the one that *was* yours," said Andy. "They want $400,000 for it."

I said, "Why don't you make them an offer?"

Andy chuckled, "I've already been down that road before with them and wound up being insulted."

"What happened?"

Recounting the moment with relish, Andy said, "Meryl and I were at C&M to view a Robert Ryman painting. You should have seen this picture—it had the most beautiful white impastoed surface and just glowed. We were serious about buying it. They wanted two million, so we offered them a million-six. I thought it was a reasonable offer—we might have even gone up a bit. So you know what the gallery woman says to me?"

"What?"

"She gets this constipated look on her face and says, 'This isn't Costco.'"

I laughed to myself. As rude as the saleswoman was, I could relate to where she was coming from.

"I still think you should go after their Fright Wig. There are so few out there."

"Well," said Andy, sheepishly, "someone already bought it."

I thought, *That'll teach him.*

Then, as if he was reading my mind, he said, "Anyway, I've learned my lesson. I want you to find us a great Fright Wig . . ."

I was skeptical. The fact he wouldn't pay my original price, coupled with his negotiating at C&M, inspired little confidence. But then he said the right thing, the words every dealer wants to hear—"Whatever it costs."

trouble at the Waldorf

When I woke up the next morning, it occurred to me that Ivan Karp once mentioned he owned a group of three colored-pencil drawings by Roy Lichtenstein. Investment-wise, the classic Pop artist was close to being a sure bet. His cartoon-derived images may have been the last great consensus in the art world — virtually everyone liked Lichtenstein.

I called Karp and convinced him to let me have a quick peak at the drawings. He suggested I stop by his loft, located directly across the street from his gallery. Back in the day, Karp sold his Warhol *Cherry Marilyn* painting for $18,000, and used the money as a down payment on the space. While a single floor of his building was now easily worth a couple of million dollars, *Cherry Marilyn* was valued at around $10 million. By May 2007 it would be worth $28 million (in 2009 it probably dropped to $15 million). Yet, Karp had no regrets about selling. As he put it, "It was inconceivable that a painting would ever be worth that much."

Viewing Karp's drawings represented a rare opportunity on a personal level. Though gregarious, he was a very private indi-

vidual outside his gallery. I didn't know anyone who had been to his home. I took the elevator up to the top floor. The doors opened into a magnificent space, filled with urban artifacts and contemporary art. The first object that caught my eye was a multi-panel cast iron railing, from the old Police Gazette Building in New York, installed in the loft's balcony. One scene featured two pugilists in action, covered in a gorgeous green and blue enamel, going at it as if they were Ali and Frazier. During the 1960s, the building was torn down and Karp found a way to salvage the railing, both preserving the wonderful object and giving it new life.

I shouldn't have been surprised. Before Karp became an art dealer, he and his friends were involved with saving old stone carvings from Manhattan buildings. When Karp and his crew came upon a structure being demolished, they plotted to rescue these anonymous sculptures. Sometimes, they would tip a security guard ten bucks to let them haul away the pieces. Or, they would sneak into the construction sites at night, asking their girlfriends to act as lookouts—they began referring to them as "rubble molls." Eventually, Karp and his friends donated most of the collection to the Brooklyn Museum. A few select carvings are displayed at the Anonymous Arts Museum, a small upstate New York institution founded by Karp.

Knowing I was someone who appreciated his adventurous taste, he gave me a brief tour of his collection. Other than a vintage roulette table, liberated from a Las Vegas casino, what impressed me most was his John Chamberlain sculpture, *Sugar Tit*. I asked Karp how he came to own it.

"It was a present. John gave it to me right after finishing it— for my fiftieth birthday in 1967," said a beaming Karp.

Chamberlain is the great sculptor who moved metal around like an Abstract Expressionist. What de Kooning did for action ·

painting, Chamberlain did for sculpture. He also solved a major problem that plagued the medium since day one. Namely, how do you bring color to the work, without compromising the integrity of the medium? In the past, sculptors painted wood, bronze, and steel, thereby obscuring the nature of the material. Chamberlain's ingenious solution was to weld sections of scrap automobile metal, salvaged from junkyards. After years of exposure to the elements, those surfaces took on a mellow range of hues. Patches of rust and missing paint left no doubt the artist was working with steel.

Sugar Tit rose about three feet off the floor. It was a bold configuration of twisted metal—a controlled storm of white, fuchsia, purple, and golden yellow. The more I looked at it, the more I was overwhelmed by its grandeur. Although I was on my way to ending my love affair with art, I still wanted to think of myself as "separated"—not quite divorced. *Sugar Tit* was certainly creating a powerful argument for staying married.

It made me recall *Ma Green*, a Chamberlain from 1964, which I once owned. Every time I glanced at its interlocking shapes of discarded metal, it taught me that beauty is everywhere—you just have to look for it. Aesthetic found objects and visually provocative street scenes surround us—be it the layered remnants of a peeling billboard or a simple composition of black asphalt studded with manhole covers and yellow stripes. Living with a Chamberlain encouraged me to view the world differently and enjoy life more.

I asked Karp, "So what made him give you such a generous gift?"

Karp, who sponsored Chamberlain's first show in 1959, when he was the director of the Martha Jackson Gallery, looked incredulous. "*What do you mean, Polsky?* He chose to reward my unerring perception, my generosity, my advocacy, and my charm."

"What about your humble nature?" I laughed.

Subscribing to the Gagosian theory that every work has a price, I began to think about how to pry *Sugar Tit* away. As much as Karp was someone easily seduced by beautiful objects, he was also a good businessman. It was time to get aggressive.

Scratching my three-days' growth of a goatee for effect, I said, "Would you ever consider parting with it?"

Then, with a gleam in my eyes, I added, "If someone made it worth your while?"

My inquiry caused Karp to squirm. He knew I was serious. While he had known me a long time, and understood I wasn't wealthy, he was under the impression I was connected to the right people. He intuitively sensed I could raise the money.

In that spirit, he responded, "Look, this was a gift. I could never sell it in Chamberlain's lifetime. Besides, there are family considerations."

I said, "What if it were handled discreetly? What if I promised that it would never appear at auction?"

"That would be understood," said Karp.

Seizing the moment, I said, "The record for a Chamberlain at auction is around $350,000. What if I could come up with $450,000?"

By the look on his face, I could tell Karp was impressed.

His final comment was, "I appreciate the seriousness of your proposal. It behooves us to revisit the subject at a later date."

I nodded while Karp led me to the three Lichtenstein drawings. They were beauties. The artist often did postcard-size sketches as studies for paintings. Over the years, the paintings became unaffordable and collectors gravitated to the drawings. As I continued to study Karp's small gems, I concluded they were worth $125,000 each. My guess was the group could be acquired for around $300,000.

I said, "So, are *they* for sale?"

"Someday—but not yet. Now that you're familiar with their greatness, you'll be ready when I summon you," smiled Karp.

"So, you'll call me . . ." I said.

"No, you'll be notified by carrier pigeon—they're coming back!" he laughed.

It had been a productive couple of days in New York. I had laid the groundwork for two potential deals with Ivan Karp and put a few others in play. With one day left, I decided to visit Edward Tyler Nahem. He was just in the midst of transitioning from operating as a semiprivate dealer to owning a public gallery. Nahem had a reputation of being a hard worker and a deal maker, yet I had connected with him on only a single transaction in over twenty years. But it was a trade of substance—we collaborated on selling an outstanding Mark Rothko painting on paper.

Besides being known for his collegial spirit among colleagues, Nahem also had a reputation for his irreverent ways. Among his favorite antics was developing acronyms for annoying individuals in the art business. His list of terminology included:

B.W.O.T.—*Big waste of time*—used to describe a client who's basically a cheapskate—common in the business.
S.C.A.D.—*Sexually confused art dealer*—self-explanatory— very common in the business.
O.F.U.—*Zero follow-up*—a dealer who puts a deal in play and then fails to follow through on the details—exceedingly common in the business.

That day, I walked into Nahem's office and noticed he was wearing his usual quasi-hip art dealer outfit: a button-down shirt,

faded designer jeans, dark loafers, and expensive eyewear. Though not a large man, Nahem's outsize personality gave him a greater physical stature. His close-cropped hair, clean-cut features, and easy smile projected an air of sincerity—a cultivated persona that totally disarmed you. That is until he opened his mouth.

As he waved hello, the phone rang. His secretary announced it was Jonathan Novak. Though friends, Nahem was predisposed toward giving Novak a hard time.

He opened the conversation by saying, "What business are we *not* going to do today?"

Then, repeating out loud what Novak was saying over the phone, so I could follow along, he said, "What do you mean you don't feel well?"

Apparently, Novak then described the nature of his ailment.

Nahem responded, in a voice resembling baby talk, "Do you have a tummy ache? Do you have to go pooh-pooh?"

Novak hung up, while Nahem grinned.

Jonathan Novak was a legitimate character in his own right. Like Nahem, he was a successful and knowledgeable dealer. But that's where any similarity ended. He had an all-too-common (in the art world) tendency to take himself seriously. Novak's modus operandi was to overreact to everything. Nahem knew this and had played it for all it was worth. So did many of Novak's clients, especially Don Rubin, a former stock analyst in New York. Though Rubin had assembled a major collection of works by Sam Francis, thanks largely to Novak, every deal was fraught with complication. Rubin was as quirky as Novak—he insisted on having Yankee bean soup everyday for lunch.

Rubin and Novak had been taunting each other for years. Matters finally came to a head one day at Novak's suite at the Waldorf Astoria. As usual, he had struggled valiantly to obtain

the best room at the most competitive rate—an equation that rarely works in the realm of high-end New York hotels. Once Novak checked in, there was an instant drama over his room being too close to the soft drink machine, necessitating a move to quieter quarters. That room also proved unacceptable because it faced the alley, which meant the potential intrusion of grinding noise from a late-night garbage truck. Finally, after his third move in as many hours, Novak settled into Room 25-Y.

Still feeling abused by the Waldorf staff, he was in a testy mood when I walked in to visit him. Moments later, we were joined by Don Rubin. Despite the hope that Rubin would buy another Francis, Novak's mood continued to deteriorate. Out of the blue, Rubin began singing—he had just composed a song about Novak called "Mr. Greedy," sung to the melody of "New York, New York."

As Novak's anger mounted, I cheered wildly, egging Rubin on. While I suppose I shouldn't have been such an instigator, how could I help it? Rubin's lyrics were the perfect antidote to the egotistical behavior indigenous to the profession. When he finished his command performance, he quickly invaded the mini-bar. Before Novak could stop him, Rubin had already popped the lid off the most expensive item in the refrigerator—macadamia nuts—at $11.95 a tin.

Novak lunged at Rubin, scattering nuts, while the two of us laughed hysterically. Then Novak yelled, "Don, you're going to pay for those nuts—I mean it! And get off my bed! I want the two of you out of my room now!"

Rubin refused to leave. Then Novak became violent. He grabbed Rubin's arm, in a vise-like grip, and began dragging him off the bed. As he did so, Rubin's rear end skated across the white duvet cover, like a dog rubbing his butt across a patch of grass after relieving himself.

Rubin's face began to turn dark red, provoking him to yell, "Let go of me or I swear I'll slug you!!"

I became a little concerned—this was on the verge of crossing the line. Fortunately, Novak opened the door with one hand and shoved Rubin out with the other before it came to fisticuffs.

Novak then turned to me and yelled, "You're next!"

I left willingly, not wishing to incur his wrath.

As I took the Waldorf elevator down to the lobby, I thought, *I used to say the art business was like high school with money. But I was wrong. It was more like grade school with money.*

The next day, I caught a cab to Kennedy Airport. When I arrived, I stood in line at United Airlines, waiting to board. That's when I ran into San Francisco's preeminent dealer, John Berggruen. Now approaching his mid-sixties, he was still on top of his game. If anything, Berggruen was probably doing the best shows of his career—including a scholarly exhibition of a Picasso sketchbook. However, that still didn't change the fact that he was fully aware of his considerable wealth and power (at least on the West Coast) and was always prepared to remind you of it.

Berggruen gave me a cursory nod, barely acknowledging me. Art-world etiquette demanded I go up to him and shake hands. It was kind of like in the military, where you had to salute a superior officer.

Following the proper protocol, I went over to him and said, "Hi, John. How was New York?"

"Fine—I did a lot of business. See you on the plane," he said, as he fidgeted with his cell phone.

Moments later, the flight began boarding. I stepped onto the plane and began edging my way through first class. Sure enough, there was Berggruen.

"So, Richard, I trust you'll be in coach—as usual?" he chortled.

His crack shouldn't have bothered me, but it did. I kept telling myself, *What's the difference? The back of the plane gets there at the same time as the front.*

About an hour into the flight, Berggruen ventured into the world of the "untouchables" to say a quick hello. I thought, *That's cool — he's making an honest gesture to be friendly. Maybe I misjudged him.*

Berggruen said, "Let's see what you're reading."

My luck — I was engrossed in a biography of Barry Bonds.

As I gingerly showed Berggruen the dust jacket, he queried, "*Barry Bonds?* Hmm, I hope that's not too rigorous for you."

"Look, John, I don't normally read junk. This was just a guilty pleasure to get me through the flight," I said, none too convincingly. "What are *you* reading?"

"Oh, I'm reading Salman Rushdie!" smiled Berggruen.

I just shook my head in disbelief.

Then he said, "Got to get back to my book," as he did a pirouette and returned to the comfort of first class.

Once the flight landed, I caught up with him as we deplaned. I said, "Hey John, think I could catch a ride into town with you?"

Berggruen furrowed his brow, "I guess so — but only if you're ready to go now. I'm not waiting around for you to pick up your luggage."

Looking perplexed, I asked, "You didn't check your luggage? Come on, you were in New York for a *full week*. You didn't bring any clothes with you?"

That's when Berggruen gave me the look — the look that said, "I'm John Berggruen and you're not."

With a smirk, he declared, "I don't have any luggage. My wardrobe is in New York — in my closet — *in the apartment I own.*"

Then he shook his head in disdain and walked away.

the end

approximately ten days later, I was back in New York for an extended stay that would culminate in the May 2006 auctions.

The spring and fall sales are unofficial conventions for the art world. Visitors from Europe, Asia, and the rest of America descend on the uptown auction houses and downtown galleries. Everyone comes with an agenda. Either you're on the prowl for the hottest emerging talent, sleuthing for a work by an established artist, or simply in town to socialize. Most fall into the latter category. They have no intention of ever buying anything—at auction or from a gallery. Instead, they treat "auction week" as a cheap form of entertainment. Unlike going to a ballgame or the movies, gallery exhibitions and auction house previews are free.

During that frantic week, I always marvel at how busy everyone appears to be—at least in their own minds. Whenever I walk into a space, I can't help but laugh to myself when the receptionist informs me her boss is "on the phone" or "with a client." On the surface, these explanations sound plausible. The truth of the matter is that ninety percent of gallery activity is monkey

motion. "With a client" usually means hanging out with some poseur collector, who consistently feigns interest in purchasing a painting. Yet he's treated with respect because he once bought something—nine years ago—and lightning could strike twice. "On the phone" often refers to the dealer ordering lunch.

Since no one in the art business has any traditional job skills, everyone has to create some hustle and bustle to validate their existence. Even a dilettante has to keep busy. The reality of the art trade is there isn't a whole lot to do. Most of the deals are done elsewhere: over dinner, during a visit to an artist's studio, or at a collector's home. On a typical day in Chelsea, most of the galleries are deserted. On Saturdays, the action picks up with lots of "lookers," but little of it is productive.

During auction week, even the top galleries only concern themselves with three or four major collectors, wining and dining them. That's because everyone is dependent on a few big buyers to keep them in the black. The art business runs counterintuitive to most businesses, where you are taught not to put all your eggs in one basket. For that reason, dealers jealously guard their key clients.

I remember attending a cocktail party at Peter and Eileen Michael's home in San Francisco. That night, the Michaels hosted a number of the Bay Area's biggest collectors. I had the good fortune to meet Charles Schwab. Surprisingly, we had something to say to each other. He was familiar with the *Art Market Guides* and enjoyed their investment analogies to his industry.

We began trading theories on the art market, when out of the corner of my eye, I saw John Berggruen rushing over. He spotted me talking to Schwab and wasn't going to take any chances. Within seconds he joined us, doing his best to elbow me out of the conversation. Although he'd never admit it,

Berggruen was being proprietary. His message was clear: stay away from my territory.

Regardless of how a dealer operates, auction week seems to bring out the worst in everyone. It's as if the participants suffer from attention-deficit disorder. People fiddle with their Black-Berries. Cell phone interruptions frustrate conversations. The statement being made is, yet again, "see how busy I am." Or, in an even ruder scenario, you find yourself chatting with a dealer who fails to make eye contact. Instead, his eyes are firmly fixed on the door, waiting to see who walks in, just in case it's someone more important than you.

So as not to sound too cynical, there *are* positive aspects to auction week. For openers, Manhattan galleries always mount their strongest shows during May and November. It's an opportunity to take the temperature of the art scene. By running around Chelsea, and speed-reading the shows, you quickly determine what's in vogue. The exhibiting artists also benefit. Foot traffic peaks during these periods, providing the artist with exposure to an international audience.

Rather than spend most of my time at the galleries, I prefer to spend it at the auction house previews. That's where you eventually run into everyone, making new connections, while maintaining current relationships. Five days before the sales, each house mounts an exhibition of their available material, segregating the evening-sale paintings from the less expensive day-sale pictures. The auction house personnel go to great lengths to hang the work in the most enticing way. During a great sale, the main auction galleries take on the subliminal quality of a museum.

The real highlight for many art world patrons is the Sunday morning brunch at Christie's (Sotheby's has a cocktail party). From eleven o'clock to one o'clock, jacketed waiters

serve champagne and tend to a spread of food, hoping to create a festive atmosphere for potential buyers. Watching my colleagues stack their plates with leaning towers of mini-bagels and lox, assorted pastries, and croissants is a sight to behold. The less important the player, the more food they take. The Yiddish word *chazzer* (pig) quickly comes to mind. I've even caught a member of "Lilco" (Long Island Ladies Co.), a posse of bored rich housewives masquerading as art consultants, sneaking food into her purse.

Personally, I only sip champagne. I'm there to do business. For that reason, I always make it a point to have breakfast before going to Christie's. There's nothing worse than trying to shake the hand of a client when yours is covered with cream cheese. Ditto for trying to have a serious discussion with a collector who's staring at your teeth, dotted with black poppy seeds from a bagel. Finally, unlike me, the real power dealers don't touch the champagne, demonstrating their taste is above the inexpensive label being served.

Simply put, the Christie's brunch offers a unique overview of the players who make up the art market. Whether it's a dealer exaggerating to a colleague about how much money he just made on a sale, a collector lying about how he was the underbidder on last year's record-breaking work by (fill in the name of a famous artist), or an auction house expert insisting whatever painting you point to is the best of its kind, it's all pretty amusing—to an outsider.

That day in New York, while perusing the art at Christie's preview, I came upon an Ed Ruscha drawing called *The End*. Inspired by old movies, Ruscha drew the words "The" and "End," and often included the vertical scratches and little tears, just as they appeared on the disintegrating celluloid. Beginning in

1993, he undertook a large series of these works, greatly vary-
ing the typography. Perhaps my favorite was his use of gothic
lettering.

Back in the late nineties, I brokered a "The End" drawing to
an ex-girlfriend, Karen Johnson, whom I had met years before
Rachael. At the time, I paid $11,000 and later sold it to her for
$16,000. After closing the deal, I told myself, *This makes up for
the $5,000 I blew through during the four months we dated.* Karen
was a piece of work who thought of herself as a Sharon Stone
look-alike. Life with Karen could be summed up by her sug-
gestion that I furnish her with a house account at Bryan's, a fancy
food emporium in San Francisco. Upon signing for her first bill
Karen exclaimed, "I feel just like Jackie O." Then she turned
to me and said, "This is good training for you." Little did I know
that she would be proven right.

When Karen and I first got together, I had recently acquired
my green Fright Wig. With her sophisticated eye, Karen fell in
love with the painting, strongly hinting that she'd rather have it
than an engagement ring. That notion was reinforced when she
found out that I had paid almost $50,000 for it. Fortunately, I
didn't succumb to *this* request. After we broke up—I suspect
her ex-fiancé had lured her back with a pair of two-carat "fancy
yellow" diamond earrings—I made one of my better decisions.
Knowing she was about to marry someone wealthy, I told her,
"Let's try and stay friends. I'd like to be your art dealer."

Karen agreed. Within a month, I had sold her a small paint-
ing by the New York abstractionist David Row. Then I offered
her *The End*. Negotiations grew tense over the Ruscha. As she
put it, "You better not be making more than ten percent off me."
To which I responded, "Off you? *Never.*" By that point, I fig-
ured I deserved whatever I could get. But deep down inside, I
knew I was selling her an important drawing.

The years flew by. Karen filed for divorce—allegedly because her husband spent too much time in front of the television and not enough in Sun Valley—and called me to see what her Ruscha was worth. It seemed her accountant was trying to figure out the value of her assets. At that point I said, "I'd be happy to give you a formal written appraisal. All I ask is if you decide to sell the drawing, please let me handle the deal. And whatever you do, don't shop it around. I can get more for it if it's fresh to the market."

Karen said, "Of course. You're the only one I trust in the art business."

Six months later, once her divorce was final, I heard back from her. This time, she was ready to sell. The conversation went something like this:

KAREN: So what's my Ruscha worth now?
RICHARD: Well, Ruscha's market is quite strong at the moment. While I haven't seen a "The End" drawing come up to auction, my guess is that it's worth about $150,000. Which means if I broker it, you'd probably wind up with $120,000.
KAREN: Why can't I have $150,000?
RICHARD: That's not how it works. If your drawing sells for $150,000 at auction, including the buyer's premium, that means it hammered for approximately $130,000. If you deduct the seller's premium, you're left with a little over $115,000. For me to be able to move your drawing, I would have to sell it for around $130,000, so that I can give someone a good deal and they'd want to buy it. Also, I have to make something. In this case, I would want $10,000 for myself. So the bottom line is I could net you $120,000, which is a little above what you'd probably get at auction.

KAREN: Then why should I give it to you if I'd get almost the same thing at auction? What if it brought *more* than $150,000?

RICHARD: Because if you deal with me it's risk free and you don't have to wait another six months until the next auction season. You know, a lot can happen in six months. This boom market isn't going to last forever. Things have changed dramatically since you bought the drawing in the nineties. This is a great time to sell.

KAREN: Can't you get me $130,000?

RICHARD: Sorry.

KAREN: Then I'll have to think about it.

RICHARD: Take your time. But remember what I said about not shopping it around. Because if you do, it's going to be worth less to me when I tell a potential buyer they're not getting first crack at it.

KAREN: Fine.

In the meantime, I lined up a potential buyer for Karen's drawing. He agreed to pay $130,000, pending seeing it in person. Then I got back in touch with Karen: "One of my clients is interested in buying your Ruscha and he's willing to pay the 'one thirty' I requested."

KAREN: Oh, that's interesting. I just called one of my friends at Sotheby's and she told me the drawing is worth more than you said. She thinks I can get *at least* $130,000 for it, *net to me*.

RICHARD: Don't you realize the auction houses will tell you whatever you want to hear to secure your property? Then, once you sign a contract, they'll call and talk you down from the reserve you agreed to. I guarantee it.

KAREN: Whatever. I want $130,000 for it. Why can't you get me that?

RICHARD: Forget it. You should take the sure thing, which is "one twenty."

KAREN (*with some hesitation*): Okay, if your guy will pay promptly. The drawing is at my old house in Sausalito. I'll make arrangements for you and your client to inspect it.

Once I had coordinated my client's busy schedule with mine, and Karen's housekeeper's, Karen flaked on the deal. When I tried to salvage the transaction and asked if we could just look at the Ruscha so my client could move on it when she was ready, Karen quickly turned me down. The whole thing struck me as odd. After doing a little reconnaissance, I learned the auction house raised their offer, promising her the moon and the stars for her drawing. Alas, I had only promised her the moon.

That was the last I ever heard from Karen Johnson. While I don't know what ultimately became of her Ruscha, I never saw it appear at auction. That day at Christie's, as I stared at a similar version of *The End*, I wondered whether Karen still owned hers. And I also wondered what my house account at Bryan's would have totaled by now, had we managed to stay together.

That night, while looking through my e-mails, I noticed one from Peter Stremmel. He and his wife, Turkey, owned Stremmel Gallery in Reno. His e-mail was not the usual gallery announcement, trumpeting their latest exhibition. Instead, it was a press release from the Coeur d'Alene Art Auction. Stremmel was a partner in the auction house, which specialized in Western art. The press release spoke of a recent record-setting auction, where the sale "galloped to a new plateau of earnings," grossing just under $30 million. That number, while small compared to a contemporary art evening sale, was impressive nonetheless.

It gave me pause. I enjoyed classic Russells and Remingtons, but always thought of Western paintings as art for people who don't like art. Given the work was strongly American and nostalgic, it seemed to have little in common with contemporary art. But the more I thought about it, the best works tried to convey the same qualities: mood, narrative, and passion. Though I never envisioned myself a buyer, I made a mental note to call Peter and learn more about the field. You never knew where opportunity would strike next.

i'm not waiting in line

my cell phone began to ring. The caller ID revealed a Boston area code. It was Andy Rose. "Any progress on the Fright Wig?"

The answer was no.

What he didn't understand was the difficult nature of the assignment. An educated guess was Warhol created only twenty-five of the twelve-inch by twelve-inch self-portraits — at the most. Two were in the Andy Warhol Museum and the rest were with private collectors. Most of the buyers had paid between $50,000 and $75,000 — I knew because I had sold seven of them. I had already begun making gentle inquiries to those individuals. So far, all had declined to sell. But then I had an idea.

I said, "I'm going to send an e-mail to John Lindell — the guy who bought my painting at auction. How much should I offer him?"

Andy paused and said, "Tell him I'll pay $475,000."

I was studying a Christie's auction catalog for that week's sales, when I came upon a Warhol item of specific interest. Lot num-

ber 61 was a group of sixteen individual "Flowers" paintings, in a variety of colors, each measuring a mere eight inches by eight inches. The presale estimate was $1.8 to $2.2 million for the entire group. I had one of those "eureka" moments. I realized I might be able to convince the collector David Flaschen that now was the ideal time to sell his two-foot Flowers.

In 1993, when the art market bottomed out, David and I were having lunch in SoHo. I had to beg him to stop by the O.K. Harris gallery to look at what I claimed was the finest two-foot Flowers painting in existence. Over introductions at the gallery, Ivan Karp graciously offered David a choice cigar from his considerable stash. David trimmed the Gloria Cubana, lit the cigar, and began contemplating the painting. At first glance, he was unimpressed. But the image grew on him. Within twenty-four hours he found himself writing a check for $75,000. It was a remarkable event, given he had never spent more than $2,500 on a work of art.

Back in 1964, perhaps to counteract the intensity of the "Disasters" series, Warhol created a large series of canvases, each depicting four poppies. When David's painting was originally sold, it went for around $250. In 1989, the same painting would have been worth $225,000. But in the early 1990s, the market for Warhol Flowers had reached its low. Karp claimed he was making only a $5,000 profit on the $75,000 sale. Through a series of missteps—I was unprepared for David to buy it—I wound up making a paltry $1,000.

Over the years, David and I stayed in touch, playing Monday morning quarterback over new developments in the art market. Last fall, I called to let him know how much his painting had risen in value. He seemed somewhat surprised to learn it was worth around $850,000. We talked about how the art market had embarked on what felt like a reckless path, and

that he should think about cashing out. David agreed with my analysis, but expressed no interest in selling. I also mentioned my concern that as the price rose for two-foot Flowers—there were seventy-three color variations in existence—more of them would find their way onto the market and prices would stagnate.

Eventually, David responded to one of my inquiries. He laughed, "I love my painting. The only problem is I'm not sure the rest of the family does."

When David bought it from me, his wife Deborah didn't discourage him. But she didn't exactly encourage him either. His concession was to let her choose the frame. Even though I cautioned against putting any sort of frame on it, Deborah won out, selecting a baroque border more suitable for an Old Masters painting.

While we were talking, David playfully yelled out to his teenage daughter, "Hey, Katherine. If something happened to me and you inherited the Warhol painting, what would you do with it? Would you want to keep it or sell it?"

I heard her reply, "Sell it!"

The die was cast.

Now, six months later, I gave David Flaschen another call. I found him at home. "Hi David, have you seen the catalogs yet?"

"I sure have—some pretty unbelievable estimates, huh? What do you make of all those Flowers coming up?"

"I'm glad you asked. I actually heard about the collector who assembled them during the 1980s—I think he was Swedish. Anyway, I'd like to run something by you about your painting: Right now, the going rate for an eight-inch Flowers is $100,000 to $125,000. If the group that's coming up sells for an average of $150,000 a piece, you should seriously consider selling your Warhol at auction."

David paused and said, "When would you suggest putting it up?"

"I would slip it into next month's sale in London—there might be just enough time."

"Why London?"

"I can think of a number of reasons. Things have been doing extremely well there. You have a lot of new buyers—Russians, Chinese—who tend to overpay and prefer to buy in London. Many Europeans are more comfortable buying there than in New York. Then there's the strength of the euro. But the main thing is the current market is Warhol-crazy," I said, allowing my words time to sink in.

Then I continued, "We could wait until the fall, but I wouldn't want to risk it. A lot can happen between now and then. It's like you once told me, 'A plane can fly into a building' and suddenly the whole world's changed. But the bottom line is you'd be selling into an overinflated market."

"I certainly agree with that. I keep hearing stories about these Russian oligarchs overbidding on Warhols at the last London sale," he said.

"The thing is, if you get two crazies in the audience who want your painting, anything can happen. Especially if you have something by a major artist that's the best of its type—like your Warhol."

This was no exaggeration on my part. According to Ivan Karp, the painting was the first one sold from Warhol's debut at Leo Castelli, in 1964. On the day the show opened, an associate of the gallery walked in and was quite taken with the work. He asked Ivan to pick the Flowers painting he thought was the best, and David's painting was the one he selected. The canvas itself featured an orange poppy, two that were fuchsia, and another painted red—all centered on a bright green background.

With its multiple day-glow colors, David's picture was not only a great Flowers painting, it was a superb *Pop painting*— capturing all the sunny optimism of its day. When he hung the canvas at home, it screamed "Warhol" across the room.

David and I concluded our conversation, without getting into any of the specifics of constructing a deal: which auction house to work with, its percentage, my commission, and so on. We agreed to speak again once we had a better sense of how the sixteen Flowers would do.

The galleries pulled out their big guns during auction week. Since John Currin was the May show at Gagosian—New York's most prestigious gallery—he was the most fortunate of artists. Currin was a realist figurative painter, whose work made specific references to the Old Masters, yet retained a contemporary identity—a neat trick, if you could pull it off.

Only two years ago, he was showing with Andrea Rosen, and his paintings were selling for around $150,000. But ensuing auction results soon doubled that number. The esteemed collector Si Newhouse took notice and acquired a major Currin depicting two nude male fishermen casting a net, while their bare asses spilled over the edge of the boat. He bought it on the secondary market for a reported $1.4 million. John Currin was now a hot commodity. Soon, he was part of Gagosian's stable.

I had recently viewed Currin's work at his retrospective at the Museum of Contemporary Art in Chicago. A number of his paintings featured craggy old men or sylph-like golden haired beauties, inspired by his wife, the painter Rachel Feinstein. Currin's figures were often involved in some form of domestic activity, such as preparing a Thanksgiving feast or making pasta. Regardless, their body language and facial features were exaggerated, with elongated necks and noses resembling ski jumps.

Though the work was beautifully painted, each scene was disturbing—as if the artist was making fun of his subjects and domesticity. After spending time with the show, I thought Currin was talented but didn't understand what all the fuss was.

A show of his current work was due to open in a few days at Gagosian and I decided not to miss the reception. Generally, openings are poorly attended, unless the artist is a local hero or an art star. Currin was both. From a dealer's perspective, gallery openings have nothing to do with business. If the artist is an important figure, the paintings have already been pre-sold. The party becomes a formality, a chance for the artist to enjoy the adulation of followers and friends.

The night of the show, I arrived at the Gagosian gallery, on Madison Avenue, at around seven. There was a long line snaking through the lobby, as people waited impatiently for the elevator. After about ten minutes, I was midway in the queue, when I noticed someone famous standing behind me. It was Steve Martin. I watched him get on his cell phone and yell, "Hey, I'm not waiting in line—would someone come down and get me?!" Within thirty seconds, a gallery employee ran down five flights of stairs, located Martin, and quickly whisked him to a private elevator. The rest of the crowd smiled knowingly—it was good to be a celebrity.

Eventually, my turn came and I stepped onto the crammed lift, whose doors opened into a heavily lit room packed with around two hundred people. I saw Larry Gagosian in one corner and recalled how Anthony Haden-Guest, in *True Colors*, referred to his silver close-cropped hair as resembling a "seal pelt." Gagosian was huddled with Steve Martin and Rita Wilson, Tom Hanks's wife. John Currin and Rachel Feinstein occupied the opposing corner. She was quite attractive in person—Currin's paintings didn't do her justice. I noticed he

was holding his young son, but looked bored as he fielded the obligatory comments about the greatness of his show and the cuteness of his child. You sensed Currin couldn't wait to get out of there and move on to his celebratory dinner.

As for the work, the gallery was ringed by eighteen small to medium-size paintings. To the artist's credit, he had taken some risks with the work—big risks. The majority of the paintings depicted nude figures whose actions bordered on the pornographic. Blatant acts of oral and vaginal sex were the primary theme—Currin held nothing back.

What was amazing was that all the paintings were allegedly sold, at prices ranging from $400,000 to $600,000. I found the whole thing hard to believe. Knowing many collectors had families, there was simply no way they would buy one of these pictures and hang it at home. I could just see it now, "Mommy, why is that man trying to stick his thing in that woman?" Despite the desire of many collectors to get in on the Currin craze, I seriously doubted someone would spend half-a-million dollars on a painting, only to place it in storage.

On the other hand, much in the same vein as how the publishing industry cannot predict what books will become bestsellers, the same can be said about paintings. Who's to say Currin's latest efforts, which appear so difficult, won't be considered easy to live with down the road. After all, who would have believed that *Seabiscuit*, a book about a champion thoroughbred who raced during the 1930s, would become a huge hit?

I went home that night wondering what it must be like to be John Currin.

The next afternoon, I went to Christie's to preview the sale. I ran into a department expert who indicated that the sixteen Flowers would sell for well over $150,000 a painting. If you had

a good relationship with a department specialist, he'd give you the inside scoop about a particular lot—or at least ninety percent of it. Once I heard the positive news, I called David to try to firm up a deal.

When I reached him, I came straight to the point, "Look, the word around Christie's is that the individual Flowers will exceed $150,000 each and might go to $200,000 a piece. My thinking is if the paintings average 200, there's a good chance your painting would bring at least $1 million."

David said, "What do you think you could get for it privately?"

"I've already spoken with John Lindell—the guy who bought my Fright Wig—he's offered $850,000 for it. But I sensed he would go to a million when he saw how good the painting was in person," I said.

"So if it was your painting, what would you do?"

Without hesitation, I said, "Personally, I would take my chances at auction. In a boom market, if you're holding an ace, chances are you're going to see a big price. The other consideration is in today's global art market, when it comes to promoting a painting, you can't beat the reach of the auction houses."

David finally said. "All right, if these small paintings bring at least 150 each, let's go ahead with it. Do you still think there's time to get it into the London sale?"

"It's going to be tricky because the catalogs have to go to press next Friday. But I've been assured if we commit this week, we'll get it in."

"Sounds good—keep me posted," said David, signing off.

He hung up before I could explain how I was counting on another auction dynamic to improve our chances. I called it the "Mugrabi Factor." The current boom market was largely based on auction manipulation. Investors, like the well-known Mugrabi family, were bidding up Warhol to sustain (and raise) the value

of their vast holdings of his work. They weren't the only ones doing this, but they were the most conspicuous.

Jose Mugrabi, the family's elder statesman, originally made his money in textiles—Columbian factories that manufactured textiles, to be specific. Rumor had it his family owned eight hundred Warhol paintings and drawings. They began acquiring them around 1987. Once they had bought up as much mature Warhol as they could, they turned their sights on his pre-1962 work. These were the shoes drawings and magazine article illustrations—the commercial work. Though the sketches have little to do with fine art, they began finding their way onto the market. The auction houses, with their insatiable need for "product," trickled the drawings into the day sales. The Mugrabis began buying them—amassing a large trove, while boosting prices.

As Jose's son, Alberto, put it, "Nobody liked Warhol at $300,000. But they love him at $3 million." When he's gotten into a bidding war over a Warhol painting, he's been quoted as saying, "I'm only helping my collection. If I don't get it, I'm keeping the market healthy. Everyone likes a healthy market."

Simultaneously, the family began stockpiling Jean-Michel Basquiat and Tom Wesselmann. If you had the bankroll and were a pure investor, you would have been smart to follow their lead. It was only a matter of time until the Mugrabis were satisfied with their position and turned their attention to boosting the value of these two artists. Barring a collapse of the market, the rise of their prices felt inevitable.

The predecessor who established this business model was the British advertising agency owner Charles Saatchi. Saatchi targeted the most significant contemporary artists and quietly cornered the market in their upper-tier works. During the 1980s, Saatchi bought heavyweights such as Warhol, Cy Twombly, and

Brice Marden, convinced their finest paintings were relatively inexpensive. More important, they were available. It was an era when you could go directly to Warhol's studio, see what was lying around, and buy a major canvas such as 100 *Marilyns*. Saatchi did just that, picking it up on the cheap.

The other half of Saatchi's brilliance was his decision to promote his own collection. As the man whose publicity campaign helped sweep Margaret Thatcher into office, he mastered the art of media manipulation. Saatchi commissioned a set of four books on his collection, with profuse illustrations, and essays by the most respected critics. The art world was shocked by both the immense quantity and quality of what he was able to amass. With this marketing ploy in place, he shrewdly began selling off his collection, reaping huge profits. 100 *Marilyns* was a good example. He made millions, selling it at auction for $3.7 million in 1992. It now resides at the Cleveland Museum of Art.

Saatchi eventually played the same game with the YBAs (Young British Artists), acquiring large bodies of work by Damien Hirst, Jenny Saville, who painted massive fleshy nudes, and Rachel Whiteread, who made clear resin casts from the interior spaces of objects, such as the interior of an entire house. This time Saatchi went one better. Besides publishing catalogs, he opened his own museum in London, the Saatchi Gallery. Once his artists were critically established, he repeated the process of selling off paintings and reaping embarrassing profits — especially with Hirst.

The Saatchi model has since evolved into wealthy investors acquiring artists like they were buying companies. Hedge-fund managers, real estate moguls, and newsprint tycoons scoop up painters they've determined are undervalued, pop them into auction, and then bid them up. It's a no-lose proposition. You support the value of your collection, while raising the bar, even

if you get "stuck" buying something. Richard Prince was a good example. Prince emerged during the mid-1980s and became known for a series of "Joke" paintings. He would stencil a corny joke onto a monochromatic canvas, such as:

DOCTOR: I have good news and bad news.
PATIENT: Give me the bad news first.
DOCTOR: You only have one year left to live.
PATIENT: What's the good news?
DOCTOR: I'm having an affair with my secretary.

These paintings sold well. But few in the art world saw them as significant. Prince was just another good artist, who ranked below his peers, such as David Salle, Julian Schnabel, and perhaps Ross Bleckner. By 2005, he was exceeding all their prices at auction—by far. In 2005, you could buy a painting from his "Nurse" series from his dealer Barbara Gladstone for $85,000— if you were connected enough to be offered one. By 2006, a Nurse brought $1 million at auction. By May 2007, Nurses were up to $2.5 million, eventually peaking at approximately $8.5 million a year later.

Putting Prince in play at auction was consistent with what the Mugrabis were doing with Warhol. But the Mugrabis took their Warhol lust a step further. Not only were they buying Warhols at auction, they were off-loading lesser works (by various artists) from their collection directly to the auction houses to help pay for the Warhols they bought.

The Mugrabis also sold privately when they could realize a big price. Rumor had it they were fielding offers for all or part of their fabulous Warhol collection. The Arab emirate of Dubai, which was in the process of building a contemporary art museum, was mentioned as a possible buyer. Until a deal was struck, it

behooved them to continue to support Warhol's market. I was partially counting on this knowledge, confident the sixteen Flowers would do what they needed to do. Their sale would ignite a chain reaction extending all the way to David's painting. I was only a day away from finding out whether the art market equivalent of nuclear fission would take place.

flower power

at long last, it was auction night at Christie's. The high point of the evening was supposed to be the sale of Warhol's *Small Torn Campbell's Soup Can (Pepper Pot)*. This twenty-inch by sixteen-inch piece of "real estate" belonged to Irving Blum, the dealer who gave Warhol his first show, and also once owned the famous set of thirty-two "Soup Can" paintings. He could be seen walking around Christie's, accepting good wishes from a crowd who collectively wondered, *Would I have been able to spot Warhol's genius so early on?*

Christie's had persuaded Blum to sell the individual Soup Can with a guarantee—generally acknowledged to be $10 million. The painting itself was estimated to sell that night for $10 million to $15 million. Christie's had pulled out all the stops promoting it, placing it on the cover of the evening-sale catalog, and running ads in every art magazine. The accompanying catalog essay included a photo of a youthful Blum having coffee with Warhol, Ed Ruscha, and Nico, the mysterious Velvet Underground chanteuse. The lucky buyer would be linked to history.

The great irony was Blum had recently appeared in a three-hour documentary, *Andy Warhol*, from the American Masters series. While being interviewed, Blum rehashed the story of how he exhibited the thirty-two paintings at his Los Angeles gallery in 1962, pricing them at one hundred dollars each. The show was considered so radical that a neighboring gallery displayed a pyramid of actual Campbell's soup cans in its window, with a sign that read, "We have the real thing for 29 cents."

According to Blum, he wound up finding only six takers for the paintings. He then had an epiphany, convinced the brave buyers to cancel their purchases, and bought the entire show for himself. Even though Warhol was due $1,600, Blum negotiated a group price of $1,000, with the added bonus of being able to pay it off over ten months. According to Blum, Warhol was thrilled with the outcome.

Joseph Helman, who partnered a gallery with Blum during the 1980s, disputed this story. According to Helman, Warhol consented to the exhibition only because Blum agreed in advance to *buy the whole show*. During the exhibition, although a few paintings were put on hold, there were no firm sales. When Blum reported the final results to Warhol, the artist calmly told him that he looked forward to receiving his check, but would round off the amount he was owed to $1,500. Blum informed him that he didn't have the money. Warhol got upset, but agreed to cut his losses and accept $1,000 — which Blum took *two years* to pay off.

Regardless, Blum's version has become part of art world folklore and the recent documentary allowed him to update the saga. In 1995, he sold them all to the Museum of Modern Art for $15 million, less than $500,000 per painting. In 2002, an individual Soup Can that was not part of the group of thirty-two came up for auction and brought around $2 million. During the

2006 documentary, Blum claimed the set of thirty-two Soup Cans would now be worth $100 million.

I arrived at Christie's, waiting to see if he was right about his current estimate. Typically, the evening sales start at seven o'clock. The usual procedure is to show up half an hour before the auction to do a little schmoozing. You have to work the room quickly, and there is little time to waste on those unworthy of your attention. As an art dealer, you hope to run into major collectors, reconfirming that you are each part of the bigger art scene.

Stepping back and observing the pre-sale crowd, the room resembled a herd of ostriches. People were straining their necks, looking for the most worthwhile person to talk to. I must confess that I was no different. That's why, to my dismay, I found myself cornered by Carole Lieff—or Carole "Grief" as I often referred to her.

Carole was a private dealer based in Santa Barbara. I had originally met her about a decade ago at a fitness club in San Francisco. One day, I looked over at the Nautilus machine next to me and noticed a reasonably attractive blond, with a good figure, reading *Art & Auction*. I recall saying, "Oh, I see you're looking at an art magazine."

Carole's face brightened, "You're a collector?"

"That's funny—I was hoping you were!"

I thought, *Can you believe this? Two dealers on the make.*

The next thing I knew, we began talking, swapping stories about the business. As the conversation wore on, I began to realize Carole was a little overdramatic. She couldn't stop name-dropping and bragging about all the business she was doing. Normally, the minute I hear another dealer tell me how successful he is, I automatically assume he's not. But Carole was so insistent that I decided to give her the benefit of the doubt.

Over time, we became friends, while running into each other at various art-world functions. We began socializing a bit, not quite dating but hanging out. Then, one evening, I got a call from her at around ten o'clock. She sounded breathless. "I just got a new car. How about if I pick you up and we grab a drink so I can show it to you?"

With nothing better to do, I said, "Sure. What did you buy?"

"You'll see."

Ten minutes later, Carole rolled up in gleaming new silver Porsche. I was impressed and said, "That's quite a car."

Carole said, "Yeah, the lease payments are pretty steep, but I got it to make a statement."

"What's the statement?"

She smiled, "If you can't afford the $1,100 monthly payment, then you shouldn't bother asking me out."

Even back then, before I married a second time, I spent too much time with women obsessed with status. It was as if my pursuit of calculating women mirrored a masochistic desire to be abused by them along with the art dealers who lauded their wealth over me. Why was I attracted to the snarkiness of these dealers and the fancy women who populated the art scene?

Not long after, Carole invited me to be her dinner escort. She had fixed up one of her clients with a girlfriend and invited me along to round out the table. It was an interesting evening. The main topic of conversation was intelligence quotients. Carole claimed her IQ was an extraordinary 160.

She asked me, "What's yours?"

I replied, "I don't know—I've never been tested. What do you think it is?"

"Hmm, you're pretty smart. Maybe 120."

After supper, I drove her home. As I was saying goodnight, she said, "That was fun. I like you, Richard. In fact, I'm going to put you on the point system."

Intrigued, I asked, "What, pray tell, is that?"

"If you get to one hundred points you get to sleep with me."

I was startled by her comment. When I recovered, I said, "All right, I'll bite. How do I get to one hundred points?"

Carole said, "I'm going to tell you: If you take me to a fancy restaurant, like Acqua, you get ten points. If you buy me some really nice flowers, like a potted orchid, that's another ten points."

I thought, *Only ten points for an orchid?*

But Carole was just getting warmed up, "If you introduce me to one of your clients and it leads to a deal, you get twenty points."

My head was spinning, as Carole said, "You can also lose points."

"How?"

"I'm going to tell you: If you insult me in any way, that's minus ten. If you contradict me, that's another ten off your score. If you take me out and don't immediately acknowledge how great I look that night, that's five off."

This ridiculous dialogue went on for another few minutes. Soon, I was fully briefed. Deciding to take a shot at Carole's offer, I asked her out, brought her flowers (though not an orchid), and took her to a high-end restaurant. In no time at all, I was up thirty points. But as the evening wore on, I grew tired of the chase. Just like the Dow on a bad day, my "industrial average" began to plummet. By the end of the evening, I was down twenty. Sadly, my "Carole account" remained under water and never recovered.

That night at Christie's, I thought about that story, as Carole blocked my path. Determined not to squander my "face time"

with potential buyers, I decided to quickly say hello, pay her a compliment, and then get the hell out of there. I said, "Hi, Carole, you look beautiful tonight."

"More beautiful than usual?" she asked.

"Absolutely."

"You know, Richard, I'm having a great year. I've already made $1 million."

"I'm surprised it's not $2 million," I said sarcastically, realizing she hadn't even achieved middle-class status, according to the "Ed Nahem formula."

"No, it's only one, but the year's not over."

I said, "Look, Carole, it's great to see you but I really have to be going. I need to talk to some people."

But Carole wouldn't let me go. She grew testy and said, "Why have you been making fun of my newsletter? Everyone loves it! All the major dealers send me e-mails that are highly complimentary. You're the only one who doesn't get it—it's probably over your head!"

Carole had recently begun sending out an art-world newsletter called *The Art Adviser*. The only problem was that the publication lacked news and its advice was suspect. Instead, the paper's contents were predominantly about Carole. Either she was boasting about a fancy party she attended or critiquing an expensive hotel she stayed at. She was also quick to pat herself on the back for her brilliant deal making. A typical comment: "You'll notice that a John Baldessari just brought a record $800,000 at auction—good thing I bought three before the sale."

I said, "Carole, look, I like you and would like to see you succeed. But no one wants to hear about all the money you make. No one's impressed by your 20/20 art market hindsight. As for all the kudos you claim to be getting for your newsletter,

these are just marginal players afraid to rile you up—it's easier for them to play along and tell you how great it is."

Now I had done it. Carole responded, "*Marginal players?*" She then proceeded to rattle off a list of well-known art-world figures who had praised her newsletter, and said, "Just for that, I'm going to tell everyone how you called them marginal players!"

Knowing I had better quit while I was behind, I finally managed to squeeze my way past her just as Christopher Burge, the auctioneer, requested everyone find their seats. The dealer Louis Meisel slid by me. Besides dominating the Photorealist market, he also represents the Pop artist Mel Ramos. Recently, one of his 1960s paintings of a cheesecake nude looking through a peephole finally crashed through the million-dollar barrier at an auction in London.

Despite his cocky ways, I always enjoyed Meisel. I said to him, "Lou, congrats on the Ramos bringing a million."

With a practiced grin, Meisel looked me in the eye and said, "Yeah, and I own fifty of them!"

With that I took my seat, listened to Burge read the preliminary announcements, and then we were off to the races. The night's offerings included a total of five Warhol paintings, with the Soup Can strategically placed to sell first. When it came up, the painting drew a number of oohs and aahs from the audience. Burge opened the bidding at $5 million and watched it climb in $500,000 increments, until he brought the gavel down at $10 million. With the buyer's premium, it sold for $11.7 million. That meant the Museum of Modern Art's set of thirty-two Soup Cans was theoretically worth around $375 million!

Irving Blum's $100 million valuation had proven to be too conservative.

The second Warhol to appear was the small but significant *S&H Greenstamps*, which demolished its $1 million to $1.5 mil-

lion estimate to sell for $5.1 million. Next up to bat was a forty-inch-square portrait of Brigitte Bardot. The pre-auction buzz was that its $1 million to $1.5 million estimate was too high. So naturally it sold for $3 million. Dealers rationalized it as European bidders viewing Bardot as "their" Marilyn Monroe.

The sale skipped along with works by Wayne Thiebaud, Willem de Kooning, and Damien Hirst selling in the multiple millions. Only a few years ago, seven-figure paintings were a big deal. Now, they were becoming so prevalent that they were beginning to spill over into the day sales. The depressing thing was with each season of auctions, if you weren't holding any inventory, you felt poorer and poorer.

Finally, it was time for the sixteen Flowers. I squirmed in my seat, thinking how so much of an art dealer's income is linked to fate, not ability. I could just as easily make my deal with David Flaschen as not. Perhaps this is my greatest frustration with the art business—my inability to control my own destiny. In most professions, such as law, if you are talented you make a lot of money. Your income is less tied to chance—certainly not to the degree mine was that night. I was dependent on wealthy individuals bidding up the value of some paintings, so another wealthy individual would let me sell his painting. Sure, there was some skill involved in positioning myself to know someone like David Flaschen. But at the end of the day, a successful dealer is someone who knows rich people or is rich to begin with—not necessarily someone with great taste, a command of art history, and a supreme knowledge of the art market.

"And we'll start the bidding at $1 million," offered Burge, with his charming British accent.

The magic number I was looking for was $2.4 million. That meant the cluster of paintings sold for $150,000 each, allowing David and me to move forward with our plan. If that happened,

I felt David's painting was a slam dunk to bring *over* $1 million in London.

I gazed at the large overhead screen, revealing four rows of canvases covered in colorful flowers. Unless you've attended an evening sale, it's hard to explain the visual fundamentals of an auction. You need to imagine a cavernous room seated with perhaps six hundred well-dressed, affluent people — an art bazaar for the elite. Behind them are the unfortunate souls who aren't important enough to be given seats. The art world has a definite caste system. It's divided into those who have comfortable seats, and those forced to stand through the ninety-minute tedium of a sale. Those seated in the sky boxes are in a league of their own.

Personally, I skirted somewhere between the two worlds. As a member of the press who wrote for *Artnet*, I was allowed to stand in an advantageous spot. This meant my art dealer colleagues could never humiliate me by saying, "I saw you standing." Instead, they saw me mingling with writers from the *New York Times*, *Wall Street Journal*, and the like. The subliminal message was I had access to insider information. This was far from the truth, but I certainly didn't discourage that notion.

Besides the pageantry of the audience, there's also the currency conversion board, which instantaneously converts every bid into dollars, euros, yen, and other currencies. Flanking the auctioneer and his podium is a battery of seated auction-house personnel. Their job is to field phone bids from around the world and relay them to the auctioneer. As they signal a bid, the auctioneer allows them a moment of notoriety, as he cries, "I have $750,000 from Laura!"

However, what turns an auction into a sporting event are the elaborate score cards — otherwise known as auction catalogs. After the sale of each lot, the crowd turns the page in unison,

creating a rippling sea of images—like doing the "wave" at a stadium. When it was the Warhol Soup Can's turn, a current of red and white rolled through the room. The Flowers produced a blur of unidentifiable colors.

"I have a million," cried Burge. By the look on his face, he knew this was going to be easy.

Unfortunately, I was too keyed up to enjoy the moment. Hands shot up all over the room. There was no hesitation on the part of the buyers. Before I knew it, the paintings had eclipsed the magical $2.4 million mark—I was home free. Now it was just a matter of how high the final total would go. About a minute later, I found out. Including the buyer's premium, the group of Flowers had sold for a robust $3,936,000—or $246,000 a painting. Although the "Warhol-voracious" Mugrabis were in the audience, I couldn't tell whether they were a factor this time.

Rather than stick around for the rest of the sale, I discreetly left the room, anxious to call David. Once I was back at my B&B, I reached him.

"So, are we going to auction?" he asked.

"We certainly are. The paintings sold for—are you ready for this?—$3.9 million, all in," I said, with zest.

"Oh brother," was all David could say.

Recovering from surprise, he asked, "So how do you want to work this?"

"Here's what we'll do: I already did some preliminary work on the deal, anticipating it would happen. I've interviewed Sotheby's and Christie's. Both were forthcoming and really want the painting. But I decided I want to go with Sotheby's because of my relationship with Anthony Grant. I've known him for twenty-five years and we've always worked well together. Is that okay with you?"

David responded, "Fine. That's why I'm hiring you—to make those decisions. So what would the terms be?"

I went on to explain to him that Sotheby's had wanted his painting so badly that they were willing to waive the seller's premium. The profit from the hammer price would be all his.

David sounded mystified, "I don't have to pay a commission?"

"Nope."

Then he asked how I would be paid. When I informed him that Grant had offered me a small percentage as a finder's fee, David was equally perplexed and our negotiations grew a bit tense.

David said, "I was expecting to pay you a commission from my side . . . but if they're going to pay you . . ."

"Well, the percentage Sotheby's is willing to give me isn't all that great. How about if you added another two percent to it?"

David, a former CEO of a financial services company with over five thousand employees, was a skilled negotiator. He did some quick calculations and said, "Tell you what, I will guarantee you $50,000, regardless of what the painting brings—as long as it sells. In other words, I will make up the difference of what Sotheby's offered you if it does poorly."

I continued to argue with David for a percentage rather than a fixed fee. I believed in the painting and thought it would bring over a million, which meant I would be better off with a piece of the action. David listened intently, but I could tell he was getting a little edgy. Rather than have him pull the plug on the deal, I steered the conversation to calmer waters and cheerfully agreed to his proposal.

I hung up the phone, noticing my dress shirt was soaking wet. A trip to the dry cleaner was a small price to pay. We had a deal.

red Elvis

The next evening was Sotheby's turn.

I was originally hoping to see John Lindell at the sale. Normally, he would be in town. But I had received an e-mail informing me he had to remain in Finland to attend to business. As for Andy Rose's offer on my former Fright Wig, although Lindell said he'd be in touch soon, I sensed he was stalling. There was something he wasn't telling me.

I entered Sotheby's and headed for the salesroom. Fortunately, there was no sign of Carole Lieff. I did, however, spot Jonathan Novak. He was chatting up a couple from Chicago. I discreetly walked behind him when I overheard him say, "Sarah, I love your dress. You've never looked better." All I could think was, *shades of Eddie Haskell.*

A few minutes later, I spotted Peter Brant. He was one of the three largest Warhol collectors in the world, along with the Mugrabi family and the Daros Collection in Switzerland. Not only did he have an incredible collection, which also included numerous works by Basquiat and Jeff Koons, he was married to

model (and former Axl Rose girlfriend) Stephanie Seymour. Brant was dressed in an expertly tailored dark suit, complemented by the perfect tie. As I approached him, I couldn't help but notice the way he exuded power.

I held out my hand, "Mr. Brant? I'm Richard Polsky. We've never met before but I've always wanted to meet you."

A big smile crossed his face, "Richard, I've wanted to meet you *too*. You did a nice job for me at the trial."

I smiled back, "Yeah, I'm glad that worked out."

Brant was referring to a lawsuit that had been recently resolved in his favor. I had been hired, on his behalf, as an expert witness. *Art & Auction* and *ARTnews* recently reported on the story, so now it was a matter of public record. The gist of the problem was Brant had purchased a Warhol painting called *Red Elvis* for $2.9 million in 2000. The 1962 canvas, which measured sixty-nine inches by fifty-two inches, featured thirty-six headshots of Elvis Presley, on a tomato-red background. Brant bought the painting from the Swedish dealer Anders Malmburg. Malmburg, in turn, claimed he represented the owner, Kerstin Lindholm, and was authorized to sell it. Lindholm had released the painting to Malmburg's custody because he promised her he could have it sold for a big price.

From Brant's perspective, it was a significant acquisition, but nothing out of the ordinary. After all, he bought expensive paintings on a frequent basis. Then things took a bizarre twist. After collecting the money from Brant, Malmburg never paid Lindholm. Before long, Lindholm filed suit against both Brant and Malmburg. In an act of anger and desperation, she decided there must have been a conspiracy to defraud her out of her painting and the money. She claimed not only were Malmburg and Brant in cahoots, but she also felt Brant grossly underpaid for the picture. Her attorneys thought that should have aroused Brant's

suspicions about the legitimacy of the deal. They also believed Brant should have gone over Malmberg's head and called Lindholm to make sure he had permission to sell the painting. Her counsel's argument was that Brant acted in bad faith.

Ultimately, Brant's case went to trial in Stamford, Connecticut. I was asked to give testimony on how business is normally conducted in the art world. During my deposition, I explained in great detail how art is bought and sold. Things I took for granted seemed to surprise the opposing attorneys. They appeared shocked by the casual nature of the art market and by the general absence of contracts. They found it hard to believe large deals were done on a traditional handshake basis.

I tried to impress upon them the system contained built-in "checks and balances." It all came down to the reputations of the parties doing business. If you're in the market for a Warhol, you know who the players are. You know which dealers have good-quality pictures. You know who's honest. Based on those factors, you choose whether to work with someone or not. Contracts are meaningless. If someone reneges on a deal, the whole art world eventually finds out. Once a dealer or a collector develops a bad reputation, they are effectively excommunicated from the business.

I went on to explain when a dealer of good repute offers you a picture, you do not question every aspect of the transaction. For instance, if a collector hires me to sell his Richard Diebenkorn "Ocean Park" painting, the person I offer it to assumes I have the right to sell it. For that reason, the potential buyer would never contact the owner directly to see if I had a mandate to do so. Lindholm's legal team argued Brant should have done just that.

What helped turn the argument in Brant's favor was that he exercised due diligence that went beyond the usual. For

instance, he hired an attorney to conduct a lien search and consulted the Art Loss Register—a database of stolen art and antiques. This impressed the judge. So did other expert testimony that consistently demonstrated that Brant bought *Red Elvis* according to "reasonable commercial standards" of the art industry.

Ultimately, Peter Brant won his case. The judge determined he acted in good faith when he bought *Red Elvis*. She acknowledged Brant dealt with someone who, at the time, was considered to be a reputable dealer. There was no reason to be suspicious. At the end of the day, it was a simple case of Malmburg defrauding Lindholm out of her money. Apparently, the Swedish court system agreed, as Malmburg was sentenced to three years in prison. At the time the case ended, Lindholm had not received restitution.

That night, I said to Brant, "Did I tell you what happened when I first took the stand at the trial? Lindholm's attorney says to me, 'I read your book and really enjoyed it'—so I knew he was setting me up. Then he hands me a copy of it and asks me to read the opening quotation out loud: 'Sometimes I lie but this time I'm telling the truth.'"

Brant laughed.

"The attorney then says: 'So, is this the way you usually do business?' I had to explain to the court the quotation was attributed to an anonymous private dealer—not me!"

Brant shook his head. We agreed to meet for dinner some time in the future. Once I found my seat, I kept thinking about the trial and the nature of doing business in the art world. It was amazing that there weren't more lawsuits. Sure, there were plenty of disagreements over prices quoted, lies over what a dealer paid for something, and the usual poaching of clients. But I had never known of a situation so blatantly dishonest that it was worth calling in lawyers—with the exception of the Michel Cohen scandal.

I was suddenly jarred to attention by auctioneer Tobias Meyer, "Good evening ladies and gentlemen . . ."

Sotheby's spring 2006 sale proved almost anticlimactic to Christie's. But overall, it did well. One of the highlights was the auctioning of the first John Chamberlain to break a million dollars. The estimate had been $200,000 to $300,000. It was a high-quality sculpture from the 1960s, not as good as Ivan Karp's, but certainly an indicator of what his was now worth. Suddenly, eighty-year-old John Chamberlain was hot.

The sale also set a record for a photograph. Andreas Gursky's 99 *Cent* exceeded its $1 million to $1.5 million estimate to sell for $2.2 million. The image portrayed row after row of colorful candy bars displayed in a dime store. When viewed at a distance, the scene blurred into pure abstraction. Adding to the absurdity of the price, the print was from an edition of six. That meant that the artist had a created a single image worth over $13 million. Photography's transition from commercial medium to mainstream art was now complete. There was nothing like high prices to validate an art form.

Years ago, the auction houses began trickling photographs by Cindy Sherman into the painting sales. Their logic was that Sherman's work was conceptual. Her self-portraits were about transforming her persona, not traditional photography. Sherman's breakthrough was her "Film Stills" series, evocative black-and-white images that cast her in a range of roles, from a hitchhiker on a lonely road, to a woman with a forlorn expression opening a letter. The auction-house strategy worked. Soon, Sherman's photographs brought prices commensurate with paintings. Now, Gursky had created a seven- by eleven-foot photograph that not only had the scale of a large painting, but also read like one when seen from across the room. Although his subject matter was manipulated on the computer, rather than shot as a natural

composition, the work received massive acceptance, which was indicative of how far both photography and its market had come.

As the sale wore on, one crazy price followed another. Even a large Andy Warhol "Gun" painting brought a spectacular amount. Previously, the series was a tough sell. A self-righteous collector once told me, "Oh, we would never hang a gun in our home." That night at Sotheby's, a red-and-black Gun, on a white background, that measured seventy inches by eighty-nine inches, soared over its pre-sale estimate of $600,000 to $800,000. It was bought by Irving Blum for $2.3 million. The sale was ironic on two levels. The silkscreened Gun (a Saturday night special) was the same model used to shoot Warhol in 1968. Equally remarkable, the painting was purchased by the first dealer to exhibit Warhol. Since Blum was always ahead of his time, collectors and dealers took note. The undesirable had become desirable.

There was one lot, however, that demonstrated how the auction houses' infatuation with guarantees could backfire. In an effort to turn back the tide on their losing battle with Christie's for market share, Sotheby's gave a ridiculous guarantee to the dealer Joseph Helman. He owned an early Roy Lichtenstein landscape painting called *Sinking Sun*. It was a classic benday-dot sunset, replete with primary colors. The painting had some nice things going for it. It was from the 1960s, it was large scale, and it had been in a private collection for many years. What it didn't have working for it was charisma.

Sotheby's promised Helman a rumored $15 million to $18 million. The split above that number was a subject of conjecture. *Sinking Sun* had been estimated to bring $18 million to $22 million. The main problem was Sotheby's touted it as one of the finest Lichtensteins to appear at auction. This was simply not true. Once the auction drew closer, Sotheby's upped the rhetoric. They soon spoke of it as one of the finest paintings of

the artist's career. The problem was it wasn't even in the top fifty.

As Tobias Meyer offered the Lichtenstein that night, the crowd's anticipation was great. The buzz was *how little* the painting would bring, not how much. The bidding got off to a quick start, then started to die at $12 million. *Sinking Sun* "sunk" to a hammer price of $14 million. Helman had a big grin on his face. Sotheby's had egg on theirs as they lost at least a million dollars.

When the auction ended, I gave David Flaschen another call to report on the evening's results. Fortunately, Warhol continued to do well. I informed David I was in touch with Anthony Grant and mentioned his Flowers painting would be picked up that week.

I then began to explain the terms I negotiated in greater detail. First off, David's painting would appear in the prestigious first thirty lots. This was crucial. The auctions always want to establish momentum, so they liberally sprinkle their best material early on. Sotheby's had also agreed to do a six-page spread in its catalog. Most important, Sotheby's promised to reproduce a letter from Ivan Karp, telling the story of how this was the first two-foot Flowers sold from the 1964 Leo Castelli show—and in Karp's opinion the finest. Grant also said that Sotheby's would accept no other Flowers paintings for the sale. Finally, he even offered a new frame for the painting, which I kept quiet for fear of insulting Deborah Flaschen.

When I asked Grant what other material Sotheby's was auctioning, he told me David Flaschen's painting wouldn't be "lonely." He had recently secured David Hockney's historical work, *The Splash*, for the sale. This was a rare Hockney swimming pool painting. It would add luster to the evening and help ensure a big crowd.

David was pleased with what he heard. Everything was coming together. We then made plans to meet in London. I explained I would be there a day early to keep an eye on things. My biggest concern was how the painting would be installed. Placement and lighting would be important. It was all about respect for the object. When I got off the phone, I could tell David felt he made the right decision.

Later that evening, I checked my e-mail, hoping for a response from John Lindell. I went online and sure enough there was a message. It read: "Thank you for your generous offer. I am currently considering the purchase of a larger Fright Wig—a red twenty-two-inch by twenty-two-inch painting. If I make a deal on it, I might sell you the green one. Though I have to caution you, my wife is quite fond of it."

I passed along the news to Andy Rose, and said, "We'll just have to wait and see how it plays out."

After a week of spectacular sales results, it was becoming painfully obvious that the art business had undergone an amazing transformation. It was all about the auctions. Collectors began looking to cash out and dealers were forced to adopt a new strategy. Back in 1978, when I first entered the field, the business revolved around building collections. The financial payoff often took place way down the road, when your clients asked you to resell pictures for them. If you sold good things to begin with, you were thrilled to get them back, and make money a second time. Today you could forget about clients—*you need material*.

As the auction juggernaut gathered momentum, it became obvious dealers were fighting a losing battle to secure inventory. You knew you were doing your collectors a disservice if you didn't steer them toward putting their pictures up at auction.

There was money to be made by acting as a liaison between sellers and the auction houses. It was now all about convincing your clients to let you handle the negotiations—for a taste of the deal. My arrangement with David Flaschen was the new paradigm. And I was only a few weeks away from seeing how it would manifest itself.

dots and spots

You're not going to believe this, but there's a Brink's truck in our driveway," said Deborah Flaschen.

In an effort to put their London catalog to bed, Sotheby's had asked an employee in its Boston office to hire an armored truck to pick up the Flowers painting. As always, insurance company requirements necessitated the move. The Flaschens' painting was carefully wrapped, driven to the airport, and then flown to London to be photographed and cataloged. Whether it traveled on a commercial airline or a private carrier was unknown; auction houses are wary about providing too much information in regard to transportation.

The next big issue was to determine a pre-sale estimate and a reserve—the minimum price the seller would accept. Grant mentioned how the last Flowers brought $880,000. Since the market was now stronger, and this was a better painting, he proposed an estimate of $1 million to $1.2 million. I thought he was dead on and told him I would clear it with Flaschen. The reserve would then be $1 million. When I spoke with Flaschen, he once again deferred to my judgment.

Later that day, my cell phone rang and Grant was on the other end. As a New York–based specialist, he hadn't flown to England yet. He said, "I just spoke to my colleagues in London. The painting arrived and they can't believe how beautiful it is. They want to boost the estimate to 600,000 to 800,000 pounds; which would be approximately $1.1 to $1.46 million."

"Great," was all I could say.

Then I made a mistake. The difference between converting dollars and pounds didn't register. I said, "The more I think about it, since the low end of the estimate was supposed to be $1 million, I want the pounds to correspond with that."

To use a cliché, assigning an estimate to a painting is an art, not a science. The idea is to find a price range that's low enough to encourage bidding, but high enough to treat the painting with respect. In this case, I was worried that Sotheby's was pushing too hard.

Grant, who was far more experienced in dealing with European currencies, said, "If you want the low end of the estimate to be exactly $1 million, you'll wind up with an odd sounding estimate—like 572,321 to 766,543 pounds. It looks weak."

He was right, of course. But I wasn't thinking and said, "That's okay, I still want the reserve to be $1 million, even if it's in pounds."

The ever-accommodating Grant said, "All right, if that's what you want. I'll call London and tell them. But it will be the only estimate like it in the catalog."

Proud of myself, for sticking to my guns, I called David to keep him in the loop. When I told him about the new estimate, he explained that Grant was right—round numbers sound stronger. I hung up, frantic to reach Grant before London went to press.

His phone must have rung five times before I finally heard, "Hello."

"Anthony," I panted, "is there still time to change the estimate back to pounds?"

"I think so, but I better call right now," he said. "So are you okay with a low estimate of 600,000 pounds, which would raise the reserve to $1.1 million?"

"Let's do it," I said with conviction. "I figure anyone who's serious about the painting will assume they have to bid up to the low end of the estimate."

In the meantime, I made arrangements to go to London. I knew David Flaschen was planning to stay at Brown's. I was already familiar with the deluxe hotel through Jonathan Novak. Years ago, he had been in London when his return flight was canceled due to mechanical difficulties. British Airways announced it would put everyone up for the night, assigning passengers to a generic airport hotel. When Novak heard that, he vigorously protested, "Sorry, that's not going to happen. I always stay at Brown's."

That day, British Airways learned a valuable lesson—never mess with an art dealer's hotel of choice. As Novak read them the riot act, the airline actually backed down and accommodated his wishes. When he relayed the story to me, I always swore some day I would go to Brown's to see what it looked like. Now, I was going to finally have my chance.

Soon, the catalogs were published and FedExed to David—mine arrived regular mail. He called, pleased that the numbers were rounded off but concerned that the estimate had been bumped up. The painting now had to sell for an extra $100,000 or there was no deal. I reassured him on our reasoning and he relaxed.

At the last minute, I invited the painter Jan Wurm to join me on the trip to London. Jan was a down-to-earth woman who

offered a brief respite from the Rachaels, Karens, and Caroles of the world. Jan had attended graduate school at the Royal Academy of Art and welcomed the opportunity to visit her old professors. Once we arrived, we fought through jet lag to view the Howard Hodgkin retrospective at the Tate Modern. There's nothing like looking at art through glassy eyes. The surfaces take on a blurred, soft-focus quality, transforming even the intense colors of Hodgkin into a tranquil experience.

After finally succumbing to exhaustion, we took a short nap, and woke up in time to attend the Damien Hirst opening at Gagosian's new London space. The irony was that Hirst was often referred to as the new Warhol. During the late 1980s he helped revive a moribund London art scene. In 1988, Hirst organized a controversial exhibition of his fellow students at Goldsmiths College called "Freeze." He emerged from the show as a first among equals, thanks to his outrageous—some would say revolting—sculpture of an actual sheep sliced in half and placed in two aquarium-like tanks of formaldehyde.

One of his mates, Marc Quinn, cast his head in his own frozen blood and displayed it in a clear refrigerated cube. There was also the sexpot Tracey Emin, whose contribution was her bed, covered in a quilt embroidered with the names of every man she slept with (there were a lot of names). Another standout was Chris Ofili, the Nigerian-born artist who incorporated balls of elephant dung in his paintings. Years later, he would gain notoriety for displaying a canvas of the Virgin Mary at the Brooklyn Museum, replete with pachyderm droppings, prompting then-mayor Rudolph Giuliani to declare, "This is sick stuff."

The English press dubbed the group "Young British Artists" or "YBAs." The artists' timing was good, as Charles Saatchi

decided to throw his weight behind them. He had recently sold off his blue-chip holdings and decided to reinvest his winnings in his country's new emerging talent. One of his key acquisitions was a sensational Hirst sculpture of a ten-foot tiger shark immersed in a tank of formaldehyde, called *The Physical Impossibility of Death in the Mind of Someone Living*. In 2006, it was sold to Steven Cohen for a rumored $12 million.

Hirst went on to win the Tate's coveted Turner Prize in 1995. A year later, he joined the Gagosian Gallery. It was easy to dismiss his work as "anything to get attention." Yet the work had a certain appeal and stayed with you. His philosophy was summed up by the Web site The Archive: "Hirst's work is an examination of life and death; the ironies, falsehoods, and desires that we mobilize to negotiate our own alienation and mortality" — whatever that meant.

I had met Hirst in 1993, when he was preparing for his first show in America at the Michel Cohen Gallery (of all places). At the time, Cohen's girlfriend, Tanya Bonakdar, was running his gallery. She was originally from London and was clued-in to the pulse of her hometown art scene. Bonakdar brought Hirst to New York, where she mounted a show of his so-called "Spot" paintings. The surfaces resembled a candy popular during the 1960s called "Dots" — rows of tiny multicolor circular candies glued onto rolls of white paper.

When I walked into the Cohen Gallery, I saw Hirst directing a bevy of assistants, busy making his paintings for him. He functioned as an art director, preferring not to get his hands dirty — at least Warhol had participated in making his art. I remember Bonakdar introducing me to Hirst, who was short and tough looking. Then he went back to instructing one of his assistants to add a little more red to a spot. I said to myself, *What a joke, this guy will never make it.*

Now, it was thirteen years later, and that morning there was an extensive interview with Damien Hirst in one of the London papers. The article claimed Hirst was worth 130 million *pounds*. At the time, that would have converted into almost $260 million. Regardless of whether you loved or hated his work, Hirst was good for the art market. His influence and notoriety helped transform the London scene into the second most important in the world.

I had to admit, I couldn't wait to go to his opening that night. Hirst was one of those artists who bedeviled me. My respect for his ambition was tempered by his contrived approach. Bisecting an animal and displaying it in a pair of oversize fish tanks would obviously ensure plenty of press. It almost seemed too easy. Then again, no one else had done it. Everything Hirst conceived was so well executed that once you got beyond the "gee whiz quotient," you had to think seriously about the piece. Somehow, he managed to impose his will on you.

We took a cab to Davies Street, and walked into a cavernous white space with polished cement floors. One large room was devoted to a museum-quality show of Francis Bacon paintings. Before he died, in 1992, Bacon had widely been rated as England's greatest living artist. By juxtaposing his show with Hirst's, Gagosian was making a profound if obvious statement about the young artist's place in the country's new pecking order.

After being thrilled by Bacon's virtuosity I walked into a room packed—make that mobbed—with television reporters, print journalists, and adoring fans. Hirst's show was a rock concert. You could barely see the work. When I managed to squeeze through the crowd, I saw several giant stainless-steel-and-glass cabinets filled with human skeletons. There was also a large tank filled with living fish, swimming around a desktop computer, with scattered syringes littering the floor.

The show's star attraction was a five-foot by seven-foot by twelve-foot glass cage filled with thousands of live houseflies and a skinned cow's head, oozing blood. In the middle of it all, the artist had rigged a contraption best described as an electrified grid that served as a fly-killing machine. The flies would buzz around, accidentally touch a live wire, and get zapped. The dead insects would then tumble into a large tray. Once the container became full, the fly carcasses would be collected for future use in Hirst paintings. The brilliance of the installation was that Hirst had created a work of art, which in turn produced "material" to make further works of art. I wondered what would happen when all the flies died. Would the piece need new flies to retain its integrity and value?

Jan and I were awed by the spectacle of it all. I saw no point in asking for a price list. All of it was pre-sold for God knows what. This was despite the fact that Hirst was repeating himself. The show's cabinets, spot paintings, butterfly paintings (real butterflies glued onto a painted canvas), and even the fly-killing machine had all been done before by Hirst. Unless he began taking more risks, he was in danger of having his work turn formulaic.

Larry Gagosian, the ringmaster, stood off by himself, survey-ing the lively scene. Gagosian now had two galleries in New York, one in London, one in Los Angeles, and was in the pro-cess of building another outpost in Rome. Thanks to his unyield-ing ambition and a burgeoning art market, he could afford to throw the best parties, publish the finest exhibition catalogs, and represent more important artists than any dealer on the planet. All the negative stories about him had gradually crumbled away. Now, the entire discussion was about his genius.

Meanwhile, during a late-night supper at Bibendum—a beautifully transformed old Michelin tire depot—my phone

rang. It was Anthony Grant. He informed me he already had two bidders lined up for the Flowers painting.

I said, "That's welcome news. Any sense of how high they're willing to go?"

"The first one says he's willing to go 'all the way' — but wanted a year to pay for it."

"*What?*" I said, balking at the buyer's nerve.

"Don't worry," laughed Grant, "I told him forget it. But knowing who he is, he'll still probably bid anyway."

"What about the other guy?" I asked.

"He's prepared to go over estimate, if you're willing to give him terms."

"What sort of terms?" I asked, cautiously.

"This collector wants three months to pay for it. Let's say the painting sells for $1.5 million. He would pay $500,000 immediately, another $500,000 in sixty days, and a final payment in ninety days."

My first reaction was to protect the painting, "How well do you know this guy?"

Grant responded, "We only give terms to clients who have an impeccable track record with us. Besides, we'd hold onto the painting until it's paid for in full."

I asked, "Is this a common occurrence?"

"It is when you get into million-dollar pictures."

Then Grant added, "The other advantage of agreeing to this is that it allows the client to stay in the game longer, which helps bid up the picture."

It was a good point. I told Anthony I'd have to clear it with David Flaschen, but would certainly endorse the idea. With a four-hour time advantage, I called Boston and spoke with David. He initially wasn't thrilled by the delayed-payment concept. But after thinking about it, he said, "Okay, I'll agree to it as long as it's payment in kind."

"Meaning what?"

"Meaning when Sotheby's receives the first installment, they don't get to deduct their full commission—they get a third, just like you and I," he explained.

"That certainly makes sense. I'm sure they'll agree to that," I said. "Assuming they do, I'll give them the go-ahead."

"Great. See you tomorrow in London," said David.

Somehow, Andy Rose had managed to track me down in England. He was the most persistent collector I ever met, which was saying something. I figured his tenacity was probably why he amassed enough money to collect high-end art.

"So," he asked, "any news on our deal?"

"Yeah, unfortunately. I just found out that Christophe van de Weghe was the guy Lindell was negotiating with to buy the twenty-two-inch red Fright Wig," I said. "And he decided not to sell Lindell his painting. He's going to hold onto it."

"I guess that's the end of getting the green Fright Wig," said Andy, sounding dejected.

"For now it is."

when the stars align

The next day, Jan and I took the tube to Sotheby's to check on the installation of the Flowers. When we walked in, I was not disappointed. The lighting was exquisite and the placement on the wall was even better. The painting was "protected" on either side by a Gerhard Richter and a Lucian Freud. Even the new frame—a simple matte black strip—struck a perfect pitch.

Cheyenne Westphal, the stylish head of contemporary art in London, came over to say hello. She was on crutches, which only accentuated her dedication to her position. She smiled, "Welcome to London. I trust you're happy with how the painting looks."

"You've done a great job. Has there been any interest? Any sense of how it will do?" I asked, while trying to sound nonchalant about the whole thing.

Westphal took me aside and said, "We've had lots of interest. It should do very well."

"*How well?*" I asked, hoping to have something to tell David Flaschen, who was due to meet me at Sotheby's in an hour.

Not wanting to commit herself, she responded, "You know how everyone tells you they're planning to bid, but you never know until the night of the sale."

Trying to put my mind at ease, she added, "Don't worry. It's a great painting. I'm sure you'll be pleased with the results."

As I walked around the room, I noticed five other Warhols. Perhaps my favorite was a forty-inch-square portrait of Mick Jagger, with a gray-blue background. Warhol had painted the Stones leader's face with a streak of green eye shadow, embellishing his androgynous appearance. Judging by the length of Jagger's hair and youthful looks, the painting was from the 1970s. As I stood there admiring it, John Lindell came up from behind me to say hello.

"Hi, John," I said. "What do you think of the Flowers painting?"

I was tempted to bring up my former Fright Wig, but decided not to. Better to have him pursue me if he was ready to sell. Nattily attired and looking as continental as ever, he said, "It's a beauty. Had I known it was *this* good, I would have made you a bigger offer."

This was just what I wanted to hear. I looked him in the eye and said, "I hope you're planning to bid on it."

"You never know—I have a feeling it's going to be too expensive," said Lindell, as he walked away, obviously not wishing to play his hand.

As I continued to tour the exhibition, David Flaschen appeared. He didn't see me at first, so I was able to observe his reaction. He immediately spotted the Flowers and stood mesmerized by it.

Then I strolled over and said, "David—you made it!"

All he could say was, "The painting looks incredible. I love the frame."

Then I noticed a touch of sadness cross his face. He said, "If it had looked this good at home, with the right frame and lighting, I might not have agreed to sell it."

Then he added, "Would I be able to withdraw it?"

Not sure if he was serious, I said haltingly, "Uh, I guess you could. But, uh, remember, you have a contract. I think you pay a three percent penalty if you withdraw it."

That seemed to sober him up. David smiled again, "Don't worry, we're still on."

Then he said, "I'm going to take off. I've still got to check in at Brown's. Why don't we have lunch later?"

He left just as Anthony Grant entered the room. I asked him, "So what's the good word?"

"It should be a strong sale. The 'Mick Jagger' is going to go through the roof."

I pointed to another Warhol, which was the artist's take on the famous Edvard Munch icon, *The Scream*. Warhol had created a stylized version of the lonely figure silently screaming while standing on a bridge. Grant and I walked over to it and he said, "Even though it's a late painting, it's such a famous image that it should do exceedingly well."

"What about the Flowers?"

As he was about to answer, his cell phone went off. Grant took the call and quickly walked out of the gallery. Still in suspense, I wandered around, looking for someone who could handicap the painting's chances for me. I ran into a colleague from America, who had always been a discreet source of information.

I said, "Just between you and me, I'm representing the owner on the Flowers tonight. What do you think it will go for?"

He said, "I already know."

Looking incredulous, I said, "What do you mean, *you already know?*"

"I've heard the Mugrabis want to see it sell for around $1.8 million."

"Really, that's interesting," was all I said, as my "Deep Throat" walked away.

Since it was common knowledge the Mugrabis owned a number of Flowers, there was a distinct possibility they had made a strategic decision to support David's painting—to the tune of $1.8 million. Whether they bought or underbid the painting, it worked in their favor. Either way, they would set a new price level for the Warhol two-foot Flowers.

Jan and I left Sotheby's, walking down New Bond Street, while marveling at the fortunes of the art market. As we passed all the luxury-goods stores, and looked up at the classic architecture, I had an epiphany about how little money it took to be a player in the art business—compared to real estate. For only $1.8 million, the Mugrabis could acquire a serious painting and help drive the Warhol market. Yet $1.8 million wouldn't buy squat in London property.

Arriving at Brown's, we entered the well-appointed lobby, taking in the conservative ambiance. I could see why Jonathan Novak insisted on staying there when he had his dispute with British Airways. I called David on the house phone and soon we were back on New Bond Street, having a leisurely lunch. I remember looking at the menu, where entrees averaged twenty-five pounds. Once again, it didn't dawn on me until later that twenty-five pounds translated into almost fifty dollars.

Over a dish of root-vegetable ravioli with poached salmon, I was dying to tell David about the Mugrabi rumor. The problem was I didn't want to get his hopes up. Nor did I want to jinx the auction. David appeared relaxed. He had once played pro-

fessional soccer as a goalie, a position probably filled with more pressure than worrying about the sale of his Warhol. I decided to keep the mood light and let nature take its course.

This being a small art world, we ran into Jonathan Novak. He was with a client, so he could only stop by our table for a quick hello. David Flaschen made a face. I realized it was because Novak once attended a party at his house, where they got into an animated discussion about the necktie David was wearing. Since he always prided himself on his taste in ties, he invited Novak to view his entire collection. Novak took a look and shrugged, clearly unimpressed. He even went as far as suggesting he replace the majority of them. By his expression, David hadn't forgotten that evening.

The hours whizzed by and soon it was time to go back to my hotel and change clothes for the sale. The plan was to meet in front of Sotheby's at 6:30 — the auction was at seven. David had invited Peter and Shirley Reynolds to join us. They were his next-door neighbors when he lived in London. They were also the same couple who were astonished when David bought the Flowers, amazed how anyone could spend $75,000 on it. I remember meeting them at a party the Flaschens threw to unveil their new painting. There was a remarkable symmetry to how the evening was unfolding.

Jan and I got there first and moments later the Reynolds arrived. It was good to see them — thirteen years and, I hoped, over a million dollars later. We exchanged warm greetings and even snapped a few photos in front of Sotheby's. A reproduction in the window of a Hirst "Pharmaceutical Cabinet" served as a backdrop.

As we entered the auction house, David turned to me and smiled, "Let's go make some money."

With that, we were seated. As my eyes scanned the room, I spotted various dealers and collectors. A London sale was different

from one in New York. For starters, the crowd was smaller and the vibe was more business-like. Participants quickly found their seats, rather than run around looking for people they knew. Everyone was also more conservatively dressed. The whole atmosphere felt more corporate than festive.

I glanced down at my auction catalog and saw the Flowers would be the seventh item auctioned out of a total of sixty-eight lots. It was a relief to know we wouldn't have to suffer through an entire sale to know our fate.

I turned to David and explained, "Sometimes during a sale, the bidding will stall out before the painting reaches the low end of its estimate and seem like it's not going to sell. But don't panic. Nine times out of ten it's just a feeling-out process, like a couple of boxers throwing a few jabs before they go for the knockout punch."

David nodded, "Good to know. But I'm telling you, if it doesn't reach the reserve, I'm prepared to take my painting home."

Usually, once someone has consigned a picture, they've "let go" and don't want it back. David Flaschen had always been a contrarian, so I knew he meant it.

The auctioneer approached the podium and read the announcements, mentioning a specific painting had been withdrawn. This was a common occurrence. The reasons why paintings are withdrawn vary: change of heart, lack of clear title, and questions of authenticity.

Then the sale got underway.

"Lot number one—the On Kawara painting. Do I have 50,000 pounds to start?" implored the auctioneer.

On Kawara is a conceptual artist whose art consists of making a single painting a day, always the same size, with that day's date stenciled onto a small monochromatic canvas—nothing

more. He had been going through the same ritual for over thirty years. When he finished painting the canvas, he would place it in a cardboard box, along with a copy of that day's newspaper.

The On Kawara quickly found a buyer, as the painting sold over estimate. Naturally, I saw this as a good sign and smiled at Flaschen. I was feeling confident, encouraged by the result along with insider knowledge about the Mugrabis—though nothing was guaranteed.

Lots number two through five came and went. Everything sold at the high end of the estimate or above. Lot number six, a 1960s Richter portrait of a woman in a big hat, went well beyond its 800,000 to 1.2 million pound estimate. The stage was set.

"Lot number seven—the Andy Warhol Flowers—and we'll start the bidding at 300,000 pounds," said the auctioneer. The painting, beautifully lit by a lone spotlight, positively glowed on stage.

"Do I have 300,000 pounds? I have it," he cried as I watched a paddle shoot up from the audience.

I glanced at David. He looked stoic.

The auctioneer began his mantra, "350 . . . 400 . . . 450 . . . 500 . . ."

My head swiveled, as I tried to determine who was bidding. I spotted Alberto Mugrabi, but noticed he hadn't made his move. A chill went through me as I wondered if the information I received was false.

Then the bidding stalled at 550,000 pounds. The room went completely cold.

I looked over at David and whispered, "Don't worry. I told you this happens all the time."

He nodded, but remained unemotional. I myself grew concerned as the auctioneer repeated, "I have 550,000 pounds. The next bid is 600. Who'll say 600?"

But no one said "600."

"I still have 550,000 pounds. Any more bids?"

At this point, I knew the auctioneer was one query away from passing the painting. It was now or never.

Then I saw Mugrabi bid. I looked over at David expecting some sort of response. But his facial expression never changed. The bidding started moving rapidly again. Mugrabi duked it out with another buyer, whose last bid was the equivalent of about $1,550,000. Mugrabi shook his head.

"Sold!" cried the auctioneer. With the buyer's premium, the Flowers had brought almost $1.8 million. I couldn't believe it— my source was right on the money.

Now David Flaschen grew emotional. He quickly shot out his hand to shake mine and said, "Good job! Let's get out of here!"

As the bidding opened on the next lot, the David Hockney masterpiece *The Splash*, we quietly made our way up the aisle. Once we were in the lobby, David reached for his cell phone to call his wife Deborah.

"Hi, Honey, It brought over a million-five."

I overheard Deborah say, "That's great, but Katherine's not feeling well. I think she has a cold."

That was it. They were going over the mundane details of the day as if nothing of consequence happened.

Then I heard him say, "We're going out for Thai food with Peter and Shirley. I'll talk to you later."

David got off the phone, "Let's grab a cab, buddy."

I walked down the street, searching for transportation. Soon, I flagged down one of the city's ubiquitous black cabs. As I opened the door, I watched David light up a cigar. A plume of smoke formed a crude Warhol poppy (or so I imagined). Then I looked up at the unusually clear London sky and saw the Big Dipper, glowing brightly.

it's all in the timing

I returned from London fully invigorated by the triumphant sale of the Warhol Flowers painting. I felt encouraged by the art market. It's funny how making a successful deal will do that to you. Then reality hit. Even though I now had more to spend, the price of blue-chip art continued to increase exponentially. I was generating more income, but the art I was pursuing was appreciating at a faster rate. Simply put, it was a race I couldn't win.

The only possibility was buying something that couldn't be classified as contemporary art. The problem was what did I know about American paintings, modern art, or Impressionism? Ditto for the "crafts" such as furniture, ceramics, and glass. I did, however, fantasize about discovering an Outsider artist (an artist with no formal training), having done one of the first Bill Traylor shows, at Acme Art in 1984.

Traylor, an ex-slave, lived on the streets of Montgomery, Alabama. Between 1939 and 1942, he produced a body of 1,200 drawings and gouaches on discarded sheets of cardboard, which reflected the colorful street life he witnessed. Traylor drew preachers, mean dogs and cranky cats, and occasionally men

standing around getting drunk. His genius was an uncanny sense of composition combined with an unerring ability to communicate the personality of his subject. Traylor's one piece of good fortune was meeting a young aspiring artist named Charles Shannon. Shannon befriended Traylor, bringing him art supplies and providing encouragement. But most important, Shannon had the presence of mind to recognize the significance of Traylor's work and preserve it.

Thinking about Traylor made me consider buying up the works of a West Coast African-American artist, a sixty-something character named Bo. Though he signed his paintings Van Bo, he also went by Bocasso and Bonet. Calling Van Bo a character was an understatement. In a past lifetime, he was a porn star who went by the unfortunate name of Big Dick Black. He eventually graduated to bit parts in mainstream movies, including *Dirty Harry*. I had recently come across Van Bo's paintings in Sausalito, a small seaside community just across the bay from San Francisco. Much as I envisioned Traylor displaying his paintings in downtown Montgomery, Van Bo spread his pictures in front of shops and restaurants along the town's main street.

I looked long and hard at the work. Van Bo's favorite subject was the Golden Gate Bridge, with San Francisco looming in the background. He painted on pieces of discarded wood and priced his works at a modest twenty to fifty dollars. Now and then I'd buy one. But when I hung it alongside other paintings from my collection, it didn't hold up. While Van Bo had a compelling personal story, which made him ripe for exploitation by an art dealer, the bottom line was that his work wasn't strong enough. Especially when compared to the authenticity of Bill Traylor. I thought, *Nice try*, and decided to move on in my quest to reinvest in another artist.

When I started working for myself in 1984, I became obsessed with investing in art that I loved. Within a year I owned a small Warhol Mao (cost: $4,500), the prime 1960s John Chamberlain, *Ma Green* (cost: $12,000), and an early Joseph Cornell box with a yellow canary (cost: $36,000). Art was escalating in value back then too, but at a more sustainable pace. The problem was my gallery's expenses were overwhelming me. I was forced to gradually sell off these works to keep the business going, but always believed I would be able to replace them. It seemed inconceivable back then that the art that thrilled me would eventually be out of reach.

But I was wrong. By 2006, the same Mao would be worth over $1 million, the Chamberlain $750,000, and the Cornell $400,000. What I earned on the Flowers deal wouldn't come close to buying any of these works that once formed the core of my collection. I came to the sad realization that I could never afford to buy what I once owned. The upward trajectory of the art market was pushing me away from the art itself.

I hadn't realized it until now, but I was transitioning into a "financial art adviser." Rather than talk about art with clients, I discussed investment strategies: tax-deferred exchanges, auction tactics, buying up overlooked bodies of an artist's production (like Rosenquist collages)—anything to make a profit. Looking back, I wished I had majored in business rather than sculpture.

On the positive side, experience and plenty of mistakes had taught me well. I fully understood the dynamics of the art market, as much as anyone could. If forced to identify a single element in any industry that meant the difference between success and failure, it would be timing. Timing a market is almost impossible. If it turns out that you bought near the nadir and

sold near the acme, you essentially got lucky. That's true of trading stocks, real estate, and art—especially art.

David Flaschen's timing had been impeccable, unlike mine, when I got the first part of my Fright Wig equation right but came up short on the second. As bad as I still occasionally felt, I realized I had seen worse. Much worse. In retrospect, I should have known better about selling my Warhol after being connected to the sale of arguably Wayne Thiebaud's greatest painting.

If there was one market that had sprinted past the others during the recent boom, it was Thiebaud's. Now eighty-eight, Thiebaud lives in Sacramento, still plays tennis, and per square inch per new painting may be America's most expensive living artist—even pricier than Jasper Johns. For years Thiebaud had been California's best-kept secret. It wasn't until his retrospective at the Whitney Museum in 2001 that the art world woke up to Thiebaud's brilliance. Until that show garnered universal praise, he lacked an international following. As the Europeans condescendingly put it, he was a good "regional" artist in America.

Wayne Thiebaud burst upon the art scene in 1962. Accompanied by his student Mel Ramos, who would eventually become a famous artist in his own right, Thiebaud traveled to New York seeking gallery representation. While Ramos would have to wait until a year later, Thiebaud's paintings of sweets and desserts caught the eye of Allan Stone. His creamy paint application, which mimicked the frosting of the cakes he depicted, became his trademark. At the time, Stone had cast his lot with the Abstract Expressionists and was completely devoted to Willem de Kooning, Franz Kline, and Barnett Newman, among others.

But 1962 was a transitional year for the art world. Not only was it the first year that Thiebaud began producing fully realized work; you could argue the same was true for Andy Warhol,

Roy Lichtenstein, and maybe John Chamberlain. With the success of Jasper Johns's targets and flags at his inaugural exhibition at Leo Castelli in 1958, the Abstract Expressionists began to feel threatened. They had worked hard to break away from European dominance to create a movement that captured the vitality of postwar America. Now they were being upstaged by paintings of Campbell's soup cans!

When Stone announced to Barnett Newman that he was going to represent Thiebaud, Newman called a meeting of the gallery's artists and issued a stern demand, "Get rid of the pie guy." Stone stood his ground and gave Thiebaud his first one-man show. As those who follow the art market know, Thiebaud's 1962 show was a success on a number of levels. Sales of the artist's "food landscapes" were unexpectedly strong and the show was reviewed by *Time*—a national news publication rather than an art magazine. *Time* singled out a specific canvas to illustrate the article. That painting was *Bakery Counter*.

Stone sold *Bakery Counter* to a Manhattan couple. It was the largest painting in the show, measuring a perfect "over the sofa" four by six feet. An educated guess is they paid five hundred dollars. The imagery was magnificent. Thiebaud had painted an almost life-size deli-style glass case, jammed with rows of multicolor pastries, donuts, and pies. If you were writing a book on art history and had to select a painting that summed up everything Thiebaud was about as an artist, *Bakery Counter* would be the obvious choice.

In 1978, I began my career in the art world with a job at a downtown San Francisco gallery called Foster Goldstrom Fine Arts. The gallery was owned by Foster Goldstrom, a Bay Area native, and his wacky Romanian-born wife Monique. Life with the Goldstroms was educational, vastly entertaining, and at times perverse. The couple had evolved an alternative lifestyle that

was straight out of Cyra McFadden's book *The Serial*. This was the late-1970s story of a Marin County hipster couple who indulged in all the hedonistic trends of the times: hot tubs, transcendental meditation, pot smoking, and partner swapping. In the Goldstroms' case, substitute fine wines for pot smoking.

Regardless of his personal choices, Foster had a terrific eye for art. Despite his background, which included no college or art exposure, he simply had an innate sense of quality. His success in the art business, built largely on developing the American market for the Austrian artist Hundertwasser, allowed him to reap numerous material pleasures. He bought a Mercedes, case after case of Chateau Lafitte, an architecturally significant home designed by Bernard Maybeck, and a stunning art collection.

Foster also had more nerve than anyone I had ever met. He was a risk taker with attitude. Foster spoke about how the movie *The Apprenticeship of Duddy Kravitz* made a big impression on him as a young person, especially the scene where Duddy waited on a guest in the Catskills who tore a hundred dollar bill in half, handed it to him, and said, "You get the other half at the end of the summer if I get good service."

Taking a page that could have been from the movie's script, Foster pooled his bar mitzvah money, managing to put together $1,000. As he tells the story, "Those were the days [1958] when the U.S. Treasury issued $500 bills and $1,000 bills. Even though they only circulated among banks you could actually call ahead and request one, which I did. Right after getting my thousand-dollar bill, I got on my bicycle and rode over to the corner drugstore, found a nickel Hershey bar, and handed the cashier the thousand-dollar bill. You should have seen how flustered she got! She said, 'I can't break this' and called the manager over. He couldn't deal with it either so I said, 'Fine, I'll take my busi-

ness elsewhere.' So I left and peddled around town doing the same thing over and over again. It was some of the most fun I ever had!"

With that sort of arrogance, Foster couldn't miss as an art dealer. As the money piled up from selling Hundertwasser prints, he wisely invested his profits in blue-chip art, including classic works by Sam Francis, Louise Nevelson, and Morris Louis. But what he really wanted was a Wayne Thiebaud. In 1979, Foster went to New York specifically to buy one from Allan Stone. The former attorney, who was both immensely eccentric and successful, got a kick out of Foster. But it wasn't enough to offer him an important Thiebaud. Instead, Foster had to make do with a rather minor painting of a cigar in an ashtray.

Foster brought his consolation prize back to San Francisco, disclosing he paid $10,000 for the ten- by twelve-inch oil painting on board. As Foster soon learned, cigars were not a favorite subject of Thiebaud collectors. After six months of being unable to find a buyer, Foster sold it back to Stone, who graciously paid him $12,000 for it. Undeterred by his initial Thiebaud experience, Foster returned to Stone, this time securing a more attractive (but still minor) painting of an office "in/out" box. But at least it was a canvas. He paid $28,000 for it and resold it quickly for approximately $35,000.

Foster was still determined to acquire something major. He visited Stone again, this time camping out in his office for three straight days. Stone, who sometimes never showed up for work until four o'clock in the afternoon, must have been impressed by Foster's persistence. On the fourth day, a large wooden crate arrived at the gallery. Foster watched the gallery preparator pry it open and carefully unpack its contents. Once the painting was slipped out of its protective bubble wrap, Foster exclaimed, "Now that's a Wayne Thiebaud!"

Allan Stone had recently bought the *Bakery Counter* back from the couple who purchased it at Thiebaud's inaugural show. Foster could barely contain his enthusiasm when he asked, "How much do you want for it?"

Despite controlling the Thiebaud market during the 1980s, Stone was fully aware that his resale prices were limited. Like fellow Californian Richard Diebenkorn, his work hadn't fully caught on in New York. The record for a painting at auction was under $50,000. Stone probably figured he'd shut this cocky guy from California up by quoting a price that would intimidate him. Stone declared, "If you really want to buy it, the price is $60,000."

Then Stone waited for Foster to make the requisite response of acting outraged. Only it never came. Foster shrugged, "Fine — I'll take it. What sort of discount can you extend to me?"

Caught off guard by Foster's willingness to more or less meet his price, Stone recalled he had given him twenty percent off on the last two paintings. So he said, "You can have your usual discount."

"Great, I'll send you a check for $48,000 as soon as I'm back in San Francisco."

Once Foster was home, anxiously awaiting his Thiebaud, he got a call from Stone, "Listen, Foster, it was premature of me to offer you that painting. I never intended to sell it. I really had bought it back for myself. But I'll tell you what, I'll send you $5,000 if you're willing to forget the whole thing."

Foster was pumped up; he lived for these moments, "Sorry, Allan, I can certainly understand why you want it back — but it's *my* painting." Then Foster hung up the phone and did a little victory jig.

And that was that. There was nothing Stone could do about it. A deal was a deal. Not long after, the painting arrived. Even

though I had respect for Thiebaud's work, he was never one of my favorites. That was until we installed *Bakery Counter* in Foster's dining room. I had to admit that this work made a powerful argument for Thiebaud to be included in the upper echelon of American painters. Foster celebrated by throwing an elaborate dinner party at his Maybeck mansion to unveil the painting to friends and clients.

Not long after, Harry Anderson, the Bay Area's biggest collector, who made his millions in the college cafeteria food service industry, got wind of Foster's painting. Anderson, who to this day owns *Lucifer*, the finest Jackson Pollock "Drip" painting in private hands, wanted to buy *Bakery Counter*—if the price was right. When I informed Foster, he was ecstatic—the great Harry Anderson was pursuing *him*. Rather than have me tell Anderson that we appreciate his interest but Foster doesn't want to sell, I was told to quote him $100,000. As Foster put it, "Don't worry, he won't buy it."

When I sheepishly told Anderson how much Foster wanted, he was peeved. He responded, "You tell Foster the day a Thiebaud painting sells for $100,000, I'll buy him dinner." Then he hung up.

When I passed the message along to Foster, his cockiness jumped another notch. In his mind he was now in the big leagues. After all, who tells Harry Anderson to essentially take a hike? Even Foster's wealthy competitor and nemesis, John Berggruen, knew better than to provoke Anderson.

Call it destiny, but within a year, a large Thiebaud painting called *Pin Ball Machines* came up to auction and sold for $120,000. According to Foster it was Harry Anderson who bought it. Once we found out, Foster asked me to place a call.

"Hello, Harry Anderson's office," answered the pleasant female voice.

"This is Richard Polsky calling from Foster Goldstrom Fine Arts. I just wanted to leave a quick message. Mr. Anderson promised Foster that he would buy him dinner if a Thiebaud painting ever sold for $100,000." Swallowing hard, I added, "Foster would like to know when would he be available for dinner?"

The secretary said, "I'll pass along the message and I'm sure someone will get back to you."

After I got off the phone, I brought Foster up to speed on the conversation. For some reason, he really thought he'd hear back and they'd have dinner together. He was already debating which fancy restaurant he wanted to be taken to. A week passed and we heard nothing. Foster commented, "He's probably out of town or something."

The "or something" proved accurate. The next day, Foster received a check in the mail for fifty dollars and a short note telling him to "enjoy his dinner" (alone). Foster was indignant, complaining, "Who does this guy think I am? I can't eat dinner for *fifty dollars*. What sort of restaurants does he think I go to?"

Foster took another look at the note and then another at the check. A smile crossed his face, "You know what I'm going to do? I'm not going to cash this—maybe it will screw up his checking account!" The next thing I knew, Foster dropped the check off at his framer. As soon he got it back, he proudly hung it in his office.

As the years passed, and the art market grew, *Bakery Counter* appreciated tremendously in value. By the end of the 1980s, Allan Stone bragged that he had sold a major Thiebaud painting of cake rows to the National Gallery in Washington, D.C., for $1 million. None of this was lost on Foster, who immediately declared his painting was better and that he wouldn't dream of selling it for "only" a million. A local dealer actually offered Foster that magical sum, and true to his word he turned it down.

Then, to loosely quote John Lennon, "life happened while Foster was busy making other plans." In 1997, the Goldstroms filed for divorce. With most of their wealth tied up in their art collection, they both knew it was going to be a nightmare dividing the art. Naturally, *Bakery Counter* was the big prize. As the divorce proceedings wore on, neither team of lawyers could come up with an equitable solution. Finally, the case went before a judge who declared everything should be sold at auction. Foster was devastated. I could certainly relate to his frustration of having to sell his favorite painting. He always envisioned holding onto his art at least until retirement. The legacy of what he had built and the status he achieved through his collection meant everything to him.

No matter, the judge's decision was final. The Goldstroms had decided to work with Christie's to sell the collection. Though Foster informed Christie's that he had rejected an offer of $1 million for *Bakery Counter,* Christie's insisted on giving the painting a modest estimate of $500,000 to $700,000.

When the auction catalog came out, there was plenty of presale interest in the painting. Supposedly Berggruen was going to make a run at it. The painter's son, Paul Thiebaud, was also a rumored potential buyer. Then inspiration struck Foster a second time (the first being when he made the gutsy commitment to pay Stone's price). A week before the sale, Foster made a curious deal with soon to be ex-wife Monique. Bombarded for months by her incessant complaints about not having enough money to live on, Foster proposed that he guarantee her the first $500,000 on the sale. Anything above that would be his. That meant if the painting sold at the upper end of the estimate, Foster would be entitled to only $200,000. If it went for the bottom of the estimate, Foster would receive *nothing*. Monique readily agreed to the bargain.

I was there on the night of the sale. I wasn't aware of the current record for a Thiebaud at auction, but I believed it was well under $500,000. Back in 1997, the art market was slowly crawling back from years of weakness. By 1998, the second boom market was underway. Once I took my seat, I quickly located the former spouses. Monique was seated in the audience; Foster was standing in the back of the room. As the preceding lots were knocked down, the tension grew.

When the great moment arrived, I shot a quick glance at Monique. She looked pale. Foster, on the other hand, had a wide grin on his face. Maybe he knew something I didn't know. The bidding started at $200,000, surging ahead in $20,000 increments. Sure enough, Berggruen was in the thick of the action. When the auctioneer cried $500,000, I looked back at Monique. Now she was smiling. But once the bidding shot past $700,000, her smile began to wane. When the bidding topped $1 million, her facial expression resembled someone sucking on a lemon.

I tried to look for Foster but I could no longer spot him. I could only imagine his racing thoughts. Maybe he fantasized about all the thousand-dollar bills he now could afford. Soon, the painting crested at $1.5 million, selling to the St. Louis collector Barney Ebsworth. Final Score: Foster $1 million, Monique $500,000. Right after the sale, Ebsworth went up to Foster and said, almost apologetically, "I know how bad you feel about selling it, but I've wanted this painting for years and would have paid more." Had Foster managed to hang onto it, which was his intention all along, it would have been worth between $10 and $15 million by the end of 2006.

I could certainly relate to Foster's situation. It was hell living in a rapidly escalating art market, knowing I had played my biggest card too soon by selling my Fright Wig. The more I thought about it, I should have listened to my mother.

the wonder

The future of the art market was starting to look more like the past. It used to be that an art dealer's most valuable asset was not his inventory but his relationships with collectors and artists. Once they were forged, it was all about maintenance. A successful dealer always spent an inordinate amount of time taking clients and painters to dinner. You always remembered birthdays and anniversaries with gifts of expensive art books. Sometimes you went as far as arranging dates, procuring rare cases of wine, and securing hard-to-get hotel accommodations. Over the last few years, dealers often let the care and feeding of their artists drift in lieu of spending more time with clients. But with collectors recently switching allegiances to auction houses, and the cost of inventory becoming prohibitively expensive, many dealers were forced to focus again on their alliances with artists in the hope that they would provide them with works on consignment.

One of the joys of owning Acme Art had been hanging out with the painters and sculptors that I represented. The good times were too numerous to mention. The greatest feeling in

the world was calling an artist and saying, "I just sold one of your paintings—and they paid for it." Though most of the artists that I met during the 1980s never caught on, I was still in touch with a few who went on to bigger things. One was Tony Fitzpatrick. While I never represented him, I had followed his work with great interest.

In 2005, Fitzpatrick's peripatetic career took root at Joe Amrhein's Pierogi gallery in Brooklyn. His inaugural exhibition sold out, despite prices that had almost tripled since his last exhibition. An original Fitzpatrick now cost $15,000.

Not only that, but the *New York Times* gave his show an unusually favorable review. A year later, the *Times* put the cherry on the cake by running a color photo of one of Fitzpatrick's superb drawing/collages. This was akin to winning the lottery, since during any given week in New York, there were at least five hundred shows running. The *Times*, like other publications, tended to feature artists whose work reproduces well because of its strong graphic quality—a key element in the success of Andy Warhol and Roy Lichtenstein.

The first time I met the Chicago maverick, he made an impression on me. There was an intimidating physicality to him. Tony stood about six foot three, with a bald cranium, blue eyes that betrayed his Irish background, and a few freckles that remained from his youth. He also carried a fair amount of weight on his frame—maybe tipping the scales at 250 pounds. He bore a remarkable physical resemblance to Tony Soprano. When he told me he was once a professional heavyweight boxer, known as the "Big Cat," I believed him. I actually believed a lot of what he said.

Part of Tony's personal lore centered around scrapes with the law. I was always curious to learn more about the specifics but

never felt comfortable asking him. Tony was also an actor, having appeared in a number of plays and various small parts in movies—where he often played a villain. On top of all that, he was a fine poet.

Over several visits, he shared stories about his memories of a Chicago that was long gone—tall tales about blues clubs, topless bars, and dangerous women. He spoke fondly about the Chicago White Sox and was ecstatic when they won the World Series. Tony also regaled me with anecdotes about his father, Jim, who went by "Ace." His dad made a living selling burial vaults and picked up a little extra money driving an ambulance at night. According to Tony, his dad's work ethic was a huge influence on his life. As Tony put it, "We're not the men our fathers were."

My memory of Tony's earliest exhibition was a display of colored chalk drawings on small slates—the kind schoolchildren used generations ago. Much of the work was inspired by scenes from the Deep South, specifically New Orleans. Many of the drawings illustrated the seamy side of the city. There was a cornucopia of pimps, hookers, winos, voodoo rites, and mambo priestesses. Alligators patrolled the bayous, searching for victims. Perhaps the most disturbing image was of the mass murderer Richard Speck. Tony's dark vision gave the work an unmistakable edge, redeemed by his ability to inject his quirky brand of humor.

The first series of slates were originally exhibited at the Janet Fleisher Gallery in Philadelphia (now Fleisher Ollman). Under the direction of John Ollman, the gallery achieved a national reputation for showing Outsider Art. Their stable included Martin Ramirez, Bill Traylor, William Edmondson—and Tony Fitzpatrick. All but Fitzpatrick were members of minorities and had long been deceased. To Ollman's credit, he recognized

Tony's vision was sympathetic to that of the Outsiders, yet unmistakably learned and relevant.

According to Ollman, he had tremendous respect for Tony's artistic skills, but found him a difficult person to do business with. There was constant financial pressure from Tony to make sales and raise prices. Eventually, Ollman grew weary of the frustrations and they parted ways. From there, Tony bounced around, showing everywhere from Portland to Boston. Each time it was the same: successful shows followed by a falling out between artist and dealer.

Simultaneously, Tony became well known in his native Chicago. His reputation was based not on his drawings, but his prints. This was unheard of in the world of contemporary art. Prints were considered lesser works, created primarily to increase an artist's audience. Crassly speaking, they made the artist and dealer money. Beginning collectors often started out buying prints (now they cut their teeth on photography). Other than Jasper Johns, major artists rarely put the same energy into their graphics as their paintings. Not Tony Fitzpatrick; his etchings were the focus of his oeuvre.

Tony's prints reminded you of the old temporary tattoos that came in boxes of Cracker Jacks. He used mellow blues, yellows, and reds to define a central image, often depicting moths, dogs, and flowers. Each was surrounded by random doodles of flotsam and jetsam from Tony's imagination, such as jesters, dice, and horseshoes. Most of the prints were small-scale; few were larger than six by eight inches. Tony's dealers priced them reasonably. During the late 1980s, they were available for $350 to $750.

Only around five years ago did Tony shift his focus to mainly producing what he called "drawing/collages." Now, he would paint, say, a cardinal on paper, and surround it with a constel-

lation of the same tiny images that populated his prints. Then, he would lay down a border of early matchbook covers and plastic "flicker" images from old gumball machine rings. Once again, these nostalgic touches harkened back to a simpler, less complicated era. The transition to drawing/collages brought him a wider audience. His work now attracted a more serious group of collectors who acquired only unique works.

Back in the 1990s, when I visited Tony's workshop, affectionately called Big Cat Press, I was struck by the level of industry. A studio assistant was running a fully inked etching plate through a press. Another was on the phone, trying to deflect a call requesting some sort of favor from Tony. I was also surprised to see two other artists working on his prints. One was a local tattoo artist named Nick Bubash. The other was the underrated actor Martin Mull, also a serious painter, who wanted to try his hand at printmaking. And at the center of all the activity was Tony himself, carefully selecting elements for a collage, while talking on the phone. I got a kick out of the organized chaos. Big Cat Press radiated good energy.

At the time, I was in town for the Chicago Art Fair, an annual event the entire art world looked forward to. It was the best art fair in America. That year, I walked around the Navy Pier, the show's traditional venue, dazzled by the sheer variety of work. Yet I was more impressed by the way Tony Fitzpatrick was treated like royalty. Despite his rough edges, or maybe because of them, members of the art community flocked to him.

While I wandered the aisles, I ran into a local television film crew on hand to interview Tony. He approached me and said, "Hey, man. I need your help for a minute."

"Sure, Tony," I replied. "You got it."

"I want you to play along. I'm going to introduce you as an important dealer. Then we're going to walk into a booth and

take a look at one of my prints," grinned Tony. "While we're examining the print, I want you to comment on it. Tell the audience why you think it's so fucking brilliant!"

I knew it was all tongue-in-cheek and found the whole scenario irresistible. As the film crew began to set up, an audience gathered. Tony and I stepped into the booth, rehearsing our "spontaneous" discussion. The cameraman gave the signal and I went into my spiel, taking great pains to exaggerate the significance of Tony's achievement. When I was done, Tony approached me and blatantly slipped me a twenty, making sure the cameraman recorded the whole thing. It was so contrived and so ridiculous, the gag actually worked. Observers thought it was hilarious.

Later that day, I ran into Tony and asked, "You want to get together later for a drink?"

"Possibly. I'm supposed to meet your soul brother Novak at Hooters. He's been making noise about wanting to buy something from me."

"That should be good for a laugh," I said. "I think I'm going to head back to my hotel. I can't take any more of this fair—too much sensory overload."

"Hey, man, I'm splitting too. I'll have a limo pick us up. Want a lift?"

"Sure," I said.

Tony made a quick call from a pay phone. Not long after, a yellow cab pulled up. Tony motioned, "Come on, here's our ride."

Before I could figure out what the deal was, the man behind the wheel yelled, "Tony!"

We got in. His driver turned out to be an off-duty cabbie. He was a close buddy who doubled as Tony's personal chauffeur. As I got to know Tony better, gestures of mutual support seemed

to be the norm in his life. I remember reading an essay by Penn Gillette, claiming he loved Tony so much that he would "take a bullet" for him.

The driver let me off at the Ohio House Motor Inn, my motel of choice when I was in Chicago. Actually, the truth was I stayed there to conserve funds, despite its shaky reputation.

As I stepped out of the cab, Tony yelled, "Don't forget—I'll see you and Novak at Hooters at six."

As everyone knows, Hooters is a chain of eateries that specialize in fried onion rings and twenty-something waitresses clad in hot pants and revealing tops. I had never been to a Hooters and frankly was looking forward to the experience, especially seeing Novak there! Six o'clock rolled around and I entered the restaurant, only to be greeted by a young woman wearing too much makeup and not enough clothing (not that I was complaining).

Jonathan Novak and Tony were already there. I pulled up a bar stool and sat down at a high-countertop table. Tony quickly grabbed the pitcher of Pabst Blue Ribbon and poured me an overflowing glass. Novak hoisted his mug, while keeping his eyes on our waitress's "bottom line." Then, looking to stir it up, he said, "So, Richard, how's life at the Ohio House? Has the exterminator been in yet?"

Novak, of course, was staying at the Four Seasons. Since I always teased him about being obsessed with "money, status, and Hollywood," I guess this was payback time.

Tony drained his beer, then opened a small portfolio that revealed two brand-new drawing/collages. Novak instantly declared, "These are great. I'll buy them both—if I can have them for half off."

As badly as Tony wanted to make a sale, his pride wouldn't allow Novak to just waltz in and lowball him. He sensed Novak

wasn't that into the art; he was into its salability. Tony was an old-school artist—it was about the work, not the deal. Now on his second beer, he grew angry, his face turning red. I looked at Tony's bulging muscles, realizing I wouldn't want to go up against him. Full of menace in his voice, he screamed, "Fuck you!"

Novak flinched, as if he had actually been hit, which looked like it might have happened had he said another word. Then, just like in an old fight movie, he was saved by the bell—actually it was his cell phone.

His beleaguered assistant, Julie, was on the other end. She was at the Navy Pier, up to her ears in shipping crates, trying to set up Novak's booth. Julie, who was given to hysteria, screeched, "*Where are you?*"

Without hesitation, Novak replied, "I'm at Hooters!"

That was all Julie needed to hear. "*What?* That's disgusting! I'm working my ass off and you're looking at titties!"

Julie was talking so loud that Tony and I overheard the whole thing and started laughing hysterically. Julie's timing was excellent—her overreaction defused the situation. Novak was off the hook—for now.

Since that glorious evening at Hooters, years passed and Tony's career began to soar. He was on the verge of becoming a star. Tony knew I wasn't a Johnny-come-lately when it came to his work, so I felt completely comfortable pitching him the next time I visited him in 2005, "Maybe you could slip me a collage every now and then. I've got some pretty good clients on the West Coast, including a few museums."

Though he was riding high, all the lean years had taught him never to blow off someone who was sincerely interested in selling his work. On the other hand, I could tell he was feeling cocky about his newfound success. Tony was starting to make enough

money not to have to wholesale work to me. What artist wouldn't let it go to his head after being recently featured in the *New York Times*?

Non–art-world denizens have no idea how overwhelming it is for an artist who has always struggled to make a modest living suddenly have his work almost quintuple in value. Rather than be thrilled by the development, you suddenly get scared. From what I understand, your fear of it not lasting swamps your emotional canoe. You think about reaching for your psychic life jacket, rather than enjoying the breathtaking scenery of the journey.

From an artist's perspective, this current art market boom is different from the last one. Back in 1989, no one lived in fear — least of all the artists. They honestly believed the good times would never end. The newly famous painters (Schnabel, Fischl, Salle, Basquiat, etc.) became hooked on their nascent deluxe lifestyles, making ever-bigger plans. They bought into the fatal trap that has been the downfall of many a dealer; artists suddenly wanted to live like their collectors.

This time around, many artists thought in terms of "getting while the getting was good." Based on their knowledge of what happened in the early 1990s, the idea was to make as much art and money as fast as you could, because you knew it wouldn't last. Artists rushed their work to market. Reputations were made quicker, prices went up rapidly, and the stakes grew higher. The bottom line was that artists who produced salable work were under a tremendous amount of pressure to keep the pipeline full.

There's a telling quotation in Paul Taylor's book *After Andy: SoHo in the Eighties*. Mary Boone revealed the key to getting major artists to produce: "Get them into debt. What you always want to do as an art dealer is to get the artist to have expensive tastes. Get them to buy lots of houses, get them to get expensive

habits and expensive girlfriends and expensive wives. That's what I love. I highly encourage it. That's what really drives them to produce."

While it was still unclear whether Tony would become addicted to the good life, things were definitely changing for him. That day, as he weighed my request, he shifted his Buddha-like bulk from one foot to another and said to me, "You really need to deal with Amrhein—everything goes through him."

Despite Tony's instructions, I had no intention of doing so. Even if Joe Amrhein offered me a generous twenty percent discount, it was hardly worth the effort. The only way it would be profitable would be to work with Tony directly and receive a fifty percent discount on a $15,000 drawing/collage. Twenty percent really meant half that because every collector expects their ten percent off. That would leave me with a grand total of $1,500 on a $13,500 sale—not exactly how you prosper in the art business.

Not long after our conversation, Tony began preparing for a show in Los Angeles at Billy Shire Fine Arts. As the exhibition drew near, he realized he didn't have enough work. In a bit of a panic, he asked some of his collectors to lend their drawing/collages to flesh out the show. This was a time-honored practice where everyone benefited. The artist had a stronger show, the lender enhanced the piece's provenance (history of ownership), and the gallery demonstrated demand for the work as evidenced by the lenders.

Seeking a loan, Tony phoned Jonathan Novak Contemporary Art. Not long after the confrontation at Hooters, Novak wound up purchasing a drawing/collage from Tony—and paid close to retail. That day, Tony spoke with one of Novak's employees about lending the drawing/collage. For some reason, Tony's request was denied. As might be expected, Tony was livid. So was Billy Shire Fine Arts, who was counting on it. Then

the truth emerged. Novak's gallery demanded complicated insurance arrangements from the Shire people to secure the loan. Apparently, the two art dealers couldn't get on the same page.

None of these technicalities meant a whole lot to Tony. He just wanted to have a knockout exhibition in Los Angeles. Tensions escalated. Communications broke down. Suddenly, what should have been a routine transaction between two galleries took on the complexity of the Egyptian Museum's loan of the King Tut exhibition.

Tony Fitzpatrick had had enough. He called Novak and basically threatened him with physical harm if he didn't lend the piece. According to Tony, Novak responded in due kind. From Tony's perspective, even though he sold the drawing/collage, it was still his work and he had a moral right to it. From Novak's perspective, his life was in danger.

The day before the show was to open, Tony flew to Los Angeles. Once his plane landed, he said to his driver, "MapQuest this cocksucker—I'm going to pay him [Novak] a visit."

Miraculously, at the eleventh hour, Novak's people and the Shire gallery worked out the loan details. From what I understand, the shuttle diplomacy that took place was worthy of the Henry Kissinger era. Though sanity prevailed, the damage was done—each side wanted nothing to do with the other. Both artist and dealer stood to lose.

Then, the tale took another perverse twist. The night of the opening, after swearing up and down he'd never speak to Tony again, Novak decided to go. He bravely showed up at the reception, bearing an expensive bottle of wine as a peace offering. Tony was impressed; Novak was relieved. According to eyewitnesses, the two embraced while expressing their love and admiration for one another. All was forgiven.

Only in the art world.

I was happy for Tony that his career was flourishing, but once again I was faced with the dilemma of finding an artist I could profit from. All roads felt like a dead end. I could buy emerging talent like Tony and make next to nothing. Or I could gamble that the blue-chip market would keep going, and risk getting stuck with a six-figure albatross if it didn't. My situation was akin to being trapped in a "twilight zone" between two worlds of art dealing. And like watching the pioneering television show of the same name, I couldn't quite grasp reality.

not so simple Simon

i know Lindell turned down our first offer. But I was think-
ing, why don't you go ahead and raise it by $100,000," said Andy
Rose, catching me by surprise. "Let's go to $575,000."

Then he added, "By the way, we never discussed your fee for
brokering the Fright Wig. How much do you want?"

Trying but failing to swallow my frustration over selling my
painting too soon, I said, "Five percent is fine." But the moment
the words left my mouth, I knew I quoted too low of a percent-
age. I wasn't focused. I was allowing my seller's remorse to cloud
my thinking.

All Andy said was, "Okay."

I conveyed the offer of $575,000 to Lindell, by sending him
another e-mail, fully cognizant of how communications have
dramatically improved since the last art market boom. In the
good old days, if you wanted to sell a painting to someone in
Finland, you'd have to figure out the time zone difference before
calling—and hope he was in. Since collectors travel frequently,
it was always touch and go. Matters grew more complicated if
you needed to send a color transparency of the painting to

Europe. Not only were they expensive to have made, but they were time-consuming to produce because you had to hire a professional photographer. Then you had to send it by Federal Express, wasting at least two days before you got a reply.

Now, you no longer worry about time zones. You just send a jpeg of the picture and receive a quick answer. Or, you could track down your quarry by cell phone. Dealers who entered the field at the start of the recent boom don't know how easy they have it.

I promptly heard back from Lindell. Despite the lure of a substantial profit, he still didn't want to sell. Andy was disappointed. He said, "All right, this is my final offer—$650,000." Once again, I conveyed the offer to Lindell and once again I struck out. He was sticking to his principle of not selling his painting until he could replace it with a more important example.

Meanwhile, I decided to go to New York to scout around for paintings I could broker. Once I arrived, my first stop was Van de Weghe Fine Art in Chelsea. Although we once did a deal, I was more interested in their current Warhol self-portrait show. As badly as I wanted to see it, I hesitantly opened the front door, fearing I'd be tortured yet again over selling my painting.

The exhibition was beautifully curated. It was the first time I was able to consider the depth of Warhol's accomplishment, as far as portraying his own likeness. He created an ongoing visual journal of himself, which traced the arc of his entire career. Beginning in 1963, you could follow the evolution of his appearance from early adulthood to his death in 1987. Naturally, the room contained a few Fright Wigs, including a green twelve-inch painting and another canvas that was orange. I stared at them for a long time—trying my best not to look back.

Then I caught a glimpse of a green 1964 "Self-Portrait," similar to the one that graced the American postage stamp. In 1989,

a British Warhol fan named Joe Simon acquired a red version from New York's Lang & O'Hara Gallery, which had bought it from me. Now Simon was on the verge of suing the Andy Warhol Art Authentication Board, since it had recently denied its legitimacy.

Back then Warhols were trading like crazy. Dealers gloated over selling paintings that they never laid eyes on. When a crate arrived containing a Warhol, the dealer would take delivery, remove the old FedEx air bill, insert a new one, and ship it off to the next buyer—without ever opening the wooden container. When I brokered Simon's Self-Portrait, I remember at least *looking at it*. I also recall inspecting the back of it, which bore a stamped signature of authenticity from Fred Hughes. As Warhol's longtime business manager, Hughes had taken on the thankless task of authenticating paintings.

I was originally offered the Self-Portrait while I was in Venice, California, visiting the private dealer Aldis Browne. The painting looked right as rain. There was absolutely no reason for me to be suspicious. I lined up Lang & O'Hara as a buyer, added a ten percent premium to my cost of $150,000, and had Browne ship it off to SoHo. Lang & O'Hara sold it immediately for $195,000 to Joe Simon. Flashing forward to 2002, Simon decided to take advantage of rising prices to cash out of the painting. He found a buyer for $2 million, but when it came time for the purchaser to write the check, he insisted Simon submit the painting to the Andy Warhol Art Authentication Board. The board had been formed to relieve Fred Hughes, who was overwhelmed with submissions. Simon protested that the painting had already been authenticated by Hughes, but his buyer wouldn't be swayed.

Joe Simon then got the shock of his life—the painting was denied. All of the gory details of what transpired were captured by Michael Shnayerson in the November 2003 issue of *Vanity*

Fair. Since the painting was screened off-premises from the Factory, Warhol's studio, the board wouldn't verify the painting was a Warhol. This was despite the fact that Warhol authorized it and gave the person screening the work the original acetate.

It's a long discussion as to what makes a "real" Andy Warhol. The core of his philosophy was that he wanted to be a "machine" by removing the artist's touch from the creative process. People forget how revolutionary this approach was in the early 1960s. Not only did Warhol use a mechanical process (photo silkscreen) to make his paintings, he would let others work on the canvases and even sign his name to them. From Warhol's perspective, he conceived the work—that was enough. Nowadays Warhol's approach has not only been accepted, it's been embraced. Witness Damien Hirst and Jeff Koons, two of our wealthiest contemporary artists, who, like Warhol, hire others to fabricate their art.

It was in this spirit of collaboration that Simon's painting was created. In 1965, Warhol traded a group of red Self-Portraits to a movie magazine publisher named Richard Ekstract for one of the world's first video cameras. Warhol took possession of the camera, but when it came time for him to keep his end of the bargain, he was too busy to make the paintings. Instead, he gave Ekstract the silkscreen acetate and instructed him to have it brought to a specific shop to be screened, which ran off a single painting for Ekstract and six others for his assistants. Ekstract then returned the finished paintings to Andy's studio and received the artist's approval. One of these paintings eventually wound up with Joe Simon.

When the committee turned Simon's picture down, they stamped the back of it with the word, "Denied." This brief but eternal act transformed a painting worth $2 million into an

object worth whatever its decorative value would bear. Instead of dropping the matter and licking his wounds, Simon launched a full-court press to get his picture validated. After extensive research, which produced reams of documentation in Simon's favor, he was encouraged to submit his painting for a second time to the authentication board — and was promptly turned down again.

A few years back I had received a call from Simon. Since I didn't know him, I began to panic after he explained the nature of his inquiry — I was part of the provenance of the painting in question. Sensing my concern, he quickly reassured me, "Don't worry, I'm not after you. I just want your help establishing the history of the painting and any other information you might be able to provide."

Heaving an inaudible sigh of relief, I responded, "You had me worried there for a minute. But sure, I'd be happy to help you. In my humble opinion your painting is the real deal — and not just because I sold it."

Simon finished laying out his grievance and closed by saying, "The board doesn't know who they're playing with. I have a lot of media connections and will do everything I can to make this story public."

True to his word, Simon contacted *Vanity Fair*, who commissioned Shnayerson. But that was only the opening salvo. London public television produced a thirty-minute documentary, *Imagine: Andy Warhol Denied*, on Simon's struggle to be vindicated. Both the movie and *Vanity Fair* focused on a single premise: your chances of getting the authentication board to approve your Warhol depended as much on who you were in the art world as on the picture itself. However, the credibility of this theory was tested and debunked when the very dealer who discovered Warhol submitted a painting of his own to the board.

Ivan Karp, who you would think should know a genuine Warhol when he saw one, came into possession of a pair of 1967-vintage Self-Portraits. These were the paintings where Warhol posed with his index finger in front of his lips, as if indicating he knew a secret and wasn't going to tell. Dealers refer to these paintings as the "Mum Voyeurs." The smallest known format in the series measured twenty-two inches by twenty-two inches, until Ivan Karp's two 12-inch-square paintings surfaced.

According to Karp, he bought the paintings from an art professor in Michigan, long before the documentary was produced. In 1967, the professor contacted Warhol, explaining his class was studying silk screening and wanted to try their hand at "making a Warhol." The artist must have been charmed by the notion and wound up sending a miniature acetate of the Mum Voyeur. The class then produced two paintings, running off a silver canvas and another in royal blue. They were conceived as a vertical diptych, with one panel placed on top of the other. At the class's invitation, Warhol actually went to Michigan and was apparently delighted by the pair of Self-Portraits. He even signed the top panel. As Karp said with a flourish, "The signature was the confirming act on the part of the artist!"

Though Karp knew what he was buying was a bit atypical, the canvases were created in a manner consistent with the way Warhol worked. Not long after acquiring the pictures, Karp sold them. The new owner sent them to be authenticated and lo and behold they came back "Denied." Karp dutifully refunded the buyer's money. Just like Joe Simon, not only was Karp out his profit, but in theory his principal had vanished too.

When I spoke to Karp about the incident, he was more upset that his historic relationship to Warhol seemed to carry no weight with the committee, than by his financial loss. After hearing this story, I thought, *There goes the theory about a*

Warhol insider receiving preferential treatment by the authentication board. But then again, Karp was no longer an insider. He rarely dealt in Warhol material, preferring instead to concentrate on promoting his own gallery's stable of talent.

The most important Warhol vendor was now Larry Gagosian. Dealers whispered that if he submitted a Warhol to the board it would waltz through unscathed. You heard similar talk about other longtime Warhol backers like Irving Blum and the Swiss dealer Bruno Bischofberger. The problem was that no one could prove any of this.

Joe Simon then decided to sue. He retained a New York law firm, which agreed to take the case on a contingency basis. He also got back in touch with me, which led to a preliminary discussion with his legal team about offering litigation support. One of his attorneys quipped, "Oh, you're that guy who wrote *I Bought Andy Warhol.*"

"Yeah, that's me," I responded.

"Well, we're going to write a book of our own called *I Sued Andy Warhol,*" declared the lawyer.

While I appreciated his sense of humor, this was no laughing matter. On the surface the thought of suing the authentication board seemed ludicrous. Their governing body, the Andy Warhol Foundation for the Visual Arts, has extremely deep pockets. It could easily defend any lawsuit. It would also be tough to fight because the board makes anyone who submits a painting sign a document agreeing to abide by its decision. Simon had signed that piece of paper.

At this writing, the Warhol attorneys were in the process of trying to convince the judge to dismiss the case. If a trial were convened, the ramifications for the art market would be considerable. As an unregulated field, with little transparency, collectors and the public alike would be privy to some of the inner

workings of the market. Though the board members are secretive about their criteria for approving paintings, not wishing to aid forgers, it's likely they would have to disclose more than they would like. Through depositions, light would also be shed on individuals who had works validated, and, equally revealing, those who hadn't. Finally, if Simon won, the management of significant artist estates would come under heavy scrutiny, possibly affecting current and future prices.

As Simon waited to hear his fate, I asked him, "What would you really like to see happen?"

Simon paused before answering. He was obviously exhausted by the ordeal. He had been through an all-consuming crusade to gather support for his position. There were dozens of phone calls and too many letters, faxes, and e-mails to remember. There was even a meeting with Vincent Fremont, the estate's exclusive sales agent and a former board member, offering encouragement and ultimately false hope. Nothing seemed to work.

I could feel the gravity of Simon's frustration as he was about to speak. Since 2002, getting his Warhol authenticated had become a full-time job. While millions were at stake, so was his reputation among friends and art-world colleagues. Not to sound melodramatic, but the fight had come to define Simon's life. It was not only a matter of money, but also a point of honor.

With all of this weighing on his mind, Simon said, in a voice filled with sadness, "I just want my painting approved and I'll go away. That's all I want."

I couldn't blame him. Nor did I want to remind him that his Self-Portrait was now worth close to $4 million.

After the auctions, I stayed in Manhattan to continue pursuing works of art that I could broker. Making the rounds, I stopped by the Charles Cowles Gallery. While Charlie was known as

someone who focused on the primary market, every now and then a resale gem surfaced in his back room. That day, as I made my way through a show of Chuck Arnoldi's recent abstractions, I spotted a black-and-white Warhol work on paper that was hard to miss—a Marilyn Reversal.

Knowing that canvases from this series were cleaning up at auction, I immediately inquired as to its price. Charlie wasn't there that day, but his assistant Lucas answered, "$65,000."

"What can you net it for?"

Looking at an accounting book, Lucas looked up and replied, "I'll have to call Charlie."

Locating him, vacationing in his native Florida, Charlie said, "Tell you what, Richard, if you pay me on Monday, you can have it for $45,000."

Grinning, I said, "But today's *Friday*."

"Well, then you better make a decision!"

Here was the classic art dealer conundrum, especially in an overheated market. My gut told me that the unique silkscreen on paper was worth as much as $75,000, maybe more. If I agreed to buy it, and sold it for even $65,000, that would be a quick $20,000 profit. Or, I could get on the phone and try to broker it for $55,000, explaining to the collector that if he made an immediate commitment, he would get a great deal. While I would make "only" $10,000, it would be completely risk free.

The underlying issue was that if I bought the Warhol for inventory, and failed to sell it privately, I would be faced with auctioning it to get liquid. In the art business, there is an unwritten code of conduct that dictates that whenever possible you try to avoid auctioning a work that you bought from a friendly rival. If, God forbid, you made a killing, that dealer would never speak to you again. Even though it was your money, you took the risk, *and* the auction results were beyond your control, it

was looked upon as running up the score on an opposing team that was getting its ass kicked.

Since I valued my relationship with Charlie, I decided the potential profit wasn't great enough to justify burning a bridge. I got on my cell phone and called the young collector Lee Root, a known Warhol aficionado. "Hello, Lee, I just found this incredible Marilyn Reversal . . ." Five minutes later, I had a deal.

And Charlie agreed to give me a week to pay for it.

David Row's dilemma

On my last day in New York, I made my way to Chelsea to take a look at David Row's new show. Row was an artist I had followed for years and we maintained a close relationship. As I climbed the stairs to the Von Lintel Gallery's second floor, I observed how unless gallery owners had a street-level location, they were screwed. There was just too much competition among the neighborhood's approximately 400 galleries—probably as many as 350 of them were unprofitable.

Plenty had been written about the gallery colonization of Chelsea. But virtually no one wanted to talk about the economics of owning a gallery there. The big names, such as Gagosian, PaceWildenstein, and Matthew Marks, didn't have to worry. Most of their artists' monthly exhibitions could more than pay the rent. There were a number of other veteran galleries who also had the artist firepower to prosper, including Robert Miller, Mary Boone, Cheim & Read, Luhring Augustine, Barbara Gladstone, Gallerie Lelong, Sperone, and maybe Paula Cooper.

You also had dealers who put on serious shows, but made their money from secondary market sales. Their ranks included

Stellan Holm, Perry Rubenstein, and Christophe van de Weghe—who consistently hung museum-quality exhibitions. There were also a host of younger dealers who appeared prosperous, like Zach Feuer, James Cohan, Andrea Rosen, and David Zwirner—who probably cleared $10 million alone on Peter Doig's work. Finally, there were galleries that did remarkable shows that never seemed to have anything for sale, such as Tony Shafrazi's. Their source of revenue remained a mystery to me.

Then there were the galleries that fell between the cracks—galleries you've heard of but couldn't name an artist that they represented. The Von Lintel Gallery was one of them. As I scanned its walls, lined with Row's paintings, I tried to calculate the show's potential profit. There were a couple paintings priced at $35,000, five at $18,000, and two at $12,000. A smaller room contained a selection of framed drawings that could be yours for $3,500 each. If everything sold, at full retail, the show would gross $201,500.

On the surface, that might seem like a fair amount of money. But, bear in mind, this was for work by an established fifty-five-year-old artist. I ranked Row as the best of the mid-career abstractionists, a group that included Richmond Burton, Mary Heilman, David Reed, Juan Usle, and Jonathan Lasker. In my opinion, Row was the heir apparent to Sean Scully—not in terms of style, but rather historical importance. Regardless, his prices were modest for an artist with his résumé.

What differentiated Row from his fellow abstractionists was that his paintings went beyond having attractive surfaces. Chuck Arnoldi coined the term "necktie art" to describe Scully's handsome stripe-covered paintings. It was an apt description. Though the physicality of Scully's paint application was wonderful, and his paintings looked great hanging on a wall, they revealed little of the emotional content that the artist poured into his work.

When you looked at a canvas by the Abstract Expressionist Clyfford Still, who applied paint with a palate knife, you sensed the sweat that dripped off his brow as he struggled to "get it right." Row's work revealed a similar soul searching.

According to the "red dots," indicating works that had been sold, I counted only three paintings and two drawings, which totaled $72,000. There were also several on hold. Giving the show the benefit of the doubt—assuming the two holds turned into sales—I came up with a total of $102,000.

Delving further into the numbers, it's a known fact everyone receives a ten percent discount just for asking. As a former gallery owner, the standard ten percent reduction was one of my pet peeves. I remember when someone came into my gallery, wanted to buy something, and asked for a ten percent "collector's discount." I couldn't figure out what that meant—wasn't everyone who bought something a collector?

These days, ten percent is nothing. Any experienced buyer knows that's where the negotiations begin. There are exceptions. A few young artists are so hot that you'd be lucky to receive *any* discount. They include Dana Schutz, who paints strange people cannibalizing themselves, Barnaby Furnas, whose pictures portray figures that feel like they're exploding, and the legion of other newly anointed geniuses few of us have heard of. But unless the artist is Jasper Johns, who allegedly allows the *dealer* to keep only ten percent, most people try to angle for fifteen percent or even twenty percent. A dealer is often willing to extend this courtesy if the collector is "somebody" or a museum.

In David Row's case, let's assume Von Lintel was a tough negotiator and refused to go down more than ten percent. That means the show netted $91,800. Since most galleries split the profits with the artist fifty-fifty, Row would eventually receive a check for around $46,000. Not too bad. Then again, that might

be for a year's work. Row also has a lot of overhead. He has a studio in SoHo that is expensive to maintain, along with a studio in Maine. Then there is the substantial cost of art materials. While he and his wife Kathleen (a successful graphic designer) had the foresight to buy their loft, they still have a mortgage along with all the associated building maintenance costs.

From Von Lintel's perspective, $46,000 would barely keep his doors open for a month—not with paying salaries for two employees, electricity, insurance, shipping, and a myriad of other fixed costs. His space's rent alone could run $12,000 a month. Each exhibition is expensive: transportation of the paintings, a color announcement, postage, framing (always a killer), wine for the reception (actually, discount that; most galleries serve the cheapest vino available, and I don't blame them), the dinner following the opening, and perhaps $5,000 for a full-page color ad in *Artforum* (maybe a bit less if he committed to a monthly contract).

Now imagine if Thomas von Lintel dared to pay himself a salary. Remember, no family can live in New York for much less than $10,000 a month, without a rent- controlled apartment. And assuming he sends his children to private schools . . . the numbers didn't add up.

Looking over Von Lintel's roster, Row is undoubtedly his top artist. You have to ask yourself, what if the best-case scenario happened and the Row show sold out? What if one of the mega-collectors you're always reading about decided Row was undervalued? Let's say he buys a bunch of Rows, puts one up to auction, and has someone bid it up.

If the above scenario took place, chances are a more established gallery would poach Row from Von Lintel's stable. All the time and money Von Lintel invested over the years would have been for naught. I know David Row personally and can

testify to his high character. But you better believe if one of the successful galleries mentioned earlier comes calling, he's out of there. Thomas von Lintel would be upset, but he wouldn't blame Row. That's the way the game is played.

Overall, Von Lintel runs a quality operation. He projects an air of integrity and comes across as genuinely committed to his vision and the future of his program. Thanks to connections from his European background, he may even broker some big deals overseas, on the secondary market. But as far as making any real money from his gallery—forget it.

Succeeding as an artist is equally if not more difficult. Row is one of the few artists I know who sells almost everything he produces—*and it's still a struggle*. When I first met him, back in 1988, he was showing with the old John Good Gallery in SoHo. Good had assembled a strong roster of talent with an emphasis on abstract painting. I bought my first Row from him— a small painting that might have cost $3,500. I also brokered a few more canvases via his gallery.

Over the last twenty years, I watched Row's career develop. Early on, he exhibited regularly in Europe, including a memorable show at Thaddaeus Ropac in Paris. I recall Row's joy when Thomas Ammann, one of the top collectors of the 1980s, bought several of his abstractions. With that level of support, it appeared he was on his way. Then the 1990s hit and the art market collapsed. The John Good Gallery closed. Nobody was buying art. However, Row more than landed on his feet. He was signed by the venerable Andre Emmerich Gallery—home of David Hockney, Sam Francis, and Hans Hofmann.

As the 1990s crisis deepened, Emmerich himself decided to retire, closing his gallery and selling off his blue-chip inventory to Sotheby's. Just like that, Row was out of a dealer again, and a major dealer at that. Row kept going and was soon pursued by

Von Lintel, who at the time was based in Germany. His gallery did a major show and flattered Row with a seventy-two-page catalog. When Von Lintel moved his operation to New York, Row agreed to let him represent him. Now, after three shows at the gallery, the work's steady growth, and respectable sales, Row wonders rhetorically, "What does an artist have to do to break through?"

It's a good question. The art world is filled with young artists who graduate from high-profile programs at Columbia and Yale. Some are scouted by dealers while still in graduate school—or even undergraduate school. It's akin to the National Basketball Association, which until recently, drafted players out of high school. Not long ago, the dealer Jack Tilton put together a sprawling show of young artists still in art school. I was told most of the work was sold to "collectors," speculating that a number of these immature artists might pan out.

Row is now working against time and the next generation of artists. While he has been exhibiting steadily for over thirty years, his paintings probably don't cost much more than a hot new painter having her maiden show. Row may be the superior artist, but that's irrelevant. The new kid on the block has a buzz factor and the future looks bright. In recent years, the commodified art market has shifted from buying mature work, to speculating on "futures."

I questioned Row's reluctance to leave Von Lintel. I wished he had the same representation as Fitzpatrick. The Pierogi gallery was considered serious and had heavy street "cred." Collectors, critics, and museum curators view the gallery as an incubator of new talent. Incredibly, my first cousin, Jonathan Herder, shows at Pierogi. He raves about Joe Amrhein and how hard he's worked for him. Recently, Amrhein arranged for Herder to have a show at the venerable Daniel Weinberg Gallery in Los

Angeles. That's exactly what a good dealer does—network his artists into other exhibition programs. With Amrhein working for Fitzpatrick, you could feel the heat being generated.

In fact, if a collector were purely interested in speculating, it almost would make sense to buy "the gallery" rather than the artist. During the late 1980s, Daniel Weinberg managed to ingratiate himself with the top New York galleries. Suddenly, he was bringing shows to the West Coast by the likes of Eric Fischl, Robert Gober, Jeff Koons, Robert Ryman, and John Chamberlain. A prescient collector would have been wise to make a commitment to Weinberg to buy one of everything from each show, in return for an early pick of the litter.

The way I see it, at this point David Row has three options and all of them are risky business. The first involves taking the course of least resistance by doing nothing. As Paul Newman said, during a card game in *Cool Hand Luke*, sometimes "nothing can be a real cool hand." If Row were to stick with Von Lintel, at the very least he could probably extract a greater commitment from him. With so much visual noise out there, Row's work needs to be seen above the fray. Advertising is one way, but participating at the most important art fairs would be better.

In an art world that thrives on "being in the moment," these fairs have changed the way people buy art. They feed on a sense of urgency. Decisions on whether to purchase something must be made on the spot or else. None of this "Can I take it home and live with it for a week?" You do your research ahead of time and come ready to buy. Art fairs have come to define the saying, "If you snooze, you lose."

In many ways, fairs are making galleries increasingly obsolete. Commercial galleries have become showrooms—no longer places where art happens. There's no dialogue and little sense of adventure—except perhaps when Gagosian does a Richard Serra

installation or Jeffrey Deitch concocts his latest extravaganza. Galleries struggle to keep up the illusion that making and selling art is about the sanctity of the work. Sure, there will always be upstart galleries with a unique vision and a sincere approach. But even these spaces inevitably succumb to the pressures of the marketplace.

Art fairs have become the place to be seen, make deals, and have fun. Currently, there seems to be at least one fair taking place somewhere around the globe every single month — sometimes more. As a dealer, it's impossible to exhibit at all of them. But if you want to promote your artists, you had better show up at Art Basel (Switzerland), Art Basel Miami, the Armory Show (New York), or the Art Show (New York).

Art fairs are sexy. Imagine flying from New York to Florida, during the cold month of December, to attend Art Basel Miami. You step off the plane, it's sunny and eighty degrees, and you're whisked away to a five-star hotel with an ocean view. That night, you go to the latest trendy Cuban-American restaurant or perhaps attend a party at a big collector's home — say the Rubells or Marty Margulies. The next day, you get up and head over to a VIP preview of the fair, before the general public gets to see it.

If Von Lintel invested $30,000 to $50,000 to exhibit at Basel Miami (assuming he's juried in), collectors might see David Row in a fresh light. Especially in contrast to all the amateurish painting at the fair and oversized photography. In the current self-indulgent atmosphere, where artists seem to have a philosophy of "anything to be noticed," Row might finally be seen for what he is — a painter who can inject some life into a canvas.

A second option for Row might be to swallow his pride and leave Von Lintel for a younger, hipper gallery. It's a viable strat-

egy, but one fraught with risk. Dealers tend to show artists of their own generation. They grow up together. But Row might be attractive to a gallery that wants to add a little more ballast to its program. After all, you can never have too many salable artists.

The real problem in working with a younger gallery is that not enough of them are hungry. When I opened my own space in 1984, after serving a five-year apprenticeship with another dealer, I was anxious to make my mark. I pursued artists who had representation in Los Angeles but not San Francisco. My strategy was to show established talent to local collectors who probably hadn't seen the work before. I called the gallery Acme Art, using a generic name to emphasize the artists, not the personality of the dealer. For the most part, the tactic worked. But it wouldn't today.

These days, the dealer is as much a star as his artists. Take the young dealer Zach Feuer, for example. Not long ago, he received a flattering profile in *The New Yorker*. Though I would be hard pressed to name more than one artist he represents, I certainly know who he is. Feuer has quietly evolved his approach to being a dealer: surround your artists with their peers and treat the whole thing like a family, which ironically was how it used to be. The only difference now is that it's more of a corporation under the guise of being a family.

If I were David Row and could show with Zach Feuer, or one of his youthful colleagues, I would do it. While it might be a tough initial adjustment, in the long run it would be no more painful than a kid moving to a new town and changing schools. At the very least, it would shake things up for Row and his work would be seen in a fresh context.

The final option for Row might be to aim high and try to show at one of the only two-dozen, or so, galleries that have reached the pinnacle. While I realize you don't just ask to join Gagosian

(they ask you), it's possible to receive representation from a universally respected gallery like Cheim & Read.

John Cheim and Howard Read met at the Robert Miller Gallery during the 1980s. Both were gallery directors who put together an innovative program, primarily of established artists who were undervalued. This led to shows of painters like Joan Mitchell and Alice Neel. They even curated Andy Warhol's last New York show before he died—a series of stitched-together black-and-white multi-image photographs. As the duo gained confidence and developed a clientele, they opened their own space and soon became a powerhouse that exceeded Miller. Their current program in Chelsea features well-curated shows by established yet edgy artists—including several abstract painters.

While getting a show at Cheim & Read is easier said than done, an artist who's been on the scene as long as Row probably knows some people who can connect him to the gallery. Artists often get shows by being introduced through a third party. For instance, if you're a collector who does a lot of business with a gallery, you better believe they're going to take a look at an artist you recommend. The same is true for a curator or critic in a similar position. Sometimes even a generous artist, currently represented by the desired gallery, will help you make a connection. Like so many things in life, it all comes down to how you're introduced.

What David Row ultimately did with his career was up to him; some of it was beyond his control. I'd like to believe it comes down to the work itself and the test of time. Regardless, it was Row's work and his decision.

The next day, I returned to JFK to fly home to the Bay Area. Just like clockwork, John Berggruen was on my flight. Feeling less inadequate after the Flowers sale, I decided to go on the

offensive. Once we boarded, and he was safely ensconced in first class, I said, "Hi, John, fancy seeing you here."

"Oh, did you decide to cash in some of your miles so you could finally sit up front?"

"No, I'll be taking my regular seat in coach," I said. Then I lowered the boom, "You realize, John, no one in the art world flies first class anymore—that's a sure sign of poverty."

Berggruen looked at me quizzically.

I continued, "Yeah, all the major dealers now have their own private jet—or at least know a collector who has one."

Growing annoyed, Berggruen yelled, "Don't worry about it. Plenty of my clients own planes and invite me to fly with them all the time!"

Grinning, I said, "I guess this isn't one of those times."

The funny thing was that was the last time I ever saw John Berggruen on a commercial airline.

i want to be Ed Ruscha

I thought about giving Ed Ruscha a call. Now that he was a superstar, I realized that while there was no chance of getting a work directly from him on consignment, perhaps he would put in a good word when I competed for the right to sell a painting from one of his dealers. Having met him in the mid-1980s, during a meal with Jim Corcoran and Ed's old girlfriend Candy Clark (of *American Graffiti* fame), I managed to loosely stay in touch.

If there's one artist who benefited the most from the latest art-market boom, it was Ruscha. As Los Angeles's unofficial artist laureate, Ruscha has had the perfect career: representing America in a recent Venice Biennale, having a highly acclaimed drawing retrospective at the Whitney, sell-out shows at Gagosian, and universal rave reviews. A few years ago, a catchy song came out of England called, "I Want to Be Ed Ruscha." There's also been a catalog raisonné published for his paintings and one in production for his drawings—honors usually reserved for an artist once he's deceased. Then again, Ruscha has always been special. It just took his market forty years to catch up.

Without going into his entire history, Ruscha's primary reputation is based on a subtle but seductive innovation: the use of language as subject matter. His secondary reputation is based on pioneering the "artist book" (a book created as an art object) and perhaps his utilization of unusual substances (such as cranberry juice) to make art. A tertiary level of recognition comes from his physical appearance; he has the looks and personality of the iconic male artist — cool but inscrutable. Besides, name another artist who would encourage his dealer to run an ad in *Artforum* (during the 1960s) reproducing a photograph of him in bed, sandwiched between two attractive coeds, with text that read "Good-bye to College Joys."

Ruscha has always produced salable art. But even during the explosive 1980s, his work never brought the big bucks — even though percentage-wise, its appreciation was considerable. It was only during recent times that Ruscha's prices allowed him to cross over to art-god status. From 1986 to 1989, he saw his trademark "Ribbon Letter" word drawings — so called because the individual letters appear three-dimensional, as if cut from a standing piece of ribbon — spurt from $3,500 to $82,000 at auction. But that was nothing. In 2005, a Ribbon Letter drawing, *Rooster*, sold for $187,000 at Christie's. A year later, also at Christie's, a smaller and inferior example, *Spoil*, brought $441,600. I was also able to verify that a major large-scale Ribbon Letter drawing brought seven-figures in a private transaction.

Then there were Ruscha's paintings. I can remember when *The Future*, a narrow green canvas from 1979, brought a record $190,000 in 1988 at Sotheby's. But the real breakthrough occurred in 2002, when Tony Meier bought the classic 1960s painting *Noise*, on behalf of Phyllis Wattis, at Phillips, crashing the $2 million ceiling. That same year, in May at Christie's, a 1963 canvas, *Talk About Space*, set a record price of $3.5 million.

While Ruscha didn't benefit directly from these sales, it caused a run on his work at Gagosian. Currently, unless you're a collector of note, you can forget about buying a painting on the primary market, which is why some collectors overpay at auction. In fact, Ruscha's prices have risen so rapidly that some veterans of the scene have cried foul—claiming someone must be bidding him up at auction.

My own involvement with Ruscha's work goes back to 1985 when Acme Art did a small show of Ribbon Letter drawings. There were seven pieces in the show that were priced from $3,500 to $6,500, including *Volume*, *Well*, and *Magnetic*. There was also a single nonverbal drawing of a marbleized bowling ball floating in space. Drawn with gunpowder, one of Ruscha's trademark materials, it was the most expensive work in the show. Jim Corcoran, his dealer at the time, walked in and without hesitation said he'd take it. Then he called the next day and asked if he could have a discount (the answer was no).

Three years later, Lia (my first wife) and I moved our gallery to Los Angeles. Once we got settled, we approached Corcoran with the concept of commissioning Ruscha to do an entire show. At the time, he had taken the bold step of painting monochromatic silhouettes of familiar subjects: houses, churches, hourglasses, and numerous other things. The works were such a radical departure from his word paintings that critics compared it to Philip Guston's gutsy decision to abandon Abstract Expressionism for a new cartoon-like imagery. Just like Guston's bold advance, Ruscha's new work initially received a mixed response. Knowing a great artist is usually a step ahead of his audience, we had faith in the work and sought to commission a series of Ice Age animals excavated from the local La Brea Tar Pits.

On the surface, the idea made a lot of sense. Ruscha had always been actively involved in painting the urban landscape

of Los Angeles: the giant Hollywood sign, Standard gasoline stations, Norm's restaurant, and the L.A. County Museum. Why not scenes from the days before Los Angeles, as we knew it, existed?

We drafted a letter outlining the deal and sent it directly to Ruscha. A copy was sent to Corcoran, which mentioned he would receive his percentage. A few days later, Corcoran got a call from the artist. The incredulous nature of his response said it all: "The Polskys want me to paint *dinosaurs*?" It blew my mind that he couldn't tell the difference between Ice Age creatures and actual dinosaurs. I also sensed Corcoran ridiculed the deal, telling Ruscha how absurd it was. As you might guess, the commissioned show fell through. Still, it could have been a great series.

Not long after, Lia and I called Ruscha directly, inviting him to lunch to propose a new idea. Actually, we didn't have a plan, but were hoping we might brainstorm something in person. Ruscha agreed to meet with us. We arrived at his Venice studio, psyched to dine with a major figure in American art. I must have been a little too wired because somehow I managed to lock the keys in the car—with the motor running.

I was panicked as I walked into Ruscha's spacious studio. Here I was, trying to come across as the sort of dealer he should be working with. Instead, I was on the verge of confessing my stupidity. I don't remember the exact dialogue that day, but the conversation went something like this:

"Hi, Richard. You don't look so good. What's wrong?" asked Ruscha, as he stood up to greet me, amidst the clutter of his workspace.

"You're not going to believe this," I said, "but I locked my keys in the rental car with the engine still running."

"Whoa!" laughed Ruscha. "Well, I wouldn't worry about it— it'll eventually run out of gas. Let's go eat."

Trying to shrug it off, I made a quick call to AAA, which said they'd be out in two hours. I was so upset during lunch that I never got around to pitching Ruscha. To this day, whenever I run into him, he brings up the story. Of course, over time the actual event became greatly embellished. So much so, a decade later at another cocktail party at Peter and Eileen Michael's house, the story came up and Ruscha said, "Oh, yeah, I remember that. Didn't we push your car over a cliff?" I just stared at him, having no inkling where he was coming from — *over a cliff?*

The Michaels had assembled an impressive collection of Ruschas, and I was pleased that I played a part in it. Back in 1998, Peter Michael was contemplating upgrading his Ruscha collection. He already owned perhaps the finest accumulation on the West Coast of the artist's works on paper. Now, he was ready to go after big game — a major canvas that said, *Honey, I Twisted Through More Damn Traffic.*

It's hard to believe now, but the large eighty-four-inch by eighty-four-inch, blue-acrylic-on-canvas beauty was estimated to sell for only $80,000 to $100,000. The sale was held at Christie's Los Angeles. At the time, the economy and the stock market were having all sorts of convulsions. Dropping $100,000 on a painting didn't feel prudent. Peter kept vacillating about the possibility of hiring me to go to L.A. and bid on his behalf. The deal was on — the deal was off — then it was on again.

Dealers frequently bid for clients at auction. The advantage of hiring a professional was the dealer's experience in gauging the mood of the room, thus saving you money by bidding intelligently. Typically, a dealer charged a percentage of the selling price — anywhere from two to ten percent. If someone else bought the painting, the dealer often made nothing, settling for expenses.

The day before the sale, Peter finally summoned his courage and gave me the go ahead. He offered me a generous $1,000

to cover my day in Los Angeles, regardless of whether I bought the painting. If I was successful, he said he'd pay me an additional $5,000. He also set a limit of spending $110,000 on the painting.

I flew to Los Angeles, took my seat at the sale, and noticed the room was only half-full. The atmosphere was gloomy; the mood felt wrong for buying art. Then the sale got underway and began to drone on, seemingly taking forever until the Ruscha appeared. Finally, it was time. The painting opened at $40,000, climbing in $5,000 increments. As I carefully scanned the room, there appeared to be only two bidders competing for it. I didn't raise my paddle, waiting to see if it would hit the low end of the estimate.

At $80,000, a paddle shot up. Then another at $85,000. The bidder who offered $80,000 bid again at $90,000. By her body language, she looked spent. The next bid would be $95,000. I decided it was time to jump in, sensing she wanted to buy it for under $100,000, and wouldn't trump my bid.

As the auctioneer barked, "Do I have $95,000? Any bids at $95,000? I'm going to sell this painting now. Last chance . . ."

That was my cue. I had waited until my competitor thought it was hers, before raising my paddle. Since this was my first bid, anyone experienced knew I was just waiting for the smoke to clear—and that I was probably prepared to go all the way. Within twenty seconds, the prize was mine. Including the ten percent buyer's premium, it sold for a total of $104,500. I called Peter immediately with news of the deal. He was quite pleased, especially when he heard we bought it for under his limit.

The next afternoon, I received an unexpected phone call.

"This is John Berggruen."

I was caught off guard. Berggruen never called me.

"To what do I owe this pleasure?" I said, sarcastically.

He responded, "I must have been distracted last night because I forgot to bid on the Ruscha painting. I heard you bought it. Why don't you sell me a half-share?"

This was a good feeling—John Berggruen wanted something from me. Playing it for all it was worth, I replied, "You know, I have no problem partnering a painting with you but I think I'll keep this one for myself. You understand."

Berggruen sounded disappointed, but there was nothing he could do. Peter Michael got a kick out of the story, which confirmed in his mind that he did the right thing. Today, *Honey* would be worth at least $2 million.

But $2 million is nothing. If you were to analyze the current state of the Ruscha market, you would easily understand why Gagosian could afford to run his international empire. It goes without saying that Ruscha's last show in Chelsea (in 2003) sold out. From what I understand, in 2007 the going rate for a new midsize (sixty-inch by sixty-inch) painting was $600,000. If the painting was complex—let's say mountains in the background, words superimposed, measuring eighty inches by seventy-two inches—you're looking at $900,000. If the show contains twelve paintings that average $750,000 each, that's a gross of $9 million. Since Ruscha supposedly works sixty-forty with his dealers, in his favor, Gagosian would walk away with $3.6 million. While Gagosian doesn't need to discount the work, he probably offers ten percent off to his best customers, just as a courtesy. Deducting another $360,000, he would still be left with $3,240,000. That's how you prosper in Chelsea.

Any way you looked at it, a show of Ruscha's work was a dealer's dream. Not only was the work eminently salable, you could be selective who you sold paintings to. It was analogous to the late 1990s when IPO's were all the rage in the stock mar-

ket. If you were an important client of the firm, you were of-
fered shares in a company about to go public, at an insider price.
Once the stock traded on its first day, it almost always went up.
This meant you could sell it that day for a profit with virtually
no risk. By offering a collector a new Ruscha painting at its pri-
mary market price, Gagosian was giving the collector a gift.
Everyone knew you could immediately sell it for more privately.

Over time, I continued to follow the Ruscha market closely,
looking for a possible opportunity to buy a drawing. On a per-
sonal level, our paths crossed sporadically. A few years ago,
Martin Muller, the owner of San Francisco's Modernism Gal-
lery, organized a small dinner party in Ruscha's honor. He was
kind enough to invite me along with the bon vivant Barnaby
Conrad III, the writer Jonathan Keats, and the museum cura-
tor Robert Flynn Johnson.

The dinner was to celebrate Johnson's recent purchase of
Ruscha's entire print archives for the Achenbach Foundation
for the Graphic Arts. The collection contained over nine hun-
dred prints, including rare color trial proofs. Part of the con-
dition of the sale was that the Achenbach receive a copy of
every print Ruscha did in the future. The deal was brokered
by Anthony d'Offay, the artist's London dealer, for a rumored
$750,000, which now looks like a bargain.

We sat down to dinner at Florio, a small neighborhood
bistro on Fillmore Street. As Muller ordered several bottles of
Chateau Soussans 2000, everyone vied for Ruscha's attention.
Conrad, who once commissioned a silhouette painting from
him of an American buffalo, wanted to reminisce about the
experience. Keats, who was writing an article for *San Francisco*
magazine, was trying to conduct a mini-interview. Johnson was
simply basking in the glory of his latest acquisition. Then there

was our host. Muller, one of the more intellectual dealers in the art world, wanted to discuss doing a show.

I also had an ulterior motive. I had been in London and saw a Ruscha drawing at d'Offay I was interested in buying. Right before the Ribbon Letter series, Ruscha created a small group of works depicting words drawn in script, as if he were signing his name. These were small pictures, averaging ten by eight inches. The one I had my eyes on was from 1966 and called *Ja'tem*. The gallery was asking $45,000 for it. When I discussed a possible deal, the dialogue went something like this:

GALLERY: Where are you from?

POLSKY: California.

GALLERY: Are you a dealer?

POLSKY: Yes, I am. I did a Ruscha show over twenty years ago at my space, Acme Art, in San Francisco. You can look it up in his biography.

GALLERY: I can't sell it to a dealer or an American. The artist consigned us these works with the understanding they would all be sold to important European collectors and museums.

At this point, knowing it was probably a lost cause, I decided to "go for it" and say what was on my mind. While it was bad business to do so, sometimes you grow weary of the hypocrisy. Sometimes, you want the other side to know they're not fooling anyone.

POLSKY: I see. Is that why most of the show wound up back in California?

I was met with silence from the Anthony d'Offay Gallery.

I knew for a fact that the gallery sold many of the drawings to American collectors. Despite Ruscha's importance, and international track record, he was never an easy sell in Europe. My guess was the gallery sold the work to whomever they could. How else could a historically important colored-pencil drawing of a Standard station—that should have gone to an institution—wind up on the walls of Rick Swig's house in San Francisco?

While I planned to sell the drawing in question eventually for a profit, at least I was up-front about my status as an art dealer. I also thought I deserved a little consideration for having exhibited Ruscha's work before he became so popular. But no matter. The deal wasn't going to happen that day.

Now, as I sat across the table from the artist, I caught Robert Johnson's attention. While the others were engaged in animated conversation, I quietly explained the situation at the d'Offay gallery. Johnson listened intently. Then he spoke, "Tell you what—if you want, I can talk to Ed after dinner. My suggestion is if he were to let you buy the drawing, you sign a letter agreeing to keep it for at least five years. That would show good faith, that you weren't just buying it to flip it for a quick profit."

It wasn't a bad idea. And it was certainly generous of Johnson to offer to "run interference" for me. But the more I thought about it, even if Ruscha agreed to it—and that could have gone either way—I didn't like the idea of any restrictions placed on the work. It wasn't that tying up $45,000 would break me, but a lot could happen in five years.

As I ate my roast chicken and French fries, sprinkled with crushed herbs, I couldn't get past the restrictive nature of the deal. I turned to Johnson, thanking him for his support. But by the time the dinner was over, I knew I would have to look elsewhere for a work of art to invest in.

That was then. Rather than call Ruscha directly as planned, I had a change of heart and decided to contact his Los Angeles dealer to see if they had a recent painting I could offer. I spoke with Gagosian gallery director Deborah McLeod, who replied, "Sorry, Richard, everything is in London and it's reserved for the big guys." I started to say something, but caught myself. As Jonathan Novak once said to me, as he spied me blow-drying my hair-deficient head at the L.A. Sports club, "Why bother?"

elbow room

The art world's summertime blues had set in, despite the emergence of a new trend. Virtually every New York dealer was now keeping their gallery open, afraid of missing any potential business, rather than rush off to the Hamptons. Personally, I hadn't noticed any increase in summer activity or sales. That's why I welcomed a call from Tony Fitzpatrick, hoping it might spice things up.

"Hey, man, it's Tony."

"What's up?" I said.

"How's your friend Novak?" asked Tony sarcastically. "I'd really like to buy my piece back from him."

Though there was little to gain, I wanted to stay friends with Tony. "Why don't I give him a call and feel him out."

Two minutes later, I was on the phone to Jonathan.

As we spoke, all I could hear was some sort of crunching noise. Straining to understand him, I said, "I can't hear you. What are you eating?"

After swallowing, he said, "See if you can guess." Then Jonathan took another bite—or perhaps it was a spoonful—of something.

Although it was summer, there was certainly no moratorium on ridiculous art-dealer behavior. Growing annoyed, I said, "I don't have time for this. I want to talk some business with you — not the usual nonsense."

Jonathan swallowed a second time, "Come on — *you have no idea what I'm eating?*"

Deciding to humor him, I said, "Fine, it sounds like granola."

"You're close! I'm having a bowl of Kashi Go-Lean with one-percent milk . . . and lots of blueberries — you know they're antioxidants."

"Look, Jonathan, would you have any interest in selling your Fitzpatrick — if it went directly to Tony?" I asked.

"No way. It's part of my private collection — the living legacy," he said, rather smugly.

"Oh, so that's what you call the schlock that's hanging in your house," I chuckled. "Let me know if you decide to sell it. Tony's a buyer."

By September, the art world was filled with anticipation over what promised to be a wild fall 2006 season. With the November sales rapidly approaching, rumors flew that the auction houses had snagged some amazing property — maybe even works from David Geffen's vaunted collection. Longtime dealers commented on how everything was out of control. But still, no one was willing to go on the record with a prediction of when it would all come to an end.

With stupefying art prices attracting growing media attention, it seemed inevitable that a celebrity would get caught up in the frenzy and do something foolish. So it came as little surprise when casino owner Steve Wynn made headlines. It seemed Wynn had struck a deal with Steven Cohen to sell him his Picasso, *Le Rêve*. Various publications reported that Cohen agreed to pay $139 million. But then, at the last minute, the deal

hit a snag—or hit an "elbow," would be more accurate. Allegedly, Wynn, who suffers from poor eyesight, was showing the painting to some friends and managed to stumble into the Picasso. Somehow his elbow penetrated the surface of the canvas, tearing a hole in the painting.

Wynn tried to see the humor in the act, saying he was glad he did it rather than one of his employees. Cohen found the whole thing less amusing, calling off the deal. While the Picasso was in the process of being restored, Wynn's wife tried to spin the loss, claiming she loved the painting and was glad the sale was scuttled. Not long after, Wynn put in a claim to his insurer, Lloyd's of London, for $54 million, insisting that's how much his painting had diminished in value. Lloyd's didn't agree, so Wynn filed a lawsuit. Eventually, he settled for a reported $40 million.

The Wynn brouhaha and other large deals were so widely reported that they served as a magnet, pulling new buyers into the market. News that people were willing to pay in excess of $100 million for a painting validated the whole concept of buying art for investment. But the real savvy players were the sellers—like the entertainment mogul David Geffen.

With the exception of Geffen, and a few others, there was always talk about why Hollywood never bought serious art. You would think with the industry's level of sophistication, artistic sensibility, and large incomes, forming an art collection would be a natural development. Not so. Collecting important art requires a serious time commitment. You have to educate yourself, which means plenty of reading, developing relationships with galleries, and visiting museums to view the top examples by each artist. It all comes down to seeing as much art in person as possible. The entertainment world's mentality was to want everything yesterday, including an instant art collection.

Part of the reason why Hollywood had such a bad reputation in the art world could be attributed to Sylvester Stallone. With the success of *Rocky*, the actor suddenly had almost more money than he could spend. Encouraged by Jake Bloom, his attorney who also collected art, Stallone made a few small purchases, including a pair of works by Mark Kostabi. During the late 1980s, Kostabi managed to carve out a small but noticeable niche for himself, thanks to his publicity-seeking ways. He painted generic android-like figures, with no faces, and cast them in a limitless number of environments, such as a painting called *Down with History*, a riff on Marcel Duchamp's *Nude Descending a Staircase*.

I recall going to Kostabi's SoHo studio, which you couldn't miss because he hung a large painting outside his window. His place was abuzz with industry, as assistants scurried about, producing hundreds of Kostabis, which sold for as little as $6,500 each. Rather than be ashamed of having others make his art, he reveled in it. When I jokingly said to Kostabi, "It looks like you've covered every subject but dinosaurs." The eager to please artist replied, "No problem, I'll paint you one."

According to the writer Paul Taylor, not long after Stallone acquired his Kostabis, the artist "bit the hand that fed him," claiming in a television interview that "Rocky" was an unsophisticated collector, whose taste ran to "tits and ass." Stallone got wind of the broadcast and exploded. He immediately dumped his Kostabis, saying something to the effect of, "Kostabi's so desperate for attention that he's like a dog who keeps soiling the rug even though he knows he's going to get beaten for it."

Stallone's next move was to start making paintings of his own. Predictably, his figurative works ran to the grandiose and the heroic. Before long, Stallone decided he needed a gallery. The Scott Hanson Gallery in Beverly Hills was enlisted. A flurry of

press releases were sent out announcing a champagne opening reception in Stallone's honor. His publicist earned her fee that evening by claiming that by the time Stallone's cronies arrived at the opening, prepared to do their duty and support Sly, the paintings had all been purchased by *bonafide gallery clients*— despite costing up to $35,000. All of Stallone's sycophants, attorneys, and accountants had to go home empty-handed and patiently wait for the next body of work!

Charged up by the validation his paintings received, Stallone went after bigger game as a collector. He hired Barbara Guggenheim (no relation to Peggy), a well-known art consultant, to advise him on his purchases. Guggenheim wasted no time putting him into a million-dollar work by the overbearing German expressionist painter Anselm Kieffer, who used non-traditional materials in his paintings. Against allegations from friends that he had overpaid, Stallone decided to sell the painting, blaming it on how the canvas kept shedding bits of straw attached to its surface.

Soon after acquiring a Francis Bacon, he grew tired of it too and once again was in a selling mood. Guggenheim accommodated him, making a deal to sell the Bacon to London dealer Anthony d'Offay. But somehow Gagosian got a whiff of the deal and offered Stallone a slightly higher price to sell it to him. Stallone now wanted to accept Gagosian's offer. Lawyers got involved, leading Guggenheim to meet her future husband, entertainment attorney Burt Fields. Fields worked his magic arranging a compromise that was acceptable to all parties, with Stallone wiggling out of the deal with d'Offay and keeping the Bacon.

Still, the damage had been done, as far as the art world's perception of both Stallone and Hollywood's flakey collecting ways. Other than taking Geffen seriously, the few additional

exceptions were his archenemy Michael Ovitz, the late writer Michael Crichton, and the actor Steve Martin — especially Steve Martin. Many of us have seen the famous Annie Leibovitz "in-jest" photo of Martin standing in front of his major Franz Kline, wearing a white suit painted with black Abstract Expressionist brushstrokes that mimicked those of the Kline. But Martin's eye for art is no joke. Over a decade ago, he sold his Kline, a large de Kooning "Woman," and his Richard Diebenkorn "Ocean Park," and began assembling a new collection of paintings composed of small gems.

As for David Geffen, he began his involvement with art early in his career when Ahmet Ertegun, the music producer and aesthete, convinced him to buy a Picasso painting for $36,000 in 1970. Geffen selected *Buste*, a small 1954 abstraction. Not long after, his apartment was broken into and the Picasso was stolen. He received an insurance settlement of $75,000. *Buste* was eventually recovered and offered back to Geffen if he returned the money. Against Ertegun's advice, Geffen kept the $75,000, gloating to his mentor about his profit. The insurance company turned around and put it up to auction, where it brought $130,000. David Geffen learned his lesson. Rather than take the "short" money, he realized art was something you held onto. He then grew serious about collecting. As his wealth expanded dramatically, so did the quality of his collection.

During the 1990s, Geffen began his pursuit of one of Jasper Johns's greatest paintings, *Target with Plaster Casts*. This was the famous icon that hung in the artist's pivotal show at the Leo Castelli Gallery, in 1958. An early visitor to the show was Alfred Barr, the curator of paintings at the Museum of Modern Art. Barr was so overwhelmed by Johns's virtuosity that he immediately agreed to buy two paintings, and expressed interest in a third, specifically *Target with Plaster Casts*. Directly above a blue

and yellow target on a red background, Johns had attached a row of wooden compartments, each filled with actual casts of male body parts; one was a green penis. Each compartment had a hinged lid that could be opened to reveal its contents or closed to hide it. Barr asked Castelli if the Modern bought it, would it would be all right if the museum kept the compartment containing the offending penis shut? Castelli said he'd have to ask the artist.

Johns gave the matter some thought and decided it would be okay to keep the penis hidden part of the time, but not permanently. When Barr learned of the artist's directive, he reluctantly turned down the purchase. In an act of defiance, Castelli bought *Target with Plaster Casts* for his own collection, for $1,200. Many years later, during a market downturn in 1995, Castelli agreed to sell it to Geffen for an unheard of $15 million. Naturally, Geffen worked the financing to his advantage, insisting on paying in three installments of $5 million. It would turn out to be one of his greatest coups.

Meanwhile, in 2006, Geffen decided to unload some of his most valuable pictures, but not at auction. Since he was a multibillionaire, people assumed he couldn't possibly need the money. But the more I studied Geffen's financial history, it became obvious what he was really doing. The press reported he was selling to raise cash for a run at buying the *Los Angeles Times*. Geffen never confirmed this was the catalyst, nor did he deny it. But if you read between the lines, he was selling privately because he sensed this was a moment in time not likely to be repeated. If someone wanted to pay him $140 million for Jackson Pollock's *No. 5*, let him. Why not take $63.5 million for de Kooning's *Police Gazette*? One would have to be a fool not to accept $80 million for Jasper Johns's *False Start*. Overall, he raised over $400 million for a handful of great paintings—and he still

owned plenty of other contemporary masterpieces, including *Target with Plaster Casts*. The bottom line was that Geffen's move was simply smart business.

There was also a fourth painting that Geffen sold, for a stunning $137.5 million—*Woman III*, another de Kooning. The story of how he came to own it provided a fascinating backdrop to the recent pruning of his collection. During the 1970s, the Shah of Iran decided it was time to modernize his country by opening a museum of contemporary art. Once the word was out that the Persians were buying, even Andy Warhol wanted in on it. There is a wonderful account of Warhol's pursuit of the Shah to commission a portrait of himself, in Bob Colacello's *Holy Terror*. Working through a third party, Warhol's staff consummated a deal. Warhol then went into his studio and painted approximately ten forty-inch by forty-inch portraits of the Shah and his wife Farah Diba. As he was just about to ship off the paintings—and get paid—the Shah was overthrown and the Ayatollah Khomeini took over.

It turned out the Shah's curators knew what they were doing. They had bought some outstanding contemporary paintings— including Warhol's *Suicide (Purple Jumping Man)* and the stellar *Woman III*—to fill the museum that was never built. Say what you want about the Ayatollah, but despite his public rhetoric about the decadence of the West, his regime knew valuable assets when it saw them. The regime hung onto the paintings, rather than burn them along with the American flag.

For years the paintings sat in limbo. Then, word filtered out of Iran that a deal was in the works to swap *Woman III* for a set of profusely illustrated historic Muslim scriptures. The details of the deal were hazy. But one day, on the tarmac of the Tehran Airport, representatives of the de Kooning collector and the Iranian government exchanged the scriptures for the painting. The

de Kooning ended up with David Geffen—who, of course, just sold it for a fortune.

I realized I hadn't heard from Andy Rose in a while. Our deal had definitely lost momentum. So, I was pleasantly surprised when he called. Sounding frustrated, Andy said, "Come on, this is ridiculous. There's no one else you can go to? Do you mean to tell me you've actually contacted everyone you ever sold a Fright Wig to?"

There was one person I hadn't spoken with, and that was the owner of a gold Fright Wig. Back in 1989, I had bought one of the greatest examples from the series (that I ever saw) for $45,000. My plan had been to keep it. Unfortunately, thanks to a rapidly collapsing art market, I was forced to sell. Though I sold the gold canvas for $65,000—and was lucky to get it before the entire market fell apart—I knew I'd regret it someday. Regardless, I managed to keep track of it over the years as it changed hands.

I had originally sold the self-portrait to the veteran gallerist Jack Glenn, who turned around and placed it with a private dealer named Frank Daluiso. The painting flipped one more time and found its resting place with a mysterious Los Angeles collector. I say mysterious because no one knew his name. As luck would have it, Novak was friendly with Daluiso and called him at my request to check into its availability.

I reported all of this to Andy, who said, "Let me analyze this a minute. If I'm willing to pay $650,000 for a green Fright Wig— and you say the gold is one of the best—then I probably could see my way clear to paying $750,000 for it."

Pausing, he finally said, "Why don't you have Novak offer him $700,000. He can add $50,000 for himself, plus what I'll pay you."

A day later, I heard back from Novak, "No luck. He won't sell it. I'll bet you're sorry you sold yours."

Then, in an added dig, he said, "I can't believe one of these paintings is worth $750,000. *What did you get for your green one again?*"

the forgotten legacy of Leon Kraushar

Stories about David Geffen, Steve Wynn, and other wealthy individuals who collect the bluest of the blue-chip are one thing. But what about collectors who rolled the dice on artists before they became ensconced in the history books? Going back to the seminal 1960s, the pioneering Pop art collectors were Harry Abrams, Richard Brown Baker, Burton and Emily Tremaine, and Robert and Ethel Scull. And then there was Leon Kraushar, who may have had the best eye of them all.

I learned of his legacy in a rather serendipitous fashion. While most of my business was a result of the diligent pursuit of collectors, every now and then you get a call out of the blue from someone who takes the initiative to solicit *you*. That's exactly what happened when my phone rang and the caller identified himself as Fred Kraushar. The name sounded familiar, but I couldn't quite place it.

Fred contacted me because he had recently inherited a group of paintings from his deceased brother, Howard, including a Dan Douke. Fred initially found my name in the annual *Art in America Guide to Galleries and Museums*, under a listing of

Douke's representatives. After offering me his Douke canvas, Fred casually mentioned his father had been a major collector. I cynically thought, *Where have I heard that before?* One thing led to another and Fred invited me to see some of the things he owned.

Later that day, on my way across the Bay Bridge to meet with him at his Oakland home, I kept asking myself why the name "Kraushar" sounded so familiar. Midway across the bridge, the proverbial light bulb went off—could Fred be related to the legendary Pop art collector Leon Kraushar?

Like a tumbleweed blowing into oblivion, Leon Kraushar came and went with the 1960s. Professionally, he was a self-made man who achieved prosperity as an insurance broker. But that was where conventionality ended. One look at him and you knew this wasn't your basic "Whole Life" salesman. When he was younger, Kraushar was a bit of a dandy, with a penchant for custom-made clothes—especially loud plaids and stripes. He was also guilty of peculiar grooming habits, including shaving his underarms. Even though he never set out to call attention to himself, he managed to do so with his shoulder-length hair, just before the hippie movement made it fashionable.

Back in 1965, he was interviewed by *Life* magazine for an article on collectors, sarcastically titled, "You Bought It, Now Live with It." Kraushar spoke while being photographed in the bedroom of his Long Island home, seated in front of a triumvirate of the greatest Andy Warhols ever painted: *Red Jackie* (Jacqueline Kennedy), *Green Liz* (Elizabeth Taylor), and *Orange Marilyn* (Marilyn Monroe).

Liz was her glamorous self and Jackie was the model of elegant sophistication. But Marilyn was beauty personified. Warhol portrayed her as a goddess with lemon yellow hair, a pink face,

ruby-red lips, light blue eye shadow, and shiny white teeth. She positively glowed against a background of deep, radiant orange. These three, forty-inch-square Warhol celebrity portraits were bought in 1963 from Leo Castelli. I later learned the average price of each painting was $1,800—not an outrageous sum, but real money for work considered vulgar by most of the art establishment.

Kraushar remained undaunted. He ranted to the *Life* reporter, "Pop art is the art of today, and tomorrow, and all the future. It's better than IBM stock. All that other stuff—it's old, it's antique. Renoir? I hate him. Bedroom pictures. It's all the same. It's the same with the Abstract Expressionists, all of them. Decoration. There's no satire; there's no today, there's no fun. That other art is for the old ladies, all those people who go to auctions—it's dead. There isn't any art except right here. I got rid of all those second-raters. Somebody else can have them."

As I knocked on the door of Fred Kraushar's tasteful Arts and Crafts bungalow, I was given a warm greeting by his rambunctious dog, Buddy, and his wife, Susan. Before even shaking hands, I blurted out, "Is Fred by any chance related to Leon Kraushar?"

"Yeah, he was his father," said Susan, matter-of-factly.

Bingo.

As I entered their home and scanned the walls, the only object that betrayed Fred's illustrious pedigree was a framed shopping bag bearing the silk-screened likeness of a Warhol Campbell's soup can. That was it. Surely there had to be something else.

Fred himself walked into the living room, rubbing his eyes after a long shift at the hospital's psychiatric ward, where he worked as a nurse. He was a good-natured man of fifty-five, with

"Brillo-pad" thick black wavy hair, green eyes, and a bemused smile. When I asked him about Leon, he was eager to talk, pleased someone knew about his dad.

We sat down and Fred began filling me in, describing Leon as a private man, uninterested in social climbing like the pretentious Sculls. He loved meeting the artists, but had no interest in joining museum boards or throwing parties to show off his collection. Fred fondly recalled the one and only time Warhol came to his house for a visit. He remembered Warhol was quiet and child-like in demeanor, a man of few words— and very unhealthy looking. Warhol visited that day to discuss the swap of his dad's spare Volkswagen for a blue multi-image painting of Robert Rauschenberg. The deal was consummated, though Fred wasn't sure if Warhol kept the car or gave it to one of his studio assistants.

I asked him, "What was the first piece of Pop art your dad purchased?"

"That's easy. It was a Roy Lichtenstein painting of a woman's hand holding a yellow sponge. When he showed it to my mom, she was unimpressed. As she put it, 'If he wanted to see a hand with a sponge, he could always watch me.' But eventually my mom came around and began to encourage him. Her approval was very important."

Fred continued, "My dad was a bit of a pied piper. As his collection grew, my older brother began to pay attention. My dad preached to Howard and his buddies to start collections of their own. He even lent my brother's friends money to buy art. I remember one loan was used to finance a Warhol *Electric Chair.*"

Besides seminal Tom Wesselmanns, James Rosenquists, and Roy Lichtensteins, Kraushar had purchased numerous works by Claes Oldenburg, including an oversized plaster baked potato.

There was also an extraordinary eight-foot-tall freestanding sculpture by John Chamberlain. But when the movers arrived with a life-size three-dimensional George Segal of a four-member rock combo (complete with a drum kit), Fred knew his days of being able to toss the football around the living room were over.

Fred talked about how a week never seemed to go by without a moving van pulling up in front of the family's home, ready to disgorge the latest piece of cutting-edge art. This weekly spectacle made an impression on the neighbors. They never knew if the Kraushars were coming or going.

I asked Fred about the difficulty of coming to grips with his past and the astronomical value of his dad's collection, had he managed to hold on to it. Surprisingly, Fred confessed there had been a greater dilemma in his life than reconciliation with his father's legacy — he had been agonizing for years over whether to get a tattoo. Eventually, Susan couldn't stand hearing about it anymore and told him to fish or cut bait. Fred finally overcame his fears and went under the tattooer's electric needle. However, as I looked him over, I saw no evidence of its decorative existence.

"So, Fred," I began, "Let's see it."

He looked at me sheepishly. Then he glanced over at Susan, looking for encouragement. Susan nodded reluctantly. A grin crossed Fred's face as he slowly undid his jeans. As his pants slid to his ankles, a large orange and green Japanese koi appeared on his hip. The tattoo was impressive, but still not as impressive as Fred's background.

The obvious question was what was it like growing up in an environment filled with such incredible treasures? Fred handed me some old photographs of the family's home. What struck me was the incongruity of all these masterpieces displayed in the most banal of settings. The space was modern and attractive,

but it was basically an upper-middle-class suburban home. Next, Fred showed me pictures of his family and once again I was struck by how ordinary they looked.

There's a smudged photo of the Kraushars having a meal together. His mother is petting Moe, the schnauzer, his father (with close-cropped hair) is drinking a glass of water and staring off into space, his brother is peeling an apple, and Fred (who looks like he's about thirteen) is sipping a glass of milk, a silver I.D. bracelet dangling from his wrist. If you didn't know any better, it looked like a scene out of *The Brady Bunch*—the ultimate functional family.

What threw the whole equation off were three modestly scaled works of art hanging in the kitchen, all of which were thematically linked to eating. One was an early Wesselmann still life, complete with an ice cream sundae and a submarine sandwich. Then there was an Oldenburg relief of three Popsicles and three ice cream bars, painted in the period's psychedelic colors. The most valuable painting, by far, was a small Warhol diptych of two Campbell's soup cans. Looking at that photograph, where the relatively minor works in that room alone could now buy the owner a small mansion, was mind-blowing.

When I asked Fred if he had any idea at the time of the potential value of these works, he replied, "I always enjoyed the art, but I was barely a teenager at the time. Give me a break! Who knew?"

One person who did know was Ivan Karp. I called him after my visit and asked what was it about Leon Kraushar that allowed him to predict the future of art history with such accuracy. Karp replied, "Kraushar was one of those rare individuals who was born with a 'chemical compound' in his head that allowed him to see with great perception. There are certain people who might

be beasts and monsters, but somehow they get it—they have an uncanny eye for art."

"So you're saying Kraushar was a monster?"

"Not a monster, the guy was more of a Sherman tank. When he ran into the gallery, Castelli hid under his desk."

I asked Karp, "Did he work him over trying to get a discount?"

"No, but he used to show up at the gallery with smoked salmon and literally forced slices of it into Castelli's mouth."

"What about you?" I asked.

"He didn't have to force me—I love smoked salmon!"

"So the salmon was one of his routines?"

"That was part of it. Kraushar was a very high-strung guy—a force of nature. He'd come into the gallery and just start dancing around. It was his way of conducting himself in the world," explained Karp.

In 1967, at the age of fifty-four, Leon Kraushar died of a massive coronary. Ironically, he couldn't get life insurance because of a known heart condition. At that point, his wife was approached by a representative of the German collector Karl Stroher. In order to maintain her lifestyle, as well as pay estate taxes, Mrs. Kraushar allowed Stroher to swoop in and cherry pick the collection, paying approximately $600,000 for the privilege. An educated guess was he paid $25,000 for each of the three Warhol celebrity portraits.

In 1988, Karl Stroher himself passed away. Sotheby's quickly organized a single-owner sale designed to prune some of his Pop gems. On the cover of the May 1989 sale catalog was Oldenburg's *Bacon and Egg*, formerly of the Kraushar collection. In fact, seventeen of the nineteen lots in the sale were once his, including Lichtenstein's *Sponge II*, the painting that got Kraushar started. This three-foot square painting that his wife

once mocked sold for $687,500. The seventeen works with the Kraushar provenance brought $5.7 million.

Then, in 1998, Warhol's *Orange Marilyn* came up for auction at Sotheby's in New York and sold for a fantastic $17.3 million to Si Newhouse. Per square inch, it was the most expensive contemporary painting ever sold at auction (at the time). Today, it could be worth $75 million to $100 million. Better than IBM stock, indeed.

Unfortunately, Fred's mother eventually sold off the remainder of her husband's collection. Worse, when Howard died, he was just coming into his own as a young adult and an art collector. That day, I wound up buying the Dan Douke painting from Howard's former collection. As for Fred, other than the few minor Photorealist works that he inherited from his brother, he received virtually no art from his father's legacy.

When I had told Fred what *Orange Marilyn* brought, he looked up, as if he were conjuring his father's ghost. With a look of resignation, he got up from his chair and walked out of the living room. I yelled, "Where are you going?"

He volleyed back, "To the kitchen—to stick my head in the oven!"

the Landsman connection

i was down in Tucson, taking a short break from the art business. There was something about the town's unvarnished ways that recharged my batteries. I liked to hang out at the Epic Café, a coffee shop whose patrons included everyone from university professors to Hell's Angels. One day, I began talking to a journalist named Curtis Marshall. He was working on an article for the interior design and lifestyle magazine *Wallpaper*. Though the publication was past its prime, it still carried a certain cachet, establishing Marshall as someone in the know.

One thing led to another, as he casually let it slip he once owned a contemporary art gallery in Virginia. I got the impression Marshall also spent a fair amount of time around the New York art scene. Over the next few weeks, we'd run into each other at the Epic. Marshall always listened attentively to my stories about the art business. In fact, he seemed to revel in them.

Then something curious happened. Marshall began to tell me a story that sounded a bit farfetched, given his appearance. Each day he'd appear wearing a watchman's cap—Tucson actually has some cool weather. He often didn't shave, and in

general looked grubby. He was also in desperate need of a dentist—the gaps from his missing teeth made me cringe. Despite being employed, he resembled one of the community's many jobless "desert rats." Yet there was a certain dignity to him. I liked the way he carried himself.

Marshall's tale was about some works of art by Roy Lichtenstein, Brice Marden, Mel Ramos, and other art gods that he claimed to own. My first thought was he probably had a poster or two. Then again, I knew of a collector named Vernon Nikkel, from the little-known Clovis, New Mexico, who owned a multi-image Warhol "Marilyn" painting and a Lichtenstein "Cartoon" canvas. So you never knew.

Marshall told me he wanted to sell his collection. Without appearing too eager, I asked, "What do you have by Lichtenstein?"

Having been in the art business for close to thirty years, I didn't hold out much hope for a worthwhile response. There isn't an art dealer alive who hasn't been tantalized by stories of a Pollock found at a flea market.

Marshall said, "I inherited a group of drawings that once belonged to Stanley Landsman. Do you know who he is?"

I was stymied. The name Stanley Landsman escaped me, even though I prided myself on knowing who all the artists were—especially those who worked between 1945 and 1990. Taking a stab at it, I said, "Did he work during the 1960s?"

"So you know him," said a smiling Marshall.

"Just a lucky guess. Tell me exactly what you have," I said, anxious to cut to the chase.

"It's a great story," continued Marshall. "Do you have some time?"

"Sure," I said, fully committing the next half-hour to a potential B.W.O.T. (Big Waste of Time).

Marshall went on to explain how at the beginning of the 1960s, Landsman was a New York artist who hung out with all the Pop figures, and later the Minimalists. He was even briefly represented by Leo Castelli. Whenever one of his friends came by his studio, he would pull out an eleven- by seventeen-inch sketchbook, and ask his guest to contribute a drawing to it. Apparently, Landsman had a lot of company, as evidenced by the book's approximately forty-five works.

Asking a visiting artist to draw something in the host's book was a fairly common practice. If you've watched the movie *Basquiat*, you'll recall a scene where Jean-Michel Basquiat and his entourage walk into the upscale Chinese restaurant Mr. Chow. Once they are all seated, Michael Chow immediately thrusts a sketchbook into Basquiat's hands. The book had already been filled with works by Julian Schnabel, David Hockney, and numerous other luminaries.

Landsman himself never achieved much recognition. His work was composed of sheets of glass with mirrored disks attached to the surface, creating an optical effect. The work was "far out" quasi-hippie art. Some of the more conservative pieces were suitable for bank lobbies. He once created something called an "Infinity Chamber," lined with two-way mirrors and six thousand light bulbs. It was part of a show in 1970 at a place called the Automation House. Landsman lived a hard and fast life and died at the age of fifty-four in 1984.

Marcia Liberty, one of Landsman's romantic interests, inherited the sketchbook. She was also a close friend of Marshall's. Not long ago she passed away, bequeathing it to him. Marshall felt so devastated by the loss that for two years he couldn't bring himself to evaluate the work. Now, enough time had passed and his own financial needs were such that he had to consider every source of revenue open to him.

Marshall said, "If you have some time, maybe you could come over and take a look. It sounds like you know the art market and could tell me if any of these drawings are worth anything."

I said, "Sure, I'd be happy to—but don't get your hopes up."

The next morning, we met at the café, and then took a short walk to Marshall's house. It was one of those gorgeous Tucson fall days—a local's reward for enduring the city's blistering summers. I entered a small light-brown brick 1930s house, whose interior was decorated with 1960s memorabilia, period furniture, and posters. None of the décor was particularly valuable, but Marshall definitely had taste and style. I thought, *This is starting to look better.*

I sensed Marshall was more interested in sharing his collection with me than doing business. I went with the flow, allowing him to show off his holdings of vintage fabrics, rare art books, and the like. Finally, after about forty-five minutes of preliminaries, he brought out the sketchbook—only it wasn't a sketchbook. It was a loose pile of drawings that had been carefully torn out.

My heart sank when I saw the first one—it was badly water stained and obviously had a hard life. Carefully, one at a time, Marshall began sliding the drawings over to me in chronological order. It turned out the tablet they came from was actually an old ledger book, as indicated by the blue rubber-stamped page number in each corner.

The initial drawing was the most valuable. It was a Roy Lichtenstein sketch, circa 1961, of a generic man pulling a chest expander exercise device across his "pecs." It appeared to be lifted from an advertisement from the back of an old comic book. The drawing was originally done in pencil, and then traced in black ink. It was also signed. On the plus side, even though it was water damaged, it was a drawing the artist clearly put some effort into. Had it been in good condition, I would have con-

servatively estimated its worth at $150,000. In its current state, $50,000 would have been more like it.

Naturally, I got excited thinking, *Maybe I should buy it*. After all, it was a finished work from the 1960s. It was also unusually large for a Lichtenstein drawing. Most resembled the ones I saw in Ivan Karp's loft—the size of a postcard. The "chest expander illustration" also had the advantage of being totally fresh to the market, along with a charming provenance. I could tell Marshall trusted me. If I offered him a check for around $50,000, he would have taken it. While I had confidence in the person I used as a paper restorer, there was a limit to the miracles he could perform. I concluded it would be too difficult to resell and I couldn't risk getting stuck with it.

I said to Marshall, "I'm impressed. It's a shame that it's damaged. Did it get caught in a downpour?"

Marshall shrugged, "Who knows? That's the condition it was in when I inherited it."

He continued to pass me sheets. Most were by artists who long since faded into obscurity. Many bore signatures I didn't recognize. Then I came upon one by Brice Marden, from his "Suicide Notes" series. It was a densely worked black ink drawing of a rectangle filled in with crosshatched lines. If it wasn't water stained, it would have brought around $35,000 at auction. A few pages later, I came upon Mel Ramos's donation—a circa 1969 portrait of Landsman emerging from a yellow Chiquita banana, complete with its classic blue peel-off label. Again, had it not been traumatized, the early Ramos sketch would have been worth $25,000.

I said to Marshall, "This is a real slice of art history that would make a terrific gallery or even small museum show. But you'd have to frame all forty-five drawings, which would be expensive."

Pausing to consider a course of action, I continued, "If you're open to breaking it up, and want to sell the Lichtenstein drawing,

I might be able to make a deal with the Roy Lichtenstein Foundation. They're flush and like to buy smaller things of historical interest. But like I said, its value is limited because of its condition."

Marshall nodded, "That would be fine. See what you can do. I'll make you a laser print of it and a few others. And let me know if you find any more information on these artists and their connection to Stanley."

I said, "I know Mel Ramos. He lives in Oakland. Maybe I'll give him a call and see if he remembers making the drawing."

I had met Ramos in the early 1980s when I was working for Foster Goldstrom Fine Arts. We commissioned him to do some paintings for the Southland Corporation. Although Ramos's career was stuck in neutral, at the time he was considered a Pop artist in good standing. He made his reputation by painting cheesecake nudes, often resembling *Playboy* bunnies, which he would juxtapose next to a commercial product, such as a woman hugging a giant Coke bottle or lying on top of a huge Velveeta cheese box.

Ramos's painting technique was flawless. His love for applying thick strokes of oil paint came from his teacher, Wayne Thiebaud. Just like Landsman, Ramos was also briefly associated with the Leo Castelli Gallery—showing through the goodwill of Ivan Karp. From 1963 through 1967, Ramos produced significant paintings that landed him in the art-history books. Then his work changed. He began combining nudes with wild animals—a pairing that didn't go over well with collectors. His canvases became repetitious, skirting that fine line of becoming a parody of themselves.

When I originally met Ramos, he was probably ripe for a comeback. One afternoon, he visited the Goldstrom gallery and

stayed until closing time. He turned to me and said, "You want to grab a beer? I really don't feel like dealing with bridge traffic." I quickly responded, "I have an idea—why don't you come over to my apartment for a drink?"

Ramos agreed and the next thing I knew, he was seated in my living room, prying off the cap of an ice-cold Rolling Rock. What made things really special was I had a date that night with a woman who was an art-history major. I originally asked her to stop by my place, before taking her to dinner. She walked in and I introduced her to Ramos. It was all done casually, as if it were no big deal having a world-famous Pop artist in my modest studio apartment.

After Ramos left, she looked at me and said, "I'm impressed. How do you know Mel Ramos?"

"He's just another artist friend of mine. Maybe I'll invite Jasper (Johns) over the next time he's in town," I said, knowing I was full of it.

Years passed and I kept in touch with Ramos. During the early 2000s, he enjoyed a revival. He began taking risks with his art. Ramos's vintage work started bringing strong prices at auction. Commissions began flooding in from collectors who wanted sexy portraits of their wives. Perhaps the real breakthrough occurred when the Gagosian Gallery included him in a show of the Pop collection of John and Kimiko Powers. Ramos was a standout.

When I reached Ramos to get a reaction to his sketchbook page, he said, "I don't exactly remember drawing that banana, but I do remember Stanley. He was a real 'cocksman'—he always had lots of women."

Amused by his remark, I said, "While I have you on the phone, I want to congratulate you for having one of your paintings break $1 million at auction. It must feel great."

Ramos sounded on top of the world and said, "Yeah, when my friends like Warhol began bringing $15 million at auction, I thought it was my turn."

I got off the phone and then called the Roy Lichtenstein Foundation. I was put through to Jack Cowart, its director. He greeted the news of the long-lost drawing with considerable joy. I explained the owner was interested in selling it and quoted him a price of $45,000. Since I didn't have a jpeg, he asked me to FedEx the laser print. Once Cowart received the image, he called back and asked that the actual drawing be sent on approval. While he made no promises, I sensed we already had a deal.

Still in hot pursuit of a Fright Wig painting for Andy Rose, I played a hunch and called Christophe van de Weghe, and said, "I meant to tell you how much I enjoyed your Warhol Self-Portrait show—great catalog."

"Thanks."

Then I came to the point, "I have a serious buyer for a twelve-inch Fright Wig and noticed you had a pair in your show owned by the same collector—a green one and an orange one. Any chance of calling him to see if he'd consider an offer for one of them?"

"I could try but it's going to be tricky. What would your client pay?" asked Christophe.

"He'll go to $650,000."

"Okay," he said. "I'll offer $600,000 and make $50,000—it's not much of a profit. But I guess if it's only one phone call . . ."

I laughed to myself, $50,000—*not much of a profit.* To put that figure into perspective, the most money my father ever earned in a year was $40,000. On the other hand, this was the art world. It wasn't Christophe's fault he came from an elite

family in Belgium. In fact, the family used to own a casino whose walls were decorated with murals done by Rene Magritte. So I guess Christophe could be excused for not being "blown away" by my offer.

As I waited to hear back from him, I did my best to keep Andy at bay. I loved his enthusiasm but was having a hard time convincing him the art market moved slowly. It was all about patience. Andy was an aggressive deal maker. His point of reference was developing commercial real estate. While securing permits and city approval for projects was undoubtedly daunting, at least there was some structure to the process.

Not so in the art market. Andy was starting to get a taste of its Byzantine ways. While the numbers he worked with in real estate were bigger, the egos he dealt with in the art world certainly weren't any smaller, as he was starting to find out. From what I understood of his business, acquiring key properties might elicit satisfaction, but it was more a game of finance than emotion. People who bought paintings were a different breed. They became so attached to their collections, they often posed for photographs with their pictures—*as if they had painted them.* And perhaps in their own minds they actually had.

bye bye Fernwood

I t was a new year and with it came the promise of abundance: more art deals, more record prices, and more outrageous behavior. Since it was January 2007, the art world was in recovery mode. The previous month, it reached a state of exhaustion thanks to the Art Basel Miami fair, and its amoeba-like seven or eight offshoot expositions. Basel Miami was the last leg of the art fair marathon. And believe me, you and your bank account had to be in shape to participate. Collectors chased today's trendiest artists, while trying to convince dealers of their worthiness as buyers, only to be told, "Everything is sold." After receiving their share of abuse, they'd go back the next day and do it all over again. Hey, collecting art was hard work.

That's not to say the dealers had it easy. Those who couldn't get into the main fair found themselves scrambling for space. Some were so desperate, they actually rented shipping containers that had been plopped on the beach by an enterprising show organizer. You can only imagine what it was like looking at art inside one of these metal boxes, with the broiling heat of the Miami sun bearing down on it. No matter. If you were a gallerist,

you were thrilled to participate — regardless of how ridiculous the venue.

Art Basel Miami's predecessor was Art Miami, which ran during the desperate 1990s. The fair was owned by David and Lee Ann Lester (who eventually sold their interest), an eccentric couple who would have given the Goldstroms a run for their money. David Lester was known for driving a golf cart up and down the aisles of his fair, stopping every few moments to schmooze an exhibitor. He was always selling. Lester would say to Jonathan Novak, "You need to sign up for my European fair — you know Polsky's doing it." Then he'd find me and say, "I hope you're planning to sign up for Europe — you know Novak's doing it." Once, on a dare from Jonathan, I stole Lester's beloved cart and took off with him in close pursuit. When he caught up with me, rather than get upset, he said, "All will be forgiven if you help me convince Novak to do Europe."

Recently, the Lesters launched Seafair, a floating gallery aboard a luxurious 228-foot mega-yacht. The highbrow concept was for Seafair to stop in wealthy "ports of call," where collectors could make appointments to view the art. After a few trial runs, even the rich apparently balked at the pretension. Never one to give up, David Lester told the press that Seafair was currently retrenching and would be back.

One thing the art market always looks forward to is tallying the auction numbers from the previous year, and the results were in from 2006. Artnet wrote that over 2,800 records were set during the fine art sales of October and November. Of that total, seventy-two of the records were for paintings which sold for over $1 million. By comparison, during the spring 2006 sales, there were 1,650 records broken, along with forty-five record prices of $1 million or more. Among a myriad of statistics, Artnet

recounted how David Geffen had unloaded $426 million worth of art. Steve Martin sold a Hopper for $26 million. The incredible numbers droned on: $40 million for a Gauguin, $87 million for a Klimt . . . it had been quite a year.

A few months later, a story in the *New York Times* gave every indication the gravy train would continue. In a front-page feature — probably the first ever about art that wasn't an obituary — a journalist chronicled a day in the life of a rabid art buyer. The article profiled a new collector by the name of Susan Hancock. Her story made her sound like she was a participant on one of those reality television shows. Accompanied by a paid art adviser, Ms. Hancock went shopping at the spring Armory show in New York. As she queued up for the opening of the fair, amidst plenty of pushing and shoving, the suspense mounted. What would she buy? How much would she spend?

We soon found out. Hancock's first purchase was a work by a little-known Japanese artist, Aya Takano. She dropped $70,000 on the painting, happily pointing out that actress Cameron Diaz was buying her work too. Then Hancock spent another $60,000 on a sculpture by the up-and-coming Gary Webb that resembled a giant painter's palette. She was quoted as saying, "You could put your head through it" — as if this were a key criterion for successful sculpture. A few hours and $230,000 later, she took a break for coffee. As a reader, I needed a break, too.

The *Times* writer went on to mention how Hancock admitted "she often couldn't remember the names of the artists she is buying." But apparently she could recall what the art was worth, bragging that a painting by Lisa Yuskavage, an established painter of buxom female nudes, which she paid $75,000 for a few years ago, was now valued at $850,000. As the article wound down, we followed Hancock's progress at a Sotheby's sale, where she was thwarted in her attempt to buy a Christopher Wool for

$450,000. Beforehand, she pleaded to her adviser not to let her go any higher. Oh, well. The story concluded with a quote from her: "There is always another art sale."

As a self-made person—Hancock and her ex-husband sold their database company, presumably for a lot of money—she certainly earned the right to spend her winnings and enjoy her life. You could also appreciate the pleasure Hancock derived from her newfound social life: cocktail parties at collectors' homes, a seat on the Whitney Museum's acquisitions group, and lots of travel on the art fair circuit. For better, and probably worse, Susan Hancock had become an icon for the current art market phenomenon, exposing the myth that collecting art was a rarefied activity. The truth was that anyone could buy their way in.

I placed another call to Christophe van de Weghe.

"Hi, Christophe. Any progress on the Fright Wigs?" I asked, hopefully.

"Sorry—the guy who lent the small ones to my show doesn't want to sell."

Venting my frustration, I continued, "Look, I know for a fact there are at least fifteen small ones in existence—maybe as many as twenty-five . . ."

"There's really nothing else out there. I've even called my contacts in Europe. Maybe something will turn up after the auctions," said Christophe, signing off.

While sales were rising and records were breaking, Fernwood Art Investments, a high-profile art investment fund, was having trouble attracting investors. Back in 2004, Bruce Taub, a former Merrill Lynch executive, announced the formation of Fernwood. This, in and of itself, was not news. Over the decades,

there have been numerous attempts to pool art into mutual funds for the rich. With the exception of the British Rail Pension Fund, all others either failed or wound up with poor returns.

Start-up art investment funds love to cite the success of the British Rail Pension Fund. They quote how they averaged an 11.3 percent compounded rate of return, from 1974 to 1989. What they don't tell you is that the fund made all its money on a minute percentage of their art picks—supposedly all the profit was made from only one percent of the art. The real story is that the fund succeeded, where others failed, through a combination of a little skill and a lot of luck.

The British investors bought Impressionists during the 1970s and sold them at the absolute peak in the late 1980s. It was a textbook example of buying low and selling high. Everything went their way. Yet, while an eleven percent annual return is nothing to sneeze at, it becomes less impressive when you consider the wild run-up in prices in 1989. They should have made a lot more than eleven percent—and would have had they not bought so much other deadwood.

Fernwood claimed it could do better. In a series of press releases, it announced it was going after high net-worth individuals with at least $5 million to invest. In order to attract capital, Fernwood hired a high-profile staff made up of former auction house personnel. Taub declared there would be two funds: one would buy up everything from Old Masters to contemporary art, and the other would pursue opportunistic situations—presumably taking positions in deals guaranteed by auction houses. Taub said he was looking to raise $100 million to $150 million.

Seasoned dealers laughed to themselves when they heard this. I know I did. Making money in the art market is not a matter of running facts and figures through a computer. It's about an intuitive feeling for quality and what will endure. Even though

common sense dictates you buy blue-chip art, you still have to pick the right examples. It takes years of experience and plenty of mistakes to learn the subtleties of each artist's market. Though Fernwood could counter this statement by pointing to its veteran staff, art investing rarely works when decisions are made by committee. Collecting art is not a democratic process.

The other reason art investment funds are doomed to failure is an inability to look beyond the obvious. When you're running someone else's money, you often make conservative investment decisions. If your picks aren't profitable, you always have an out by telling your investors, "Look, how would I have known Microsoft would go down? It's always performed well." Even if you were a fund manager with a daring vision, you'd have a hard time finding investors who would buy into that vision.

There are exceptions, of course. In theory, you could have a fund that buys emerging artists. But no one really buys emerging artists. You're buying artists who have actually emerged. If you buy a new hot name, like Dana Schutz, she's already showing with a name gallery, which in turn is selling to name collectors. She's also being actively traded, which means she's not cheap. A fund that pursued true emerging artists would have to find them before they found gallery representation. That means trying to ferret them out the hard way—meeting artists, listening to their tips, and so on. Usually, it's too work intensive for a nondenizen of the art world.

If your fund buys blue-chip art exclusively, it is competing with everyone else who does the same thing—the multitude of international collectors, dealers, and even museum curators. There's not enough great art to go around, so you're going to pay a lot for it. A fund manager would also be competing with the Mugrabis of the world—speculators who have been doing it for years. You might say, why not hire one of the Mugrabis or

another mega-collector to run your fund? The answer is you couldn't pay them enough. They don't need you.

It came as no surprise, then, when months later the *Art Newspaper* ran an article announcing the demise of Fernwood Art Investments. By May 2006, it was out of business after only two years in operation. Now it was being sued. Fernwood was able to raise only $8 million, and none of it ended up in the art market. Despite numerous media attempts to contact Taub and get his side of the story, he was nowhere to be found. Dealers joked perhaps he was hanging out with Michel Cohen, who was last seen in Rio de Janeiro.

I was back in Tucson, enjoying some downtime before the spring season began. One day I went to the Tucson Museum of Art to look at a show of Mexican retablos. These were small paintings on tin, depicting saints, which hung in people's homes as objects of worship. Many were a century old. They were considered folk art and highly collectible. After enjoying the show, I wandered into a gallery filled with Western art. At first glance, everything seemed clichéd. There were oils of Indians on horseback, cowboys on cattle drives, and paintings of the desert in bloom.

As I continued to look, I was able to see beyond the obvious. Many of these pictures had one thing in common—color and light indigenous to the area. I dug deeper and learned that many of the landscapes were painted outdoors, directly from nature. Art historians call this "plein air" painting. When an artist works outside, he has to work quickly because conditions are always changing. A cloud can pass overhead darkening part of the foreground. Sunlight can fade, blurring the horizon. Wind can make it difficult to concentrate. The upside is how the natural light inspires an artist's palette. If you're good, you can capture the landscape's true colors with a few dashes of brushwork.

"Plein air" painting is a spontaneous distillation of the moment, resulting in a "pure" painting. Think Van Gogh's final work, *Wheatfield with Crows*.

Later that day, I came upon a shop on Fourth Avenue called Arroyo Designs. The interior was lined with handcrafted mesquite furniture. The workmanship was exquisite. The tables and chairs were influenced by the Arts and Crafts movement, yet they were remarkably contemporary. Circling the walls was a group of "plein air" landscapes. Each small study was displayed in the genre's typical gold-leaf frames. The landscapes depicted were nothing out of the ordinary. Instead, it was all about how they were painted. A mesa's red rocks glowed, as if the light source came from within. A sunset captured the fleeting moment that illuminated a distant mountain range and "called" it forward. A desert storm darkened the sky in the immediate foreground, while patches of blue stealthily crept up from behind.

The painter's name was Bill Anton. I left Arroyo Designs feeling refreshed, wondering why couldn't most of today's contemporary artists leave me with the same feeling. Maybe I would be better off buying an Anton—even though he was a Western artist. The fact that Anton's prices were reasonable reminded me that it was still possible to find an emerging artist to invest in. Or maybe I needed to go to the other end of the spectrum and pursue a deserving older artist who never received recognition. For that matter, I probably should have been looking at women artists, many of whom have been undervalued for years.

That was the thing about the art world, it was youth-oriented and male-dominated. I began to think about past instances in recent art history where a noteworthy female artist was either overlooked or had a burst of initial success and promptly faded from view. The name that came to mind was Lee Bontecou. She was the only woman artist to show with Leo Castelli during

the 1960s. For that matter, other than the Minimalist painter Agnes Martin, the lyrical abstractionist Helen Frankenthaler, the sculptor of organic forms Louise Bourgeois, and the constructivist sculptor Louise Nevelson, Bontecou was one of the only women to show *anywhere* then.

Dating back to the macho Abstract Expressionists, women were rarely taken seriously as painters. There's a memorable scene in the movie *Pollock*, where Jackson Pollock visits Lee Krasner's studio for the first time. As he wanders around her space, carefully inspecting her work, he says to her, "Hmm, you're a good woman painter." Although the female audience in the movie theater let out a collective groan, Pollock had not been condescending. Quite the contrary. By the standards of his day, he was paying her the highest compliment.

This was the world Lee Bontecou stepped into when she emerged during the early 1960s. Her ferocious abstract wall reliefs, often ovoid forms with dark cavities, were composed of welded steel rods, wire, and raw canvas. The work certainly didn't look "feminine." Had the viewer not known her gender, he would never have guessed that Bontecou was a woman. In other words, her work stood on its own merits. It was just art.

At the end of the 1960s, Bontecou took what turned out to be a thirty-year break from exhibiting, preferring to teach, and virtually disappeared from the art scene. Much has been written about what motivated her to give up a promising career. Some claim it was due to the poor reception that a new body of work, composed of vacuum-formed fish and flowers, received. Other stories ranged from devoting her time to being a mother to throwing her support behind her husband's unsuccessful efforts to make it as an artist. Bontecou's self-imposed exile was the art world's loss.

But Bontecou never quit making art. In 2003, the UCLA Hammer Gallery in Los Angeles brought her back from obscurity by organizing a show of never seen before post-1960s work. The exhibition traveled to the Museum of Modern Art in New York, where it opened to rave reviews in the *New York Times* and other publications. Much of the work consisted of intricate, almost surreal drawings. There was also a smattering of free-hanging organic forms. The successful reception the new imagery received also led to a surge in prices at auction for Bontecou's vintage wall-reliefs.

Aside from Bontecou, I had trouble turning up another overlooked woman artist whose art I could catch on its upward trajectory. The names of female artists that I came up with were so obscure, they weren't considered auctionable. As I continued to ponder the possibilities, my thoughts drifted to the secondary market. Soon it would be April. We were only six weeks away from what promised to be the grandest auction season of all.

made in Los Angeles

Since living in Santa Monica during the last boom, I continued to stay in touch with the Los Angeles scene, frequently visiting the area's galleries and artists. Though it had obviously grown over the years, there was still a fundamental sense of inferiority—Los Angeles remained the number-two art center in America. It would never compete with New York. However, it wasn't the City of Angels' fault. The local zeitgeist is dominated by Hollywood. Art was part of the social fabric of the city, but was unlikely to share the film's industry's media supremacy. Gossip about movie stars was sexier than stories about artists.

Once I arrived, I pulled into the circular drive of the Beverly Hills Plaza Hotel situated on mid-Wilshire—about as central a location to the galleries as you could find. I checked in about an hour before my appointment with the painter Chuck Arnoldi. I wanted to take a look at his new work down at his studio, and I hoped to find something I could sell.

Chuck Arnoldi was one of a small group of L.A. painters ripe for market exploitation. Beginning his career during the late 1970s, Arnoldi's early work instantly won a large collector

following. His breakthrough came when he discovered the wonderful linear quality of tree branches. Soon, he was joining together eucalyptus branches, forming rectangular compositions that resembled maps from vanished cultures. Once he slathered them with paint, they took on a beauty that was both contemporary and primitive—a combination that was hard to beat.

At the top of the list of viable Los Angeles artists to deal, however, was the German-expressionist Roger (pronounced Ro-jay) Herman. Outside of David Hockney, he may be the best natural painter in the entire city. As a full professor at UCLA, Herman was certainly connected. He also used to show at the notorious Ace Gallery, under the auspices of Doug Chrismas, a controversial dealer with a deadly eye. Chrismas had a history of doing museum-quality shows, while also pissing off the wrong people, such as Andy Warhol.

Herman's exhibitions at Ace were a genuine art experience. Thanks to Chrismas's meticulous installations—he would rehang a ten- by fifteen-foot painting if it was off by an inch—you would walk into a room full of Hermans and leave a "better person." It was as if Herman were able to channel the German art gods, like Max Beckmann, and imbue his work with their power and authority.

Roger Herman was also a charismatic personality. Tall, blessed with a boyishly handsome face and a pleasing German accent, Herman attracted plenty of female admirers. You might say he drove women crazy. I remember the time the painter Sabina Ott was after him. According to Herman, one night, at a bar, she grew jealous and slammed Herman in his groin with a pool ball. But his charm wasn't gender specific—men also responded to Herman. They identified with his strong masculine presence and enjoyed his company.

Herman had a reputation for being generous. Many years ago,

he began a series of erotic ceramics. He gave me a black-and-white glazed bowl as a gift and explained I should fill it with candy. As the candy disappeared, a design on the bottom of the bowl was gradually revealed. Soon, you got a rude surprise—a woman with her legs spread apart.

I remember once having lunch with Herman and Arnoldi at La Serenata de Garibaldi, an expensive Mexican restaurant in a grungy neighborhood. The two rivals eyed each other warily. They were both respected artists, but polar opposites as painters. Arnoldi's work was cool and detached. Herman's work was filled with passion. As they continued to make small talk, you could read their minds; each thought he was the superior artist. But when the check came, they quickly fell into agreement— the dealer always paid.

I felt it was only a matter of time until Roger Herman received his due in the art market. But there were no guarantees. Why Mike Kelley and Paul McCarthy were being bid up at auction, and Herman and Arnoldi weren't, was beyond their control. It was probably a matter of meeting the right people. As Arnoldi often said, "All you need is one major advocate."

As I drove past the Rose Café and Gold's Gym in Venice, I soon found myself at the Arnoldi studio. His impressive space was camouflaged behind a graffiti-strewn gray facade. Regardless of escalating real estate prices, you never forgot you were in a ghetto. I was buzzed in, wondering if my Honda Civic would still be there when I returned. Then I thought of Jonathan Novak, who would consider losing my vehicle to be a blessing. I could just hear him saying, "Great, now you can buy a *real* car."

Chuck Arnoldi stood there, shoulders slouched from his morning workout. Things had changed. Gone was the usual cocky expression on his face—along with my tendency to pro-

voke him. Maybe we both had matured. He greeted me warmly, "You made it. Good to see you, man."

Now sixty years old, Arnoldi was making some of the best work of his career. Not necessarily the most salable, but his switch from wood to linen had been the right decision. His paintings were juxtaposed canvases that formed one complete painting. They were covered with colorful oval forms that had been squeegeed while wet, which caused the shapes to attract and repulse each other, creating a striking surface tension.

I looked over his inventory, setting aside two particularly good paintings. Then we agreed on prices and discounts. Once we finished, I said, "Did you know your Warhol 'Skull' painting is worth a lot of money?"

Back in 1987, Arnoldi had called me for my opinion on a trade he was considering. Charles Cowles, his New York dealer, owed him $35,000 from a recent sale. Cowles proposed Arnoldi take a Warhol Skull painting (since he owned two) in lieu of payment. Arnoldi wondered what I thought. Without hesitation, I told him he should make the deal. If for no other reason than Warhol had recently died and there weren't going to be any more. Arnoldi took my advice.

That day at his studio, I told him I could sell it for $1 million.

"You're serious?" he asked, reeling back with shock.

"Yeah, I've got someone in New York who'll pay it," I said, envisioning my $50,000 commission.

Still stunned, Arnoldi said, "Let me think about it. I'll have to talk to my accountant and get back to you."

With that, we took off for lunch at Rockenwagner, which had just opened a café on Abbot Kinney. Our meal was filled with the usual chatter over escalating Venice real estate prices. Once we finished, and Chuck had paid—things really had

changed—we got into a discussion about injustices in the L.A. art world.

Arnoldi said, "Did you hear about that Paul McCarthy? The one with a bear having sex with a stuffed rabbit? You know what it brought at auction? Close to a million! Man, you might as well drive a stake through my heart. Who buys this shit?"

It was a good question. "Made in Los Angeles" art had come of age, at least at auction. Along with McCarthy, John Baldessari (photomontages) and Mike Kelley (assemblages that often commented on adolescence) had become art market stars. Whether they deserved it was another question—a question Arnoldi was now voicing. The art market had become desperate for new material. Since the aforementioned artists had local credibility, primarily as influential teachers, speculators smelled money and took action. I told Arnoldi to be patient, his turn would come.

After we had coffee, Arnoldi said to me, "I saw where you dissed Eli Broad in the *Los Angeles Times*. Think that was the smartest thing to do?"

He had a point. As most people know, Eli Broad is the wealthiest collector in America. He is also a civic-minded individual, frequently throwing his support behind significant Los Angeles cultural endeavors—the Frank Gehry–designed Walt Disney Concert Hall and the L.A. County Museum of Art, to name two.

Arnoldi was referring to an article in the paper about the city's big-name collectors. Flattered someone requested my thoughts on the topic, I gave the reporter what he wanted—a controversial remark. I told him that although Broad had the city's largest and most diverse holdings, I would rather own David Geffen's comparatively small collection.

I explained how Geffen acquired true masterpieces, whereas Broad had more of an accumulation. Granted he owned some wonderful things, and certainly gets credit for being early on

Basquiat. Yet Broad's collection always felt bloated, feasting on the obligatory names. Geffen was far more focused and selective, targeting individually superior works. To use a variation on an old Joseph Duveen (the godfather of art dealers) quote, "Broad had the mountains, but Geffen had the peaks."

As Arnoldi ordered an espresso, my cell phone went off. Normally during lunch, I switch it over to "vibrate." For some reason, I forgot to do it and it rang. I saw it was from Christophe van de Weghe and quickly said to Arnoldi, "I hate to be rude, but I've got to take this—give me five minutes."

I went outside and answered, "Christophe, what's going on?"

"Hi, Richard," he said, in his suave "hard to place but somewhere from Europe" tone. "Remember when I asked the collector who lent the small Fright Wigs to my show if he'd sell one, and he said no? I just spoke with him and he might be willing to sell now. Is your collector still interested?"

"You bet."

"Fine. What will he pay at this point?"

It was a good question. With less than a month to go before the May 2007 sales, everyone was hedging their bets. My sense was the Fright Wig owner was open to selling one painting, hoping to cover both his upside and downside. If he got a good price before the sale, and the auctions were flat, he made a good deal. If he sold one now, and the auctions spurted to the next level, he still had a painting in reserve.

Making a snap judgment, I said, "My guy's still motivated to pay $650,000, net to you, which means you're back to your $50,000 profit."

"That's okay," answered Christophe. "Let's see what he says. I'm not promising he'll sell, but I know he's interested in some other paintings and might be willing to work something out. Do you have a color preference?"

"See if you can get the green one. I prefer it to the orange," I said, signing off.

I glanced behind me, making sure Arnoldi was occupied. He was—an attractive woman stopped by our table to say hello to him.

I called Andy Rose, "Hey, you're not going to believe it, but I think I've got something going on a Fright Wig." Then I momentarily panicked, "You're still in, aren't you?"

"Yeah, of course I am," said Andy, with his usual intensity. "Tell me what you've got."

"Christophe's client—the collector who lent the two small Fright Wigs to his show—might have changed his mind about selling. I'm trying to get the green painting and told him we'd still pay six-fifty, right?"

"Sure, I remember they both had good 'screens.' When will you know?"

"I can't say. We just have to hang in there."

I returned to my table and noticed Arnoldi was winding up a cell phone call of his own. He finished and said to me, "That was my accountant. I don't think I'm going to sell the Skull. After paying taxes, I'd be down to just six hundred, maybe six-fifty. Besides, I don't need the money."

With a sinking feeling, I nodded, "I understand. But I'm telling you, this is a moment in time. Even after the tax bite, that's still a lot of money."

"Maybe if I wait it'll be worth $2 million in a year," grinned Arnoldi, his old swaggering ways resurfacing.

I just rolled my eyes. Arnoldi lived through the last crash. I recall how he struggled to sell paintings. Yet now that he was doing well—through selling art and real estate investments— he was cavalier about $1 million. It made me wonder if I raised the offer to $2 million, would he have demanded $3 million? Arnoldi was hardly alone in his belief the market would go

nowhere but up. He and the other true believers lacked the perspective of my investment banker friend Rick Dirickson, who warned me, "These boom periods run longer than anyone expects—but so do the crashes."

The next morning, I began the day by browsing an L.A. collectibles shop called Urban Cowboy. After looking at some remarkable shooting gallery targets from an old carnival, I thought about how expensive contemporary art was by comparison. Amidst the clutter of folk art and memorabilia were these beautiful cast iron forms—lions, squirrels, and owls. Many had vestiges of their original paint. Others were pocked with a wonderful surface of BB-gun dents. Most of the targets, mounted on black metal bases, were priced at $750. That would barely buy you a frame for an Arnoldi painting.

My thoughts drifted to Bill Anton's cowboy art. Seeing all of these wonderful objects made me think about how authenticity transcended genre or art classification. I found the nearest café and went online, hoping to learn more about Anton. What I discovered was that he was born in 1957, and grew up in Chicago. Upon moving to Prescott, Arizona, he fell in love with the West and had an epiphany. He bought a ranch and made the commitment to paint full time. Judging by his photograph and artist's statement, Anton lived the life he painted. He appeared wearing a black Stetson, looking very much the iconic cowboy himself. Anton was quoted as saying, "My work is *not* about the 'cowboy.' It is about how I feel about the West. The work is about mood and passion."

As I scrolled through images from his archives, I became convinced that he was the real deal. While most Western paintings begin to look alike after seeing a roomful, none of Anton's paintings conformed to a formula. They really *were* about mood

and passion. Many artists who work from nature are capable of making convincing paintings. However, there is a difference between painting a cowboy on horseback in a realistic manner, and going beyond that to convey what the artist actually *felt* when he painted the scene. Bill Anton could do that.

From Urban Cowboy, I was off to lunch with the dealer Kay Richards. As we sat down to eat, we initially avoided talking about art. It was always more productive to make fun of our industry. Kay got the ball rolling by saying, "I heard a good one: What does an art dealer say when you ask him how much is two plus two?"

"What?"

"Depends if I'm buying or selling," she laughed.

We finally got around to discussing business. Dealers usually open a conversation by asking, "You got anything for me?" But Kay and I were beyond that. Experience with one another taught us to be specific. With that in mind, she asked, "What are you looking for?"

I came straight to the point, "Right now, my top priority is a twelve-inch Fright Wig."

I was almost sorry I said anything. I was already in touch with all the top Warhol dealers in the country, and none of them could find anything. Only Van de Weghe offered a glimmer of hope.

That's why I was dumbfounded when she responded, "I may know of a pink one."

"You're kidding," was all I could manage.

"No, I'm not. I was just offered it. Is your buyer serious?" she asked.

"Absolutely," I said. "See if you can get an image. My guy makes quick decisions."

"Great," said Kay, adding a dash of pepper to her eggs. "Let me tell you what I'm looking for . . ."

• • •

The following day, I got up bright and early and drove over to Il Fornaio for breakfast. As I observed Doug Chrismas, sitting in a booth at the back of the restaurant, I received a call. I didn't recognize the number on the caller ID, but the voice was familiar. It was Kay Richards.

"Any word on the pink Fright Wig?" I asked.

"Well, I've got good news and bad news. The bad news is the painting isn't pink," said Kay with a touch of embarrassment in her voice.

"So what's the good news?"

"It turned out there were two of them," she said.

"Really?" I said. "What color are they?"

"*Green* and *orange*."

Could it be? Given the limited number of Fright Wigs out there, these were obviously the paintings Christophe was tracking. The question was how did Kay ace out her competitor?

"Great," I enthused. "Nice to have a choice."

Before I could say another word, Kay spoke, "There's just one catch . . ."

what's another fifty (thousand)?

There's always a catch. I've never done an art deal of substance without having to overcome an obstacle. Some problems are reasonable and can be solved with a little creativity. Others are so absurd that you can't even address them—yet you have to if you want to make a sale. My favorite was the time a corporate curator, who shall remain anonymous, insisted we fly to Jamaica. Ostensibly it was to look at paintings by Rastafarian artists—he was trying to add an exotic touch to the collection and wanted my advice. The truth of the matter was he wanted to experience the local ganja firsthand, while letting his company underwrite the junket.

Kay Richards's "catch" fell somewhere between the reasonable and the absurd.

"So what's the problem?" I asked with trepidation.

"Your collector would have to buy both paintings. The owner won't sell just one," she said. "It's not that big of a deal . . ."

Obviously, Kay couldn't see the face I was making. If she could, she would have seen an art dealer with a worried expression. *Not that big of a deal?* It was hard enough to sell a single

expensive picture. Andy Rose was a collector, not a dealer. He wasn't looking to inventory work.

I took a deep breath, and replied, "You're sure your guy isn't flexible?"

"Positive," she said. "Tell you what, call your client and explain to him how Warhol's art is about the multiple-image— he'd be better off hanging two in his home so he could have the full Warhol effect."

At this point, Kay began laughing, knowing how ridiculous she sounded. Her comment broke the tension, as I laughed too. I asked, "So what's the lucky number? How much are they?"

"I need $1,625,000—that includes me."

"Sounds high."

Kay responded, "What do you mean? I was able to get him down $50,000 from $1,675,000."

All I could say was, "Fine, I'll let you know. But it's going to be tricky."

Rather than dwell on the problem, I decided to play up how I accomplished the impossible. Not only did I produce a Fright Wig, but I had gone a step beyond and secured two. All Andy had to do was write a check. When a collector buys million-dollar pictures, it's not a matter of money. If someone can afford to spend $1 million, they can afford $2 million. Psyching myself to think big, I began to focus on selling the pair.

Now that Andy knew how rare they were, there were a number of compelling reasons for him to buy them. He could keep the better of the two and eventually auction off the other. If the market kept going, a profit was a foregone conclusion. Knowing Andy had two daughters, he might want to give one to each of them. As wild as that sounds to people with ordinary incomes, the wealthy do things like this all the time.

I reached Andy at his office, having almost forgotten he actually works. His secretary put me through, "Hi, Andy. Are you sitting down?"

"Ri-chid?" he said with his Boston accent. "You found a painting?"

I thought, *Here goes,* "Not 'a' painting—two paintings!"

"What? What are you talking about?"

Now that I had his attention, I shifted into to full art-dealer mode, "Remember Christophe's green and orange Fright Wigs— the ones he couldn't produce? I was recently down in Los Angeles and had lunch with the dealer Kay Richards, who told me she now controls them."

Andy was all worked up. He interrupted me, "How much does she want? Maybe I'll buy them both!"

Pausing to make sure I heard him correctly, I thought, *That was easy.* Then I said, "I'm glad you're open to that possibility because that's the only way we're going to get them. Kay said the owner would only sell them as a pair."

"So how much?"

I thought, *Now for the close,* "You're looking at $1,625,000— plus my commission."

Andy reacted by saying, "Can we get them for less? Are they open to an offer? You know in real estate . . ."

Now it was my turn to interrupt, "This isn't real estate. You've been offered something we haven't been able to find for over six months. Granted, you have to buy two. But the main thing is these are both first-rate Fright Wigs. We've both seen them in Van de Weghe's show, so we know they're good."

Andy said, "Agreed. Let me think for a moment . . . Just one question: what do you honestly think each one is worth right now?"

Without hesitation, I said, "Based on their quality and scarcity, I would say $850,000 apiece."

"All right," he said, "Let's do it. Make the deal, subject to inspection. I need to move some money around, but tell her she can have a check once we've seen the paintings."

I was ecstatic. I had pulled it off. Not only did I come through for my client, but I was on the verge of a sweet commission. As I tried to reconstruct the deal in my mind, I traced it to pure serendipity. If I hadn't had lunch that day with Kay, this never would have happened. What made the whole thing unlikely was how Kay was not known for dealing iconic Warhols (though she did sell a Marilyn Reversal). She was more of a force in the Basquiat market. It was no knock against her, but she never was on my list of dealers to contact for a Fright Wig.

My deal with Andy was a microcosm of a typical art transaction. Just when you think you have it figured out, an opportunity comes out of left field and humbles you. But at the moment it was hard to be humble. I felt like celebrating. Many dealers treat themselves to an expensive new toy, like an SUV. During the 1980s, more modest dealers were content with a pair of Belgian shoes. Now you bought Pradas.

Meanwhile, I made arrangements to have the paintings inspected at Crozier's warehouse in New York. For a hefty fee, Crozier's provides a small showroom for dealers and collectors to examine a painting in privacy. They also take care of the uncrating, hanging, and lighting of the work. A dealer provides his own insurance. Crozier's is also known for housing paintings from the Andy Warhol estate.

A date was set for the viewing. Andy Rose decided he would send his wife Meryl to look at the paintings. As he put it, "She has the better eye." I booked a ticket to meet her in New York the following week. It was a shame we were getting together only days before the big auctions. The thought of running back to New York didn't thrill me. But with a large deal at stake, it

was worth getting on a plane before either party changed his mind.

When I purchased a ticket, I also bought another to fly to Tucson, which was rapidly becoming my second home. I now had a girlfriend there and wanted to spend time with her before auction week. Forty-eight hours later, I left L.A. and was on my way to Phoenix. Once I arrived, I rented a car and drove 110 miles to Tucson. This was actually the most expedient way to get there from the Bay Area. As I cruised down Highway 10, and approached the "Old Pueblo," the city's three semi-tall office buildings came into a hazy focus. They looked like Bill Anton painted them. Although it was only May, the temperature hovered in the nineties, with the promise of triple digits soon to come.

Soon, I arrived at my girlfriend's house. Her name was Kathryn Marshall, but she went by Kay Martian — don't ask why. She was the antithesis of an art dealer: Kay drove a pickup, shot a mean game of pool, and drank Tecates with lime and salt straight from the can. This was one woman who never would have coerced me into selling my Fright Wig. Once I unpacked, I headed to my favorite hangout, the Epic Café. I brought my Apple laptop along, planning to check my e-mail for a confirmation from Crozier's. After greeting some old friends at the café, I went on the Internet and sure enough, everything was all set for viewing the Fright Wigs.

Feeling restless and distracted, I decided to go for a walk down Fourth Avenue. Before long, I found myself passing Arroyo Designs. With Bill Anton's "plein air" landscapes on my mind, I ventured in. The air conditioning blanketed me, providing a cool rush. A woman behind the desk waved. After so many years of being ignored by disinterested receptionists in New York galleries, it was refreshing to feel welcomed.

I said, "I just want to take a look at the Anton paintings."
"Sure. He's pretty amazing, don't you think?"

Surrounded by a nucleus of gorgeous mesquite furniture, I moved to the perimeter of the room and saw my favorite painting, *Rain on the Mesa*. Because of the gold frame's wide borders, and the small dimensions of the canvas, I felt like I was looking through a very private window. I stood back about seven feet. Now that I was growing near-sighted, the imagery blurred slightly, even at that short distance. The upside was my eyesight now blended the colors together, creating an even richer viewing.

Whatever Anton experienced working outdoors that day, he got it right. If you've ever watched a desert storm unfold, you're familiar with how the clouds sneak up from out of nowhere. They swiftly transition from white, to gray, to dark gray, to almost purple—a certain malevolence hovers in the air just before the heavens open up. Anton's painting captured that perfect moment. Directly behind the storm clouds, there was a flicker of blue sky, trying to break through. In the middle ground, Anton laid in paint that formed a red rock mesa, capturing the distinctive geology of Northern Arizona. Finally, the artist created a foreground of juniper trees, providing a vantage point to view the cloudburst. Anton's painting captured not only what the mind already knew, but what it hoped to see some day.

I approached *Rain on the Mesa* for a closer look. Upon inspecting the surface, the clouds, mesa, and trees disintegrated into a mess of brush strokes. There was absolutely no definition. It was all about the temperature of color. The artist worked with a deliberate economy to nail down the essence of the scene, striving for a basic accuracy without seeking perfection, but somehow achieved it. Having seen more paintings than I can remember during my lifetime, I couldn't get over how he did it.

Bill Anton's work was analogous to Chuck Close's most recent work. In Close's case, he created incredibly realistic giant portraits. Only upon "closer" inspection, they broke down into a mosaic of abstract patterns—spirals, dots, and dabs. But once you stood back from the canvas, your eyes took their cue from Close's brush strokes and kneaded everything together. The result was something akin to magic. The difference with Anton was that his was a "slow" art. While Close hit you instantly, Anton's work opened up gradually, like a fine bottle of wine.

Feeling invigorated, I left the gallery and returned to the Epic. The auction catalogs had arrived the day before I left the Bay Area and I intentionally brought them with me to savor in Tucson. As usual, the catalogs were massive. Since Sotheby's opened the week of sales, I turned to its volume first. On the cover was a powerful Francis Bacon portrait of a seated Pope. Already, there was talk among the trade that you were looking at the first $50 million Bacon. But that wasn't Sotheby's only big gun. Even more potentially valuable was its Mark Rothko painting.

The Rothko, known as *White Center (Yellow, Pink, and Lavender on Rose)*, belonged to none other than David Rockefeller, the last living son of John D. Rockefeller. Although he was ninety, David Rockefeller was still a fixture on the New York social and philanthropic scene. A desire to donate the painting to the Museum of Modern Art triggered the sale. The story being circulated was Rockefeller offered his classic 1950s painting to MoMA as an outright gift. Since MoMA already owned five Rothkos of comparable quality and period, it gently turned down the donation.

Rockefeller decided to test the market. He received an auction estimate of around $40 million, but was advised it could easily go higher. With that in mind, he signed a contract with

Sotheby's, receiving a whopping guarantee of $46 million plus a percentage of the profit if it exceeded that. Rockefeller announced he would donate whatever money the painting brought, and part of it would go to MoMA. The best part of the story was he paid only $10,000 for the Rothko when he bought it in 1960. Initially, he wasn't a fan of the painting and acquired it only because an astute adviser pressured him. In a recent interview, Rockefeller talked about how the painting grew on him and that he came to love it.

After an hour of examining catalogs, I decided to save the day sales for another time. Once an afterthought for the evening sale crowd, they had become important in their own right. Now they were chock full of million-dollar paintings. As a result, serious collectors and dealers could no longer afford to "blow them off." It was only a matter of time until the *New York Times* recognized this and began running articles on the day-sale results.

As I contemplated the auctions further, my cell phone rang. It was Kay Richards.

"I've got bad news."

Judging by the nervous tone of her voice, I knew she meant it.

"The owner changed his mind about selling the Fright Wigs, unless he gets another $50,000."

Then Kay went off on a monologue: he's being coerced to put them up to auction. Sotheby's said they'd bring a huge price. He was unhappy about giving me a discount.

I was oblivious to what I was hearing. I knew I was screwed. And I definitely wasn't looking forward to calling Andy Rose and giving him my "Houston, we have a problem" speech.

no secrets in the art world

are we all set for the viewing?" asked Andy Rose with enthusiasm.

I came straight to the point, "I don't know how to tell you this, but the owner of the paintings—not Kay—wants an additional $50,000 or he won't sell them."

Then I paused, allowing him time to absorb what I was saying, and added, "I feel awful about this. But I can't control these people. Maybe if . . ."

"Forget it," yelled Andy. "I'm out!"

I thought, *I can't say I blame him. But if I can keep him talking and let him get his anger out, maybe I can still salvage this.*

"Look," I said. "The owner's obviously a greedy asshole. But it is what it is. Let's take a deep breath. Hypothetically, what if you went through with it and paid his price? It would cost you $1,675,000, plus me, and still leave you close to the $850,000 per painting we talked about."

Andy would have none of it, "I hate your business. *It's worse than real estate.* How does someone agree to a deal and then

wake up and decide he wants more money? I resent this whole thing. It's not worth it!"

Despite his rantings, I could tell the gears in Andy's mind were turning. He was recalibrating the deal. We had come this far and it was hard to turn back.

At that moment, I instinctively knew I had to make a strong move of my own. I needed to show I was on his side. With no prior thought, I blurted out, "I'll tell you what. If you go ahead and buy these two paintings at the higher price, I'll agree to forgo my commission until we sell the second painting."

Andy immediately jumped in, "Now *that's* interesting. So you're saying I don't have to pay you your five percent until we dispose of the other painting."

"Exactly," I said, while wondering if I was crazy. "If these Fright Wigs look as good as I remember them, I'm comfortable with letting you pick the better of the two and then selling the other one, in order to make my commission."

While I obviously didn't want to have to sell the same painting twice to earn my money, there didn't seem to be any other way. It was that or have the deal fall apart.

He said, "You really think we can sell the other at a profit?"

"I'm pretty sure. All those major Warhols coming up to auction—like *Green Car Crash* and *Lemon Marilyn*—will push the market up. Even if *Green Car Crash* only brings the low end of the estimate ($25 million), it will set a record for Warhol—and boost the prices on the Fright Wigs."

"You know," said Andy, "the owner is a complete asshole for reneging, but I'm going to ignore that for now. Let's go through with the viewing. Tell them we'll pay their price."

• • •

The next day, I was back in the Bay Area. While finally looking over the day-sale auction catalogs, I received a call from the painter Dan Douke.

"Hey, Dan, how's it going?" I asked.

"Everything's good. I've got a new piece under way—a group of four mailbox forms," he said. "I painted them to look like metal but they're made out of canvas, with a little resin."

"Do they hang on the wall or are they free-standing?" I asked.

"They'll be installed on the wall in a straight line, kind of like a Donald Judd 'Bull Nose' sculpture," he explained.

"Send me a jpeg when it's done. It sounds like it would be perfect for the Diricksons," I said.

"I'll do that," said Douke. "But I really called to ask whether that story about you arm wrestling Chuck Arnoldi is true?"

I had to laugh. I attended a recent dinner at Bix in Arnoldi's honor, following a show of his new paintings at Modernism in San Francisco. The restaurant's slick interior was designed to feel like a 1920s jazz supper club, lending a dignified touch to the dinner proceedings. I was part of a contingent of twelve, seated at a long table. During the course of our meal, Arnoldi was bragging how his golf instructor told him his swing was so powerful that if he was younger, he probably could have played professional baseball.

I shook my head and made a barely audible derisive comment, which Arnoldi heard and obviously didn't appreciate. Having had a couple of martinis, I foolishly started provoking Arnoldi, finally challenging him to arm wrestle.

Arnoldi cried out, "Let's put some money down!"

"Fine. How much?" I yelled back. I figured I was in deep and might as well go for it.

"One hundred dollars—right now!"

Our carrying on had attracted the attention of the whole table, including our concerned host Martin Muller. My good buddy Barnaby Conrad III also looked on. I quickly caught his eye. My facial expression said it all; I was pleading with him to get me out of this. But Conrad, a writer in the macho tradition of Hemingway, wanted to see it happen. He asked Arnoldi to flex his biceps. Conrad then felt the one closest to him. His eyes grew larger. Arnoldi's religious workouts at Gold's Gym had paid off. Then Conrad turned to me, "He's pretty strong."

Conrad patted Arnoldi's muscle again and egged me on, "Go for it, bet him. It's only a hundred bucks."

I was doomed. I was about to waste one hundred dollars.

"Come on!" yelled Arnoldi.

"Maybe this isn't such a good idea," I muttered.

Just then, our entrées began to arrive at the table and just like that, I was off the hook. Knowing I was safe, my bravado returned. I felt like Barney Fife on the old *Andy Griffith Show*, as I said to Arnoldi. "Yeah, well maybe another time."

He chortled to himself, "You'll never beat me."

As I came to the end of the story, Douke said, "I wish I would have been there—that must have been hysterical."

"Yeah, I don't know what it is about Chuck. He just brings it out in me," was all I could say.

Later that day, I heard from Andy Rose. He had urgent news, "You're not going to believe this—there's an orange twelve-inch Fright Wig coming up to auction in London next month. Someone consigned it to Christie's at the last minute, but nobody will know about it until the catalog comes out."

"So how did you find out?"

"Christie's knows I'm in the market for one so they called me."

"That's useful information," I said.

"And wait until you hear the estimate," panted Andy.

"Yeah, how much?"

"Are you ready for this? Four hundred thousand to 600,000 pounds—about $800,000 to $1.2 million," he said. "We've got to get those two paintings before they find out!"

Two days later, I was on a flight to New York to meet Meryl Rose and view the Warhols. Arriving a few minutes early for our appointment at Crozier's, I ran into two private dealers I hadn't seen in years—Jim Jacobs and Peder Bonnier. We spent a few minutes outside catching up, when Peder said, "You know, Jim and I are renting a space here—just a little office to show paintings and house some inventory. Would you like to see it?"

"I'd love to but I'm waiting for a client," I said.

Just then, I saw a cab pull up. Out stepped Meryl Rose. I hadn't seen her for a while and almost forgot what she looked like. That day, she was decked out in the latest fashion, including a large pair of Chanel sunglasses. After greeting her, I had no choice but to introduce Peder and Jim. Ever charming when there was an attractive woman around, Peder grinned, "When you're done with your viewing, why don't you come by."

Meryl said, "Okay, that would be fun."

I knew Peder meant well, but I saw his invitation as a distraction. Meryl and I needed to stay focused on the business at hand. With that in mind, the four of us climbed the steps and entered the soot-covered brick warehouse.

Meryl's cell phone rang. She looked down at the number and said to me, "It's Andy. I don't want to talk to him yet—we just got here!" Then she let the call go to voice mail.

Once we were inside the lobby, I saw the two Fright Wigs hanging in an open room next to the front desk. Employees

wandered through the space. Phones were ringing. So much for privacy. I made a mental note to shoot Kay Richards. She had offered to pay for the viewing and was obviously saving money by agreeing to hang the work in a public area.

Peder and Jim followed Meryl and me into the room. I thought, *I can't believe these guys are joining us. Now the whole art world will know what I'm up to.*

It was too late to do anything about it. Turning my attention to the paintings, I stood back about five feet, as Warhol's spooky face bore down on me — in duplicate. I looked over at Meryl. There was a big smile on her face. I could tell she was thrilled.

Peder spoke first, "These are really good. If you don't buy them, I will!"

Jim Jacobs concurred, "Yeah, these late self-portraits are terrific. How much are they?"

Making a face, I cut Jim off, "I can't comment on that."

"Sorry," he said.

Meryl's cell phone went off again. She looked at it and winked at me. Smiling and shaking her head, she let it go a second time.

Then I took each painting off the wall to inspect them closer. I noticed the green one was missing a speck of paint — literally no bigger than the letter "a" on this page. The orange one had a bit of discoloration in the black background. I pointed out the two areas that disturbed me to Meryl.

She asked, "Is that a problem?"

Peder barged in, "That's nothing! You can't even see it."

Jim looked too, and remarked, "*Are you kidding?* These are in *great* shape. They're all like that. I used to watch Warhol work. He'd lay the paintings out on the floor. Then he'd use his foot to nudge one — sometimes he'd kick it. Paintings got scuffed all the time. That's how he worked."

While I already knew this, it helped having someone knowledge-able verify it, especially in front of the client. Peder and Jim's intrusion turned out to be a lucky break. Once I turned each canvas over, and confirmed they had authentication stamps from the Warhol estate, I was fully satisfied. So was Meryl. Then as a courtesy we took a look at Peder and Jim's space. The two longtime partners had some great things, including a rare Robert Ryman painting.

After chatting with them a bit longer, Meryl turned to me, "Let's talk about what *really* matters. Where should we go for lunch?"

I laughed, "I'm glad you have your priorities straight. Let's go to Pastis. It's in the neighborhood."

We hailed a cab. As soon as we got in, her cell phone rang. Predictably it was Andy. This time she answered. I overheard his anxiety-filled voice, "Well? I'm going crazy. What happened?"

Meryl said, "The paintings are great. I don't know which one I want to keep. Maybe we should keep both. It's going to be hard to choose."

She handed me the phone, "Hi, Andy. Personally, I prefer the green. But the orange one might bring more on the open market. Collectors usually like intense colors."

Andy could barely contain himself, "I've got some news for *you*. I just spoke with Christie's. There's a lot of interest in their Fright Wig."

"Really?"

"Yeah, they spoke with a few other clients after calling me and they're saying there's a good chance it will bring the high end of the estimate—or go over."

"When do the catalogs come out?" I asked.

"Next week."

"Whoa—we better move on this," I said.

Almost shouting, Andy yelled, "Tell Kay I'll wire the money first thing tomorrow. We can't lose these paintings!"

buy high, sell higher

At long last it was auction week. With Sotheby's due to open the May 2007 festivities, it was doing everything it could to ensure the success of the "Rockefeller Rothko"—and thus the overall success of their sale. Sotheby's took out a two-page, full-color spread in the *New York Times*, promoting the masterwork. The ad was as eye-popping as the painting's colors, particularly the deep pink. Dealers whispered it was an attempt to counter Christie's separate catalog approach to Warhol's *Green Car Crash*. Regardless, the battle for auction supremacy generated excitement in anticipation of a record-setting week.

There was talk about whether the ever-increasing buyer's premium, which seemed to go up with every sale, would inhibit bidding. At twenty percent on the first $500,000 spent, and twelve percent on anything above that, the auction houses were raking it in. Shrewd players recognized this and took advantage. Sellers of multimillion-dollar properties were asking for—and getting—a piece of the buyer's premium. Rockefeller almost certainly received those terms, in addition to not paying a seller's premium, which had also just been increased.

Meanwhile, I received a call from Andy, "Richard, the Fright Wigs just arrived. Oh, my God! I hung them and they look incredible! Even my kids like them!"

"That's great news," I said.

"Did you ever hear anything from Christophe van de Weghe? Was he pissed?" asked Andy.

"You know, I've been afraid to call him and find out," I responded.

"By the way," said Andy. "I just sent you a check for $10,000 — sort of a down payment on the future success of our deal."

"Hey, thanks a lot. I really appreciate the gesture," I said with delight.

Moving on, Andy asked, "So are you ready for the big sales?"

"I don't know if ready is the word. But I'm certainly looking forward to the Warhol results."

"Me too," said Andy. "I want to see what the little Maos do. I figure they're the best comparison we've got to the Fright Wigs. When you think about it, if a twelve-inch by ten-inch Mao brings the usual million-plus, what does it make our paintings worth?"

"Well, in some ways, they're hard to compare," I said. "The Maos were done back in 1973. They're historic at this point. But then again, given there are probably as many as ten baby Maos for every small Fright Wig, a Fright Wig should be worth at least as *much* as a baby Mao — and eventually more."

"I totally agree," said Andy.

Later in the week, Tobias Meyer, Sotheby's premier auctioneer, took his place in front of a packed house. There was talk Meyer was losing his edge. Although considered the heir apparent to Christopher Burge, Meyer's presence seemed less commanding. From what I could gather, it looked like he was spending too much time socializing and not enough on the

bottom line. Then again, just as a football coach is only as good as his players, an auctioneer is only as good as his material. Though Sotheby's had some wonderful items, Christie's had the stronger sale.

What much of the public doesn't realize is that a good auctioneer not only knows how to squeeze every dollar from a sale, but also understands how to "set up" a sale before it happens. During the week before the actual event, Tobias Meyer (who's also Sotheby's worldwide head of contemporary art) spends his time contacting likely buyers for the most expensive pictures to be auctioned. If Meyer and his staff have done their homework, he pretty much knows what's going to happen before the first lot comes up. Since evening-sale seats are assigned, he can consult a seating chart, knowing where to look for bids on each lot. This allows him to conduct a sale with confidence, which becomes infectious and spills over into the general audience.

Meyer opened that week's evening sales with the words, "Lot number one—the Elizabeth Peyton portrait *Craig*." Before you knew it, the painting had sold for $384,000. What struck me as remarkable was that *Craig* was only fourteen inches by eleven inches—a minor sketch by an artist who had barely proven herself. Yet it exceeded the price paid for my Fright Wig, sold only two years earlier. From there, the auction went from strength to strength, until it was finally time for the Mark Rothko. The Bacon had already brought $52.6 million.

All eyes were now on *White Center (Yellow, Pink, and Lavender on Rose)*, installed up front near the auction podium, like a purebred pet waiting for adoption. It was about to find out where it would reside, after over forty-five years of hanging in David Rockefeller's office. That evening, Rockefeller watched the sale from the comfort of an auction room skybox. You had to wonder what was going through his mind. If forced to guess,

I would say something along the lines of "that was the best $10,000 I ever invested."

Tobias Meyer opened the bidding on the Rothko at $33 million—already a new high for a contemporary painting. Then he began raising the bar in million-dollar increments. Until then, $500,000 jumps had been the most I ever witnessed. The Rothko soon found its future home. The buyer paid $72.8 million—a world record for a work of contemporary art. Sotheby's relentless marketing campaign had paid off. All told, Sotheby's set a record for an evening contemporary art sale—a whopping $254.9 million.

As they say in sports, records are meant to be broken. Only most records in the athletic world usually last longer than twenty-four hours. Not so in the current art world. The next night, Christie's sale tallied $384.6 million, obliterating Sotheby's ephemeral high water mark. If the after-sale mood at Sotheby's was one of joy, then the after-sale vibe at Christie's was pure bliss.

The first indication that Christie's was in for a big night was the early triumph of Marc Newson's *Pod of Drawers*, a cabinet of exquisite design and materials, which sold for $1 million. Newson has become the most prominent name in the burgeoning new auction house category "Design." This record price confirmed Newson's reputation. Christie's had succeeded in stretching the contemporary art market to include high-end "art furniture." Was "art jewelry" next? Dealers who worked with these remarkable artists/artisans were licking their chops at the thought of what the future now held for them.

The Newson sale was only the preliminary. As Christopher Burge called the audience's attention to lot number fifteen, the auction room grew quiet. After watching the Rothko set a record, everyone probably shared the same thought—were we about to

witness a new one? *Green Car Crash* would soon provide the answer.

Burge started the Warhol out at $16 million, raising the ante by $500,000 bids—a less aggressive ploy than Meyer's $1 million raises the night before. The painting seemed to have found a buyer at around $60 million. Then Larry Gagosian yelled out "Bidding," causing a collective case of whiplash in the room. What had appeared to be the painting's closing act turned out to be only an interlude. Alas, Gagosian lost the painting. The eventual buyer, whose identity was not revealed, paid $71.7 million—only $1.1 million off the Rothko record.

As for the small Maos, they performed admirably. Four examples appeared on the auction block, averaging $1.2 million. If Andy Rose's theory was correct, about a small Mao being worth the equivalent of a small Fright Wig, then the deal we made was a winner.

As patrons filed out of Christie's, I overheard someone say, "This has to be the peak. It can't possibly go any higher."

Then I heard a familiar voice from behind me say, "Hey, Polecat, let's grab some dinner. I have some business I'd like to discuss with you." It was my friend Barnaby Conrad III.

"Where do you want to go?" I asked.

"Let's go to Demarchelier," he suggested, referring to a restaurant in the East 80s that we often frequented together. The food itself was so-so, but we enjoyed the scene. Besides, it gave Barnaby a chance to practice his French.

Over a round of martinis, a bottle of wine, two steak frites, and after-dinner drinks, Barnaby mentioned he was considering selling his Ed Ruscha silhouette painting of a buffalo. Naturally, he wanted to know what I thought it would bring at auction. His picture, while attractive, wasn't quite what

Ruscha enthusiasts preferred—a painting with at least one "word" emblazoned on it.

Barnaby seemed disappointed when I said, "I think you're looking at $750,000—not bad considering you paid only $60,000 for it."

Looking glum, he said, "I wouldn't sell it for less than a million."

"That's fine—it's your painting," I offered. "Maybe it *would* bring a million at auction. But if you want to sell it privately, and not wait six months for the next sale, that's all I think you'll get."

"Let me sleep on it," he said. "I might have you put it up for me next May, when prices should be even higher!"

Here in a nutshell was what was wrong with the art market. It was a lose/lose scenario. If I had given in, and told my buddy what he wanted to hear, I would pay for it later when I failed to get him what he expected from a private sale. If I told him the truth, and stuck to my guns, he'd run to the auction houses. If Sotheby's or Christie's agreed to give the painting an unrealistic estimate, just to secure the consignment, the painting would likely pass and both seller and auction house would wind up losing. If this happened often enough, the art market would collapse rather quickly.

As auction-goers discussed the post-sale successes and failures, almost no one wanted to talk about the state of the American economy. The stock market was stronger than it had been in years. Real estate remained stable—at least in the Bay Area and New York. Regardless, there were always doomsayers. They pointed to problems with subprime loans and the vulnerability of mortgage companies and banks that held these loans. The theory was mortgage defaults would have a negative ripple effect on the entire economy. There was also talk of inflation. Led

by the upward movement of fuel prices, businesses were afraid the prime rate would rise. If the art market was looking for excuses to fold, they could be found. But at the end of the day the buying went on.

Andy Rose was certainly optimistic. He called me to discuss selling one of the two Fright Wigs. We considered various options: a private sale, placing it in the next auction, or hiring an auction house to broker a deal with a big collector—what's known in the trade as a "private treaty" sale. As the conversation ended, Andy disclosed he had set up a meeting at Christie's. Now that it was public knowledge an orange Fright Wig would appear in London, the auction house saw possibilities with Andy's paintings. He was on his way to New York to hear what Christie's had to say.

Not long after, he called me and came straight to the point, "Christie's offered to buy the orange painting outright for $1 million. *Can you believe it?*"

"Wow," was all I could say.

I was caught by surprise. I hadn't been aware Christie's was buying individual paintings. While I certainly knew auction houses occasionally bought collections, as well as guaranteed art they auctioned, speculative purchasing of single paintings from collectors was a new wrinkle—in effect Christie's had become an art dealer. Quickly analyzing its offer, I concluded it was splitting the estimate of what the London Fright Wig was expected to bring ($800,000 to $1,200,000).

With visions of receiving my commission, I said, "Sounds like a good offer. Did you take it?"

"I'm thinking about it, but a million dollars just doesn't sound inspired," said Andy.

"What do you mean?" I countered. "It would allow you to accomplish your goal—and then some. The idea was to end up

with a single Fright Wig. This gets you off the hook of owning a second one, you make a profit of over $100,000 in only ten days, and the value of the painting you keep just went up by $150,000. If you look at it that way, you just made $250,000."

"I know, I know," laughed Andy. He was clearly enjoying the permutations of the potential transaction.

"It shows you," I said, "that we made a solid deal."

"Look, I know you'd like to be paid but I'm going to turn them down," said Andy. "Don't worry, you and I will work something out."

I placed a call to Ivan Karp, hoping to check on the status of *Sugar Tit* — the John Chamberlain I coveted — now worth over a million dollars.

His greeting was characteristically blunt, "Now what?"

"Is that any way to talk to someone who wants to put money in your pocket?" I joked.

"My pockets are already bulging," he laughed.

"I heard a rumor you were ready to sell your Chamberlain to me. Any truth to it?"

"Polsky, you know I never deal in rumor — only in the unvarnished truth. And the truth is I will send you a signal when I'm ready to part with it."

Playing along, I queried, "What sort of signal might I expect?"

"A smoke signal wafting across the country from SoHo to San Francisco — like the Indians used to send each other," said Karp, not missing a beat.

I reflected on how Karp reminded me of my dad, who recently passed away — not so much personality-wise, but more in terms of background. They were born the same year, raised in the Bronx, fluent in Yiddish, and so on. Once, I was in O.K. Harris when I blurted out, "You could be my father." Marilynn

Karp, an art history professor at NYU, was standing at her husband's side. Known for her caustic tongue, she cut in, "He could be, but he's not!"

I felt a touch of poignancy over the old guard. Allan Stone, the last link between the Abstract Expressionists and the Pop artists, had died earlier that year. I had always admired Stone's pioneering taste in art. Anyone involved in the scene during the 1980s would visit his gallery and leave mesmerized. Every square inch of Stone's space was crammed with Chamberlain sculptures, African masks, Thiebaud paintings, old wooden barbershop poles, Cornell boxes, and even the occasional shrunken head. There were so many objects on Stone's Bugatti desk that when you sat across from him, you played a game of hide and seek to look him in the eye.

Over the last few years, even Stone's sense of adventure was fading. Not long ago he was quoted as saying, "Let someone else pull the plow." Of the old guard, Irving Blum was still going strong. But for me, Ivan Karp was the true keeper of the flame. His life has been a lesson in how to appreciate the diversity of the visual world. When he once filled his gallery with primitive handmade wooden washboards, he taught us there were wonderful objects all around us. All you had to do was look.

I wondered: when Karp was gone, who would grab the torch and become the art world's next patriarch?

too much is not enough

as the dust settled from auction week, Sotheby's continued its offensive with a series of full-page ads in the *New York Times*, offering actual credit cards. It had struck a deal with MasterCard that would allow clients to use Sotheby's card for various perks: free admission to art museums, invitations to Sotheby's events, and reward points with every purchase redeemable for "unique experiences in the arts and beyond."

The first ad depicted a black-and-white photo of Andy Warhol having dinner with his friends, including the writer William Burroughs. Below the nostalgic picture was a color reproduction of the credit card, decorated with Warhol Marilyns. The next day, Sotheby's followed up with another full-page promotion, running a photo of Frida Kahlo and Diego Rivera. This time, the credit card was illustrated with a self-portrait of Frida.

I contacted MasterCard and was told membership was only eighty-five dollars a year. Then I was pitched on how I could use the points I accumulate for a hot air balloon ride over wine country in California—or the Swiss Alps (with enough points, of course). It struck me as odd that most of the rewards weren't

art related. When I responded that I preferred my current Visa arrangement, which allowed me to acquire airline miles, I was told, "But with us you get Sotheby's monthly *Preview* magazine for free."

Meanwhile, during mid-2007, there was bigger news to digest. The *New York Times* reported that Steven Cohen had purchased Warhol's *Turquoise Marilyn* from Chicago collector Stefan Edlis, who once owned the two Fright Wigs Andy Rose just bought. Larry Gagosian was credited with brokering the deal for a reported $80 million. If it were true, this was now the most expensive Warhol ever sold, eclipsing *Green Car Crash*.

Turquoise Marilyn was one of five paintings from the forty-inch-square Marilyn series painted in 1964. It was also the only canvas without a repaired bullet hole in the middle of Marilyn's forehead. As the often-told story goes, a woman entered the studio and seemingly joked with Warhol about permission to shoot a Marilyn. To what must have been Warhol's considerable shock, she proceeded to pull out a gun and fire it at the canvas leaning against the wall. Not only did she pierce the painting, but the slug passed through three other Marilyns stacked behind it.

Warhol restored the damage to the portraits, which became known as the "Shot Marilyns." All of them wound up in significant private collections, including those of Peter Brant, Si Newhouse, and Philip Niarchos. The tale behind how the pictures sustained damage only added to their lore—and value. Talk among the trade was that Cohen had purchased the finest one from the series. It was considered the finest because of its turquoise background. The art market judges certain Warhol colors to be more desirable than others.

With the $80 million Warhol as a backdrop, the art market was primed for the next outrageous event. Dealers speculated that Sotheby's or Christie's might attempt to buy Phillips.

Personally, I thought one of them would buy Gagosian instead for $100 million. It turned out I was right about the $100 million figure. Only the number wasn't the cost of purchasing a gallery—it was the asking price for Damien Hirst's newest extravaganza, *For the Love of God*.

In a story making waves on both sides of the Atlantic, Hirst had recently created a life-size human skull, cast in platinum, and covered with 8,601 investment-grade diamonds. In the center of the skull's forehead—ironically the same spot the Marilyns were shot—jewelers set a flawless light pink fifty-two-carat pear-shaped diamond. According to Bentley & Skinner, who were hired to source the diamonds, Hirst purchased so many stones that he drove the diamond market up by fifteen percent worldwide. Allegedly, Hirst invested $23.6 million of his own money to fabricate the artwork.

At first I was impressed. Then I called a friend, who had been a diamond merchant before becoming an art dealer. He scoffed at the numbers, claiming the breakup value would be "less than $10 million." Numerous reporters questioned whether "blood diamonds" were used in the piece. They were told by Bentley & Skinner that all the diamonds were "ethically sourced." But as my friend explained, "Conflict-free diamonds are hard to prove." Since Hirst claimed the piece was about "death," questions surrounding the origin of the diamonds took on added gravity.

In June, the skull went on display at the White Cube gallery in Mayfair, England. According to the press, *For the Love of God* was surrounded by guards with conspicuous bulges under their tailored black jackets. When someone queried whether there was interest in the piece, Hirst's gallery claimed it already had three or four people seriously considering it. Alberto Mugrabi offered $50 million for it, but was turned down. My guess was

the piece would eventually be sold at a deep discount, but the media would be told it went for $100 million—preserving the illusion.

In another sign of the times, White Cube set up a separate temporary space next door that served as a glorified gift shop. Inside were limited-edition silkscreen prints of the skull that ranged in price from $2,000 to $20,000. The most expensive prints were covered in *diamond* dust, an idea swiped directly from Andy Warhol's "Diamond Dust Shoes" series. Should a less affluent buyer feel left out, there were also T-shirts for sale, priced in the hundreds of dollars.

Talk of the $100 million Damien Hirst filtered through the Basel Art Fair. Prices at the show were "beyond human comprehension"—as one dealer put it. Depending on to whom you spoke, sales were either strong or nonexistent. What always struck me as amusing was whenever an exhibiting dealer claimed business at a fair was slow, he would follow it up with the remark, "But I've done well."

From Basel, Switzerland, the art world moved on to London for the season's last round of auctions. With the incredible success of New York's May sales, London's June sales promised more of the same.

About a week before the auctions, I received a call from Andy, "Richard, I want to ask you something."

"Shoot."

"Would you still take a million dollars from Christie's for the orange Fright Wig?"

I thought about it for all of two seconds, "Sure. Like I said before, even if their painting brings the high end of the estimate in London—$1.2 million—you still did well and the value of your green one went up."

"You really feel that way?"

"Yes, I do."

"Okay," said Andy. "I've decided to hang onto both paintings but I'm going to send you a check today for the money I owe you—based on accepting $1 million from Christie's."

"Sounds good to me!" I yelled into my cell phone. Our deal was finally completed—at long last.

"Just so you know, I'm sending Meryl to London," said Andy. "I figure she'll have fun and she can call me from the sale so I can follow the bidding on the painting."

Not long after, Meryl Rose flew to London to attend the auction previews. According to Andy, she inspected the Fright Wig and decided their orange one was better. She also ran into an auction house representative, who continued to press her to sell them their painting. Andy reveled in all the reports he received from his wife, updating me each time they spoke. With the sale twenty-four hours away, he insisted on calling me the moment the painting sold.

The next day, as I awaited Andy's phone call, I reflected on all that had happened during the last year. I wanted desperately to turn back the clock—way back. I missed the good old days when dealers at least made vague attempts to enjoy the art. Now that paintings had been reduced to a commodity, it became a contest to see who could make the most money. Had I known things would end up this way, I never would have gotten into the profession.

I looked out the window and noticed a storm was coming. I immediately thought of Bill Anton's *Rain on the Mesa* and how much l loved that painting. I was initially interested in Anton for his potential as a moneymaker. But despite my obsession with reinvesting the Fright Wig money, and the reality of making a living in a galloping art market, this particular painting thrilled

me. I always advised collectors that whenever they came across a picture that gave them a jolt, the first thing to do was get away from it and see if it "stayed" with them. A great picture exerts a force that works on your psyche. You find yourself constantly thinking about it. This was a clear sign that you should take another look. Upon seeing it again, one of two things always happened. You either said to yourself, *I can live without it* or *It's better than I remember it.* Having viewed *Rain on the Mesa* several times, I knew what I had to.

Later that day, I placed a call to Arroyo Designs and purchased *Rain on the Mesa,* for $1,700. When I tried to negotiate a discount, I was told the gallery was in the process of raising Anton's prices to $2,500, so I was getting a "good deal." Whether it was Western art or contemporary art, art dealing was art dealing.

Once the landscape arrived, I placed it in a spot where the Fright Wig would have hung had I managed to keep it. Though the Anton and the Warhol were of similar size, they couldn't have been further apart in terms of content. My memory of living with the Warhol was how it always looked different every time I glanced at it. Most paintings are like one-liners; once you get it, that's the end of the experience. The best works of art, like the Warhol, reveal something fresh whenever you look at them. As the day wore on, the Anton was proving up to the task.

The key element in the painting was what the artist referred to as a "walking thunderstorm." This is an isolated cloudburst, viewable at a great distance, that seems to slowly advance across the landscape. It is a natural phenomenon that is as much a part of Southwest summers as snow is a feature of Northeast winters. Looking at Anton's painting reconnected me to my frequent travels to Arizona, specifically the day I spotted an unusually large walking thunderstorm, near Meteor Crater. I pulled off the road, mesmerized by its relentless march, as it spewed streaks

of rain. Anton's *Rain on the Mesa* took me back to that moment. Who knew where it would take me next?

The London auction results began to trickle in. As expected, sales were strong. Virtually everything did well. One of the big surprises was the success of Warhol's *Three Marilyns*. During the 1990s, I received a call from a young New York collector who had been offered the painting. I was already familiar with it. *Three Marilyns* had been making the rounds, jumping like a hot potato from gallery to gallery. It was one of those awkward pictures that dealers had trouble placing at any price.

The painting was a vertical strip of three Marilyn Monroe headshots, resembling a souvenir from a photo booth. It measured only 43½ inches by 9½ inches. Though each portrait was painted with a classic group of Warhol Marilyn colors—a turquoise background, yellow hair, pink face, and red lips—the work was unattractive. Its surface was marred by too much silkscreened black ink, as if Warhol had lost control. When I once inspected the picture, it appeared as if it had been trimmed off of a larger canvas.

Three Marilyns was given as a gift from Andy Warhol to his brother, Paul Warhola. After Andy's death, Paul had consigned it to various dealers, where it ultimately wound up at C&M Arts. The collector who called me for advice asked the usual questions: Was the price of $750,000 fair? Why had it been on the market so long? How could a multi-image Marilyn from the 1960s not be more valuable?

I attempted to answer his questions by keeping it simple. I told him *Three Marilyns* didn't appear to be a finished painting. In fact, I was sure of it. While it was a genuine Warhol, it was a reject. The artist had a tendency to give his two brothers scraps and paintings he was dissatisfied with. The collector told

me he received a similar response from other experts. Then he thanked me for my time and proceeded to buy it. About a year later, I remember seeing it in his Park Avenue apartment. The painting sported an elaborate gold-leaf frame. But no amount of dressing up could disguise its tawdry feeling. As my friend sat there beaming, I tried to be polite, telling him I was glad he found something he enjoyed—while secretly thinking, *What a sucker.*

So what happened when he decided to cash in and auction it in London that night? *Three Marilyns* brought over $11 million. This time I thought, *Good thing he didn't listen to me.*

There were other revelations during the two nights of London sales. For instance, a single Warhol blue Jackie—known appropriately as a "Smiling Jackie" because of the smile on her face—sold at Christie's for $2.8 million. The price was outrageous, considering the group of *four* blue Jackies—two "Smiling," two "Mourning"—brought $2.8 million approximately one month ago, at Sotheby's in New York. The quadrupling of the price for a single Jackie in thirty days was lunacy. As a side note, it also belonged to the collector who sold *Three Marilyns*, leading me to consider asking *him* for advice.

The result that really had the art world buzzing though was the price paid for Damien Hirst's *Lullaby Spring*. This was one of his "Pill Cabinets," lined with 6,139 hand-painted bronze pills. Hirst became the most expensive living artist at auction, eclipsing Jasper Johns, when the piece sold at Sotheby's for $19.2 million—or approximately $3,127 per pill. The artist's business manager (yes, he had one), Frank Dunphy, was quoted as saying, "Damien was blown away by the price. We were betting it would go for $10 million to $20 million."

Not long after, approximately in December, the *New York Times* wrote an editorial on the art market—another first. Titled

"Dumping the Shark," it discussed how Steven Cohen had agreed to lend the Metropolitan Museum of Art his recently acquired Hirst—the infamous shark immersed in a formaldehyde-filled glass tank. The editorial pointed out that Cohen was trying to come off as doing the museum a favor. The *Times* opined that his act of generosity was an attempt to validate his own taste, as well as boost the value of the piece, through the Met's endorsement.

Wealthy collectors have been doing this for years. Museums go along with it, hoping to lure the collector as a future big donor. But what the editorial astutely pointed out was that Damien Hirst was also a hedge-fund manager, of sorts. He directed the fund of "Damien Hirst's art." As the *Times* concluded, "No artist has managed the escalation of prices for his own work quite as brilliantly as Mr. Hirst." The piece ended by declaring the convergence of Cohen and Hirst was the coming together of "two masters in the art of the yield."

And what of the orange Fright Wig? Incredibly, it too belonged to the seller of *Three Marilyns* and the Smiling Jackie. Would the owner hit a trifecta? The auction house personnel predicted it would do well. They told Meryl there was plenty of interest. She reported to her husband that it would definitely break a million and could easily approach the high end of the estimate. But you never knew for certain with the auctions. If it turned out there was only one bidder, the self-portrait wouldn't go above the low end of the estimate—$800,000. Since the auction would be conducted in British currency, this was the equivalent of approximately 400,000 pounds.

My cell phone began to ring. I didn't even have to look to know who it was. I let it ring a few more times. In the blink of an eye, I thought about the green Fright Wig I once owned. Now Andy possessed one—make that two—and I didn't. On the other

hand, what the hell! I made a nice profit on the sale to Andy. It was time to let the sun shine on him. Such is the way of the art world—it's all a gamble.

I let the phone ring one more time. Then I answered it. Beating him to the punch, I yelled, "Hi, Andy! Well, how'd we do?"

Playing it for all it was worth, Andy paused for a split second, "Are you ready?"

"Yeah. What did it bring?"

"It brought 1.2 million . . ."

I heaved a deep sigh of relief. The Fright Wig had sold at the high end. The price certainly exceeded Andy's expectations when he bought the pair. I could tell he was happy, and I was happy for him.

But then I realized he hadn't completed his sentence. There was still one more word to come.

". . . pounds!"

here comes the sun

by January 2008, my transition from a true art dealer to a "financial art adviser" was complete. The calls were streaming in from collectors who bought art during the 1980s and were ready to cash out. All of them, not surprisingly, were looking for top dollar for their treasures. If they were willing to be even remotely realistic, whether selling at auction or privately, I knew I'd find them the right deal.

Amidst a flurry of sellers came a call from Andy Rose with a surprising request. Having recently resold his extra Fright Wig (the orange one) for a seven-figure sum, he had essentially gotten the second painting for free. Now, he wanted to reinvest his profits, and was open to suggestion. For some reason the name Roy Lichtenstein popped into my head. Knowing I had a good relationship with the estate, after selling them the figurative drawing from Stanley Landsman's collection, I called the director, Jack Cowart. When he purchased the drawing from me, he had agreed to the asking price, but gently indicated he would accept a ten percent discount. While I knew the Lichtenstein estate hardly needed the money, experience had taught me that

everyone likes to feel special. With that in mind, I gave him a $4,500 reduction.

By doing so, I was now in a position to ask a favor. I said to Cowart, "I know there's very little left in the estate, and I also realize you can pick and choose who you sell to, but I have a serious collector who wants to own a small painting."

"Tell me about the collector," said Cowart.

"Are you familiar with the Rose Art Museum at Brandeis University?" I queried.

"Of course. It owns *Forget It/Forget Me*." This is an early Lichtenstein Cartoon painting of a quarreling couple.

"Well," I said, "not to name-drop but my client Andy Rose's aunt founded the museum."

"Good to know," said Cowart. "I'll speak with Lucy [of Mitchell-Innes & Nash, the estate's representative] and fill her in."

After letting a few days pass, I called Lucy. I already knew her from her days at Sotheby's. During the glorious 1980s, she was the head of the contemporary art department and one of Sotheby's best auctioneers.

"Hi, Lucy. Have you heard from Jack Cowart?" I asked.

"Yes, but as you probably can imagine there's almost nothing for sale. There might be an "Entablature" or possibly a late "Brushstroke." I'll take a look and see what I can do."

The Entablatures, which resembled strips of architectural ornamentation, were a tough sell. So were the late Brushstrokes. Unlike Warhol, Lichtenstein sold almost everything he produced during his lifetime (he died in 1997). There were only three bodies of work that didn't sell well and they formed much of the estate—the aforementioned and the "Perfect/Imperfect" paintings. Regardless, Lichtenstein was never prolific to begin with.

A week later, I received a FedEx delivery with a Mitchell-Innes & Nash return address. As I tore the cardboard envelope's zip tab, I figured the gallery was offering me a "Brushstroke Apple" painting. This was a late body of work where the artist painted stylized brushstrokes that formed an abstract apple. They were pretty good paintings, but never really caught on with collectors.

I opened a gray folder and my eyes grew large as I pulled out a photo of a twenty-inch by twenty-four-inch 1964 "Landscape" called *Sunset*. Unlike more minimal examples from the series, this painting had overlapping benday-dots of blue and red that formed a foreground and a sky with wispy clouds, along with a yellow setting sun—most of the others in the series only depicted an empty landscape. The painting was so good that I figured there had to be a catch. The accompanying letter revealed the work came directly from Roy Lichtenstein's family. It had been a gift to his nephew and had remained in the family for the last forty-four years. It couldn't have been any fresher to the market.

Then I went to page two to find out its cost. I thought, *Here it comes*. When I saw how much the gallery wanted for it, I could scarcely believe it. The price was fair.

I immediately phoned the gallery and requested that a jpeg be sent to the Roses. Time was of the essence. I was anxious to reserve the painting before it was offered to someone else. When you ask a gallery to hold a picture for you, you're essentially using up your currency with that dealer. If the client buys the painting, then everything is fine. But if he rejects it, you'll receive a cool response the next time you ask the gallery to reserve something. Worse, you usually don't get a second chance with the top galleries, and Mitchell-Innes & Nash fell into that category.

I phoned Andy, "Hey, I think I've got something."

"Yeah, I saw it. The gallery just sent me a jpeg of the image," he said. Then Andy hesitated a bit, "I guess I like it. But I wish there were some rays emanating out from the sun . . . if only it were a cartoon . . ."

"It would be five or six million," I said, completing the sentence.

"Ri-chid," said Andy, "I've told you before that I like Lichtenstein—and I'm certainly open to seeing this painting—but Pace offered me a Rothko on paper. I'm sending Meryl to New York next week to look at it. See if you can arrange for her to see this too. But I have to tell you, I'm almost certain we're going to buy the Rothko."

Years ago, I would have been discouraged—make that suicidal. But I knew I was holding an ace. With my newfound strategy, based on treating the art market as pure business, I said, "I'll set up the appointment. But I'll tell you something: a Lichtenstein Landscape is far rarer than a Rothko on paper—there seems to be one in every sale. But let's see what Meryl has to say. I know this painting is an opportunity—a 1964 Lichtenstein—with a sun. What can you say?"

"Okay," said Andy, sounding a little more optimistic. In all our dealings, he knew I was not one to exaggerate. He was beginning to pick up on my genuine enthusiasm.

Nineteen sixty-four was a great year for contemporary art. Not only were Lichtenstein and Johns doing some of their classic work, but Robert Rauschenberg was creating the best of his "Photo-Silkscreen" paintings. These canvases were, in my opinion, even better than his highly vaunted "Combines" from the late 1950s. Rauschenberg gave Warhol full credit for turning him on to this reproductive technique. As he once said to Andy, "Us silk-screeners have to stick together!" Unlike Warhol, who preferred

screening single-color individual images, Rauschenberg collaged multiple full-color images that reflected the times: the Kennedys, the Mercury space capsule, Janis Joplin, home-run slugger Roger Maris, and other period icons.

However, that year's indelible symbol was Warhol's red, white, and blue "Brillo Box." After shocking his audience two years earlier with portraits of soup cans, Warhol returned to the supermarket for inspiration to create his first sculptures. The Brillo Boxes were shown in 1964 at New York's Stable Gallery. Viewers at the opening were forced to confront the works directly, navigating a grid of boxes laid out on the wooden floor. Despite being priced at only fifty dollars each, they were met with confounding glances, and only three or four sold. At the beginning of 2008, a Brillo Box was being offered for $995,000.

My closing words to Andy were, "Think about it. Not only is this a first-rate Lichtenstein canvas, it's also a great piece of Pop art."

A week later, Meryl arrived at PaceWildenstein, took a quick look at a Rothko painting with soft red and yellow "cloud" forms, and noticed the lower left-hand corner had sustained a bit of water damage. Even though the gallery assured her that its conservator could make it vanish, Meryl knew enough to realize that if she bought it, each time she looked at the painting her eyes would always gravitate to that spot. With that kind of money involved, why deal with it?

Off she went to Mitchell-Innes & Nash. Under the watchful eye of gallery director Robert Grossman, Meryl confronted *Sunset*. When it comes to a major work of art, there comes a moment where all of the hype is put aside. Ditto for its cost. That's when the painting takes over. The picture has to sink or swim on its own merits. And swim it did. In fact, it might be a small

exaggeration, but *Sunset* performed like Michael Phelps at the 2008 Olympics.

Later that day, I received a call dripping with intensity from Andy. He came straight to the point, "How much do you think we can buy it for?"

I quickly made it clear to him that we were not dealing with some emerging artist where you could negotiate a whopping discount—nor was this Costco. This was a situation where you got out your checkbook and asked, "How do you spell Mitchell-Innes?"—before the gallery changed its mind about selling it to you.

Andy went to New York, viewed the painting, and later that day agreed to a deal. Without giving away all of the private details of the transaction, I received a nice commission with the promise of a substantial bonus based on the painting's future appreciation. Once we had dotted our "i's" and crossed our "t's" on the paperwork, I poured myself a glass of Barham-Mendelsohn pinot noir. Then I did something that was both corny and meaningful; I put on the Beatles song "Here Comes the Sun." It brought me back to the year 1987, when my first reaction to Warhol's death was to play the David Bowie song "Andy Warhol."

While I sipped my wine and listened to George Harrison singing, I had a bit of an epiphany. Years ago, a Bay Area collector named Richard Mendelsohn (of Barham-Mendelsohn) once explained to me how important it was to reward yourself after you closed a major deal. The day he and his partners signed off on the sale of a twenty-plus-story office building, on downtown San Francisco's Montgomery Street, Richard went out and bought a Breitling titanium watch. On the back of it he had the jeweler engrave the words, "Thank You, 405 Montgomery."

Recalling his example, while also acknowledging that I would be celebrating my thirtieth year in the business in September, I decided to give myself a nice gift. I wracked my brain thinking about what to treat myself to. This was too big of a victory to merely buy a new pair of Pradas. Dinner at Chez Panisse seemed unimaginative. Even a vacation to someplace exotic didn't feel right—after all, I always felt like I was on a permanent vacation.

Twenty years ago I would have bought a painting. But now that I had come to the conclusion that my new "financial art adviser" approach was the way to go, I thought I was finally detached from the art itself. It was no longer about my love for the work, it was about wringing value from it. Clean. Succinct. Honest.

I began to daydream about all of the wonderful works I used to own: the gold and green Warhol Fright Wigs, various Joseph Cornell boxes, and a painting that would have ultimately become the most valuable—a half-share of Ed Ruscha's 1964 masterpiece, *Securing the Last Letter*, a blue and orange oil of the word *Boss* held up by a pair of C-clamps. Even though I let all of these works slip through my hands, the truth of the matter was that I sold them for a profit. And all of those profits were reinvested in more inventory. I reminded myself it was just business. And yet . . . and yet . . .

As I savored the wine and music, I gazed up at my Bill Anton painting, *Rain on the Mesa*. It positively glowed, much like the warm yellow sun in Lichtenstein's *Sunset*. Visions of the Roses' painting made me envious. I wished I owned it. The next thing I knew, I leaped up from the sofa and placed a call to Prescott, Arizona. Since purchasing Anton's painting, I had met the artist and his wife for dinner, in the old Arizona copper mining town of Jerome. Listening to him talk about his work further

enhanced my appreciation of it. As dinner progressed, I felt like we were becoming friends.

"Hello, Bill? I was just enjoying *Rain on the Mesa* and would like to commission you to do a small painting for me. Perhaps you could return to the same spot, just as the sun is setting . . . maybe give it *a warm yellow?*"

Charles Darwin. Not exactly the first name that pops into your head when you think about the art market. Yet Darwin's classic "survival of the fittest" doctrine would accurately describe what was about to go down. Unlike his natural selection theory, which held that species evolved gradually over *many* generations, retaining the traits of their strongest members, the art market didn't have the luxury of time. Art traders had less than a year to adapt or face extinction. Or at least no longer be able to afford Pradas.

The May 2008 auctions came and went. The sales were strong, although there were no surprises. During the summer, Sotheby's and Christie's hopped back on their "hamster wheels," running in place as they battled each other to secure the fattest consignments for the fall sales. Based on auction house propaganda, November 2008 promised to be the highest grossing season ever.
 Not.
 In September, the American economy fell apart, thanks to a credit crunch, and the rest of the world followed. Like a monster tsunami that rose up out of the sea, there was no advance

warning. A severe contraction in lending to businesses, followed by dramatic stock market declines, led to a consumer confidence meltdown. The result was a global recession.

In what proved to be a harbinger of things to come, the venerable investment bank Bear Stearns had collapsed in March, only to be rescued by J.P. Morgan in a government-brokered shotgun marriage. During September, the "thundering herd," also known as Merrill Lynch, stampeded into the waiting arms of Bank of America. Washington Mutual was also acquired by J.P. Morgan. In October, Wells Fargo bought Wachovia. As the stock market gyrated through 500-point swings, talk of a government bank bailout to the tune of $700 billion dominated the news.

Lehman Brothers wasn't so fortunate. No one stepped in to rescue it. Among the big sellers in the fall auctions were its CEO, Richard Fuld, and his wife, Kathy. They had consigned a group of sixteen postwar drawings to Christie's, receiving a reported guarantee of $15 million. Among the treasures were works by Barnett Newman and Arshile Gorky. The funny thing was that Mrs. Fuld claimed that they were just pruning their collection— money wasn't an issue. Given that she was a Museum of Modern Art trustee, why not donate them? After all, Richard Fuld earned a reported $480 million during his tenure at Lehman. Perhaps she knew something that we didn't when she consigned their drawings during the summer.

With these and other fall auction properties secured, and numerous guarantees given based on May 2008 prices, the art market held its collective breath. Personally, I couldn't face going to New York in November to watch the carnage. Instead, I went two weeks before the sales, hoping to gauge the mood. Dealer after dealer talked a good game: "Quality will always sell," "The art market is too global to fail," and my favorite com-

ment, "I can't wait for prices to collapse so I can scoop up the bargains." Based on my experiences during the last boom/bust cycle, when a market heavily corrects, no one has the guts to step in and buy. The reason? You're afraid it might go even *lower*.

The moment I knew we were in real trouble was when an auction house specialist took me to an expensive lunch at the Sea Grill, located at Rockefeller Center. As I savored my crab cakes and watched ice skaters circle the rink, he remarked, "Better enjoy it. I have a feeling my entertainment budget is about to be cut."

Enjoy it I did. But once I left the restaurant, I began to get a queasy feeling. Since I didn't own inventory, I wasn't worried about my stock losing value. Nor would I suffer from knowing I didn't sell in time. No, my thoughts drifted to my Warhol green Fright Wig. Though I had since made peace with auctioning it before the boom, I couldn't shake the knowledge of not cashing in at the perfect moment, now that making a living was going to be a tough slog.

Right before the New York sales, London held a sale of its own. In what the trade was calling a "game-changing" event, Damien Hirst made a deal with Sotheby's to cut out the middleman (his dealers) and auction his art directly. Every work in the sale came from him. Sotheby's pulled out all of its promotional skills, issuing a lavish group of three sales catalogs, sandwiched in their own elegant slipcase. Several hundred lots were offered, representing all of Hirst's major themes: Spin paintings, Butterfly paintings, Spot paintings, Pill cabinets, and a number of formaldehyde-filled tanks containing farm animals—along with one large shark.

The talk among dealers was that if the sale did well, other major artists would follow Hirst's lead and bypass their galleries

to sell through the auction houses. Not only would they keep a larger percentage of the profits, but their work would enjoy far greater exposure. Personally, I thought the whole thing was much ado about nothing. Hirst was uniquely positioned to "go direct." He had enough speculators to support his market and his "assembly-line" approach allowed him to produce enough art to hold a "single-artist" sale. With the exception of Takashi Murakami, no other artist had enough market clout and a large-enough staff to duplicate Hirst's efforts.

Against a backdrop of toppling world financial markets, the two-day Hirst sale was an unqualified success, exceeding the high aggregate estimate to gross over $200 million. The art world's response mimicked a line from a Led Zeppelin song—it was "dazed and confused." Put another way, who was buying this stuff and writing all those checks? We may never know the answer. After the sale there was speculation that Hirst himself, through surrogates, had used his considerable wealth to prop up the auction. Additionally, that "collectors," who had taken a big position in Hirst, also did their best to keep prices artificially high.

The final piece of the puzzle may have ironically been added by his principle dealers, Larry Gagosian and Jay Jopling. Prior to the sale, Gagosian was quoted as having told Hirst that his plan was a bad idea. Ditto for Jopling. Only a few days before the main event, Gagosian and Jopling were seen at the London preview taking a far different tack—they were talking up the sale. The obvious conclusion was that at the last minute, Sotheby's decided to give them a small taste of the action in return for their endorsement.

When the Hirst sale exceeded all expectations, many dealers tried to convince themselves that perhaps the art market really *was* immune to the greater economy's ills. Even if the Hirst

auction results were artificially enhanced, perception usually becomes reality. Maybe, just maybe, the art market would skate through unscathed.

Those who did business in the "real world" weren't buying it. A few days before the first contemporary sales in November, David Flaschen called me and commented, "Unbelievable—I don't know what happened with Hirst, but the New York auctions are going to be highly disappointing. Trust me."

The night of the Sotheby's sale, Andy Rose called me from New York while the auction was underway, "Rich-id. Unbelievable! I've never seen anything like it. Things are either not selling or going below their low-end estimates. And when something does sell, there's only one bidder going up against the reserve."

I nervously asked, "Is *anything* doing well?"

"I guess Calder's holding up . . . wait . . . hang on a second . . ." whispered Andy, so as not to disturb those seated next to him. I could hear auctioneer Tobias Meyer's distinctive voice in the background. Then I heard the gavel come down and a lone chilling word reverberate through the room, "Passed."

"Let me call you back," said Andy.

Thirty minutes later, my cell phone rang again. "Boy, that must have been the shortest sale on record," declared Andy. Evening sales typically last an hour and a half. During a boom market, they can drone on for two hours. Often they start late to allow all the glamorous wives a chance to work the room and show off their new couture outfits. But Andy had clocked this sale at exactly one hour.

After Christie's went through its own debacle, the press reported how each house had predicted it would sell $200 million to $300 million worth of art, but missed its targets by approximately $100 million—*below the low end.* Sotheby's reported that it lost over $50 million, thanks to guaranteed lots—led by a

$20 million Roy Lichtenstein that didn't pan out. Christie's did no better, holding the bag on a $40 million Francis Bacon. It also got burned on the Fuld collection of drawings, which grossed only $13.5 million, resulting in a loss of at least $1.5 million.

A few days later, once the smoke had cleared, I began calling around. The consensus was that there was a burgeoning number of sellers and painfully few buyers. I even heard that Hirst himself had laid off over half of his employees, making you wonder even more about the truth behind his glorious sale. Hirst wasn't the only major artist who was affected. Everyone was cutting back. Rumor had it that even Ed Ruscha had listed one of his Malibu properties for $7 million.

I spoke to a few artists with simpler lifestyles, including Dan Douke. He anticipated that changes were coming, regardless of your station in the art market pyramid. "Hey, I'm just going to continue doing what I've always done — concentrate on making the work. You and I have been through this before. The ones who should be scared are the young artists who most of us have never heard of. You know, the guys who come up at auction during the afternoon sales and bring six figures. They're going to get clobbered. But the veteran artists who have stayed true to their vision and are willing to be flexible on discounts will be fine."

My guess was that this art-market recession would cut deeper than the last one in the 1990s, but be over quicker. It all came down to when the "point of capitulation" was reached. This is an expression economists use to indicate that sellers have thrown up their hands and shouted, "I'll take whatever I can get." That's when savvy investors step in and gradually start buying and the cycle begins anew. Based on history (and greed), the art market would rise again, though it would be painful to work through the process.

In desperate need of some comic relief, I checked in with Kay Richards in Santa Monica. "Hi Kay, what's going on?"

With a laugh, she responded, "Funny you should ask. I've spent the last few days doing grief counseling for art dealers."

Then it was my turn, "Did you see *Flash Art* magazine? It just printed this wild e-mail that Gagosian sent his staff."

"Tell me. What did it say?" said Kay with palpable enthusiasm. If there was one thing art dealers lived for, it was Larry Gagosian stories.

"Let me read it to you: 'If you would like to continue working for Gagosian, I suggest you start to sell some art. Everything is going to be evaluated in this new climate based on performance. I basically put in eighteen hours a day, which any number of people can verify. If you are not willing to make that kind of commitment please let me know. The general economy and also the art economy are clearly headed for some choppy waters; I want to be sure that we are the best swimmers on the block. The luxury of carrying underperforming employees is now a thing of the past."

The superdealer had captured the zeitgeist of the moment. The shift in the art market was now official. As I surveyed the ravaged landscape, it was apparent that dealers really would have to work harder and settle for making less money. So would the auction houses. One of my friends at Christie's sounded relieved: "Our jobs just got easier. No more guarantees, no more giving up the buyer's premium, no more rebating part of the seller's premium, no more agreeing to ridiculous estimates . . . if they don't want to be reasonable, they can hang onto their property." Then he added, "I admit, we're going to have to be happy with grossing $100 million rather than $200 or $300 million, but a $100 million sale was considered great only a few years ago."

"Aren't you worried about getting good material? I think you're going to have a hard time getting people to consign anything of quality," I said.

"You'd be surprised. There are always estates. We'll do fine."

"How about Warhol?" I asked. "His results weren't so hot last week. Where do you think his market's going?"

There was silence in New York. His unwillingness to commit to an opinion was an indication of how far Warhol prices had fallen. Even the Fright Wigs have come under pressure. When I sold my small green one in 2005, it brought approximately $375,000. As mentioned in chapter twenty-four, in June 2007 an orange example attained a mind-boggling $2.4 million in London, during the market's absolute acme. From there, small Fright Wigs began an equally dramatic descent. The *gold* Fright Wig, which graced the cover of Christie's November 2007 catalog, sold for $1.6 million. While that was the last one to appear at public auction, by the summer of 2008 the talk in the trade was that if one were to come up for sale, the asking price would be under $1 million. This was confirmed when I called Christie's in late 2008 to get an estimate for a client who owned a yellow version that was more or less equal in quality to my former painting. Christie's estimate? Just $600,000 to $800,000.

Given that most paintings at the November 2008 sales went for below the low end of the estimate, it's reasonable to assume that had the yellow picture gone on the auction block, it would have brought around $500,000. An educated guess is that if a Fright Wig were to appear during the next rounds of sales, in May 2009, you'd be down to an estimate of $400,000 to $600,000 or even $300,000 to $500,000.

With that in mind, it seemed almost prophetic that John Lindell sent me an e-mail stating: "If you have a serious buyer for my

(your) small green Fright Wig, I would be interested in selling it." The question was, would he take $375,000 for it? Assuming he would, my checkbook was ready. But the truth of the matter was that I couldn't pull the trigger to make him an offer. When push came to shove, my "Fright Wig moment" had echoed many of the recent auction results. It passed.

acknowledgments

I would like to thank Bonnie Nadell, of the Hill/Nadell Literary Agency. While most agents are satisfied selling a client's book, Bonnie went the extra mile to match me with what every writer fantasizes about—a simpatico publisher. Which brings me to Other Press and Judith Gurewich, who brought me into the world of literary publishing, forcing me to "up my game"—for which I am grateful. I would also like to express my appreciation to the staff of Other Press, especially my editor Corinna Barsan. As any author will tell you, the right editor can make your prose glow. Corinna is the right editor. Finally, I want to single out Sonja Bolle, who has mentored me in bringing greater depth to a story.

I wish to acknowledge friends and family members who have been supportive. In alphabetical order: Barnaby and Martha Conrad, David and Deborah Flaschen, Bill and Denise Kane, Lee Kaplan, Jonathan Marshall and Lorrie Goldin, Zalman and Kay Marshall, Martin Muller, Marlit Polsky, Andy and Meryl Rose, Gunter and Marcia Stern, and Joel Wachs.

Note: The following are among the best places in New York to see outstanding examples of work by artists mentioned in this book (unless otherwise noted). For an immediate look at imagery by each of these artists, simply go online to Artnet.com and click on "Artists."

BILL ANTON—Altermann Galleries (Santa Fe)

CHUCK ARNOLDI—Charles Cowles Gallery

FRANCIS BACON—MoMA

JOHN BALDESSARI—Marian Goodman Gallery

MATTHEW BARNEY—Barbara Gladstone Gallery

JEAN-MICHEL BASQUIAT—Independent (sometimes seen at Tony Shafrazi Gallery)

ROBERT BECHTLE—Barbara Gladstone Gallery

MAX BECKMANN—Neue Galerie (museum)

CHARLES BELL—Louis K. Meisel Gallery

LEE BONTECOU—MoMA

RICHMOND BURTON—Cheim & Read

JOHN CHAMBERLAIN—PaceWildenstein

CHUCK CLOSE—PaceWildenstein

JOSEPH CORNELL—L&M Arts

JOHN CURRIN — Gagosian Gallery

WILLEM DE KOONING — MoMA, the Met

RICHARD DIEBENKORN — Greenberg Van Doren Gallery

PETER DOIG — Michael Werner Gallery

DAN DOUKE — O.K. Harris Works of Art

MARCEL DUCHAMP — Philadelphia Museum of Art

WILLIAM EDMONDSON — Fleisher/Ollman Gallery (Philadelphia)

TRACEY EMIN — Lehmann Maupin

ERIC FISCHL — Mary Boone Gallery

TONY FITZPATRICK — Pierogi (Brooklyn)

SAM FRANCIS — MoMA, the Whitney

LUCIAN FREUD — Acquavella Galleries

PAUL GAUGUIN — MoMA, the Met

ROBERT GOBER — Matthew Marks Gallery

RALPH GOINGS — O.K. Harris Works of Art

PHILIP GUSTON — The Whitney, MoMA, the Met

MARY HEILMANN — 303 Gallery

JONATHAN HERDER — Pierogi (Brooklyn)

ROGER HERMAN — Independent (Los Angeles)

DAMIEN HIRST — Gagosian Gallery

DAVID HOCKNEY — Richard Gray Gallery (Chicago)

HANS HOFMANN — MoMA, the Whitney

EDWARD HOPPER — The Whitney, MoMA

JASPER JOHNS — Matthew Marks Gallery

DONALD JUDD — PaceWildenstein

ON KAWARA — David Zwirner Gallery

MIKE KELLEY — Metro Pictures

ELLSWORTH KELLY — Matthew Marks Gallery

GUSTAV KLIMT — Neue Galerie (museum)

FRANZ KLINE — MoMA, the Whitney

JEFF KOONS — Gagosian Gallery

MARK KOSTABI — Adam Baumgold Gallery

STANLEY LANDSMAN — Not viewable

JONATHAN LASKER — Cheim & Read

ROY LICHTENSTEIN — MoMA, Mitchell-Innes & Nash

MORRIS LOUIS — MoMA, the Met

PAUL MCCARTHY — Independent (sometimes seen at Hauser &
Wirth, London)

MARTIN MULL — Carl Hammer Gallery (Chicago)

TAKASHI MURAKAMI — Blum & Poe (Los Angeles)

LOUISE NEVELSON — PaceWildenstein

BARNETT NEWMAN — MoMA, the Met

MARC NEWSON — Gagosian Gallery

CHRIS OFILI — David Zwirner Gallery

CLAES OLDENBURG — PaceWildenstein

ELIZABETH PEYTON — Gavin Brown's Enterprise

PABLO PICASSO — MoMA, the Met

JACKSON POLLOCK — MoMA, the Met

RICHARD PRINCE — Gagosian Gallery

MARC QUINN — Mary Boone Gallery

MARTIN RAMIREZ — Fleisher/Ollman Gallery (Philadelphia)

MEL RAMOS — Louis K. Meisel Gallery

ROBERT RAUSCHENBERG — PaceWildenstein

DAVID REED — Max Protetch Gallery

JAMES ROSENQUIST — Acquavella Galleries

MARK ROTHKO — MoMA, the Whitney

DAVID ROW — Independent (New York)

ED RUSCHA — Gagosian Gallery

ROBERT RYMAN — PaceWildenstein

JENNY SAVILLE — Gagosian Gallery

JULIAN SCHNABEL — Independent (sometimes seen at Gagosian
Gallery)

DANA SCHUTZ — Zach Feuer Gallery

SEAN SCULLY — Gallerie Lelong

GEORGE SEGAL — Caroll Janis Inc.

FRANK STELLA — Paul Kasmin Gallery

GUNTER STERN — Independent (Huntington, N.Y.)

AYA TAKANO — Galerie Emmanuel Perrotin (Miami)

WAYNE THIEBAUD — Allan Stone Gallery

BILL TRAYLOR — Fleisher/Ollman Gallery (Philadelphia)

JUAN USLE — Cheim & Read

VINCENT VAN GOGH — MoMA, the Met

ANDY WARHOL — MoMA, the Whitney

GARY WEBB — Bortolomi

TOM WESSELMANN — Independent (sometimes seen at Robert Miller Gallery)

RACHEL WHITEREAD — Luhring Augustine Gallery

CHRISTOPHER WOOL — Luhring Augustine Gallery

JAN WURM — Stephen Rosenberg Fine Art

LISA YUSKAVAGE — David Zwirner Gallery

Behrman, S. N. *Duveen*. Boston: Little, Brown, 1972 (Random House, New York, was the original publisher, 1952).

Blum, Evan and Leslie Blum. *Irreplaceable Artifacts*. New York: Clarkson N. Potter, 1997.

Christie's Post-War and Contemporary Art auction catalogs (various), London and New York.

Colacello, Bob. *Holy Terror, Andy Warhol Close Up*. New York: Harper Collins, 1990.

De Coppet, Laura and Alan Jones. *The Art Dealers*. New York: Clarkson N. Potter, 1984.

Editorial. "Dumping the Shark" (on Damien Hirst). *New York Times*, June 20, 2007.

Haden-Guest, Anthony. *True Colors*. New York: Atlantic Monthly Press, 1996.

Helfenstein, Josef and Roman Kurzmeyer. *Bill Traylor, Deep Blues*. New Haven: Yale University Press, 1999.

King, Tom. *The Operator, David Geffen Builds, Buys, and Sells Hollywood*. New York: Random House, 2000.

Konigsberg, Eric. "Novice Art Collectors Find Access Is Priceless." *New York Times*, March 3, 2007.

La Placa, Joe. "Believe It" (on Damien Hirst's Skull). *Artnet*, June 21, 2007.

Shaw, William. "The Iceman Cometh, Damien Hirst Sends a Chill Through the Art World." *New York Times Magazine*, June 3, 2007.

Shnayerson, Michael. "Judging Andy." *Vanity Fair*, November, 2003.

Shulman, Ken. "Once Bitten Twice Denied" (on Joe Simon's lawsuit). *Art & Antiques*, December, 2007.

Smith, Roberta. "After the Roar of the Crowd, an Auction Post-Mortem" (on Hirst London auction). *New York Times*, September 21, 2008.

Sotheby's Postwar and Contemporary Art auction catalogs (various). London and New York.

Taylor, Paul. *After Andy: SoHo in the Eighties*. Melbourne: Schwartz City, 1995.

Thomas, Kelly Devine. "'Red Elvis' Case Resolved." *ARTnews*, November 2005.

Thornton, Sarah. "High Times" (on the New York auctions). *Artforum .com*, May 17, 2007.

Tully, Judd. "Suspicious Minds" (on Red Elvis). *Art & Auction*, November 2005.

Vogel, Carol. "Buying a Warhol 'Marilyn.'" *New York Times*, May 25, 2007.

———. "A Sparkling Skull, Shrouded in Mystery." *New York Times*, September 7, 2007.

———. "In Faltering Economy, Auction Houses Crash Back to Earth." *New York Times*, November 16, 2008.

"You Bought It Now Live With It." *Life*, July 16, 1965, 56–61.

Richard Polsky is the author of *I Bought Andy Warhol* and *The Art Market Guide* (1995–1998). He began his professional career in the art world thirty-one years ago and in 1984 cofounded Acme Art, where he showed the work of such artists as Joseph Cornell, Ed Ruscha, Andy Warhol, and Bill Traylor. Since 1989 he has been a private dealer specializing in works by postwar artists, with an emphasis on Pop art. He is currently a contributor to *artnet* magazine online and lives in Sausalito, California. The author can be reached through his Web site: www.RichardPolsky.com.